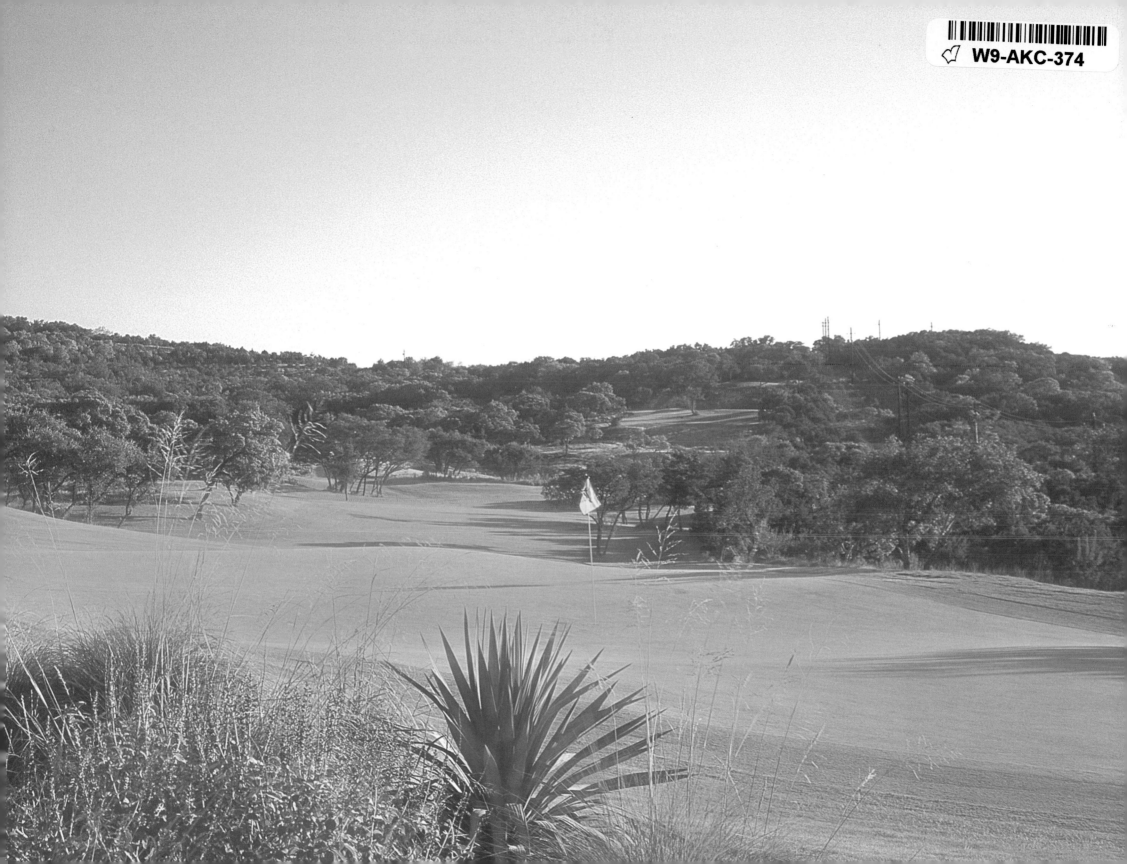

SPECTACULAR GOLF

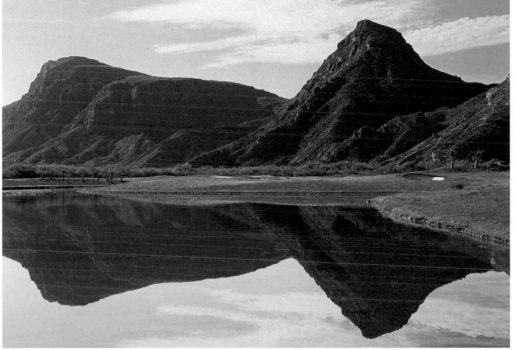

AN EXCLUSIVE COLLECTION OF GREAT GOLF HOLES IN TEXAS

Foreword by Byron Nelson

Published by

13747 Montfort Drive, Suite 100
Dallas, Texas 75240
972-661-9884
972-661-2743
www.panache.com

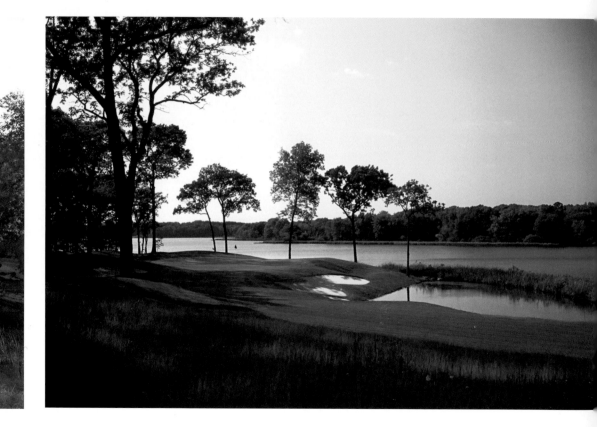

PUBLISHERS: Brian G. Carabet and John A. Shand
EXECUTIVE PUBLISHER: Steve Darocy
SR. ASSOCIATE PUBLISHER: Martha Morgan
ASSOCIATE PUBLISHER: Karla Setser
ART DIRECTOR: Michele Cunningham-Scott
EDITOR: Mike Rabun
Copyright © 2006 by Panache Partners, LLC.
All rights reserved.

No part of this book may be reproduced or transmitted in any form
or by any means, electronic or mechanical, including photocopying,
recording, or by any information storage or retrieval system, except
brief excerpts for the purpose of review, without written permission of
the publisher.

Printed in Fort Worth, Texas

Distributed by Gibbs Smith, Publisher
800-748-5439

PUBLISHER'S DATA

SPECTACULAR GOLF OF TEXAS

Library of Congress Control Number: 2006928265

ISBN Number: 1-933415-26-6
978 1 933415 26 0

First Printing 2006

10 9 8 7 6 5 4 3 2 1

Previous Page: Lajitas 3rd Hole

This Page and Facing: Gleneagles 12th Hole, Cascades 1st Hole,
Boot Ranch 10th Hole

INTRODUCTION

by mike rabun

Once upon a time on a golf course out in the country located conveniently somewhere between the Red River and the Rio Grande, a few of my chums and myself were frantically trying to locate an early morning putting stroke in preparation for the day's battle.

Into our midst suddenly appeared the facility's head professional, who we assumed had taken a personal interest in our presence in order to size up just how much damage we might cause to the grounds during the next few hours.

"You know what's the greatest thing about this game?" he asked without warning.

It was almost metaphysical. Here was a fellow unacquainted with any of us materializing out of the lingering fog and suddenly asking a question for the ages.

What, indeed, is the greatest thing about golf? Any number of answers might be put forward. But would this gentleman in the khaki pants and knit shirt have the ultimate revelation?

"Don't keep us in suspense," said a member of our group.

"The greatest thing about golf," the head pro said, "is that by the time you get to where your first tee shot has landed, you have forgotten about everything happening away from the course and you become submerged in the experience."

"Sometimes," I said to him, "it doesn't take too long for me to get to where my first tee shot has landed."

"No matter," he responded without hesitation. "As soon as you walk off the first tee, it's all golf."

Well, maybe it wasn't THE answer. But he had a point. And his theory can now be put to the test by all who wander through the following pages.

Herewith is presented something about as close to a golfing experience as one can get without actually setting foot on the course.

And not just one. Dozens of such havens are presented, some old and some very new. They are found in the harshness of the Big Bend, in the glory of immense pine trees, in the striking landscape that makes up the Hill Country and right in the middle of the big cities — where not even the heavy weight of day-to-day existence can snuff out passion for the game.

From these courses are offered up the most spectacular golf holes in Texas.

As is mentioned from time to time in this volume, there are always differences of opinion when it comes to golf. It might be, therefore, that someone who makes this journey will find a hole has been omitted that he or she deems to be the epitome of spectacular.

If that is the case, it will have to simply be put down as another in the sport's long line of disagreements.

By happenstance, my favorite hole in Texas will be found within these covers. It is the fifth at the Colonial Country Club in Fort Worth.

There is no waterfall on the hole and there is no waste area filled with exotic plant life or massive boulders. But between the rows of trees lining the fairway as it makes a subtle right-hand turn alongside a fork of the Trinity River, history oozes out of every square foot of turf.

As the golf cart arrived at the point where an unexpectedly good tee shot had come to rest on the fifth fairway during a recent pilgrimage to Colonial, I felt an irresistible urge to pontificate.

"Just look at that," I said to my playing partner, gazing down the avenue of trees to the distant target that beckoned like a siren. "Isn't that beautiful?"

All true golfers, regardless of how many strokes they require to complete an 18-hole assignment, would have understood the feeling.

And although it was not part of the thought process at the time, the words that philosopher had spoken on the putting green years earlier soon made a return engagement. Long before we had reached the fifth hole at Colonial that day, all the cares of the world had been tucked away into one of the brain's recesses.

Those cares, as they always must, eventually returned. But during the time spent on the course, they were overwhelmed by the altogether satisfying sensations created by a day spent with friends in mutual pursuit of the unobtainable perfection.

It is hoped that as you immerse yourself in some of the most appealing golfing scenes Texas has to offer, you will be subject to the same sensations.

Michael Rabun

FOREWORD
by Byron Nelson

ABOVE: 17th hole at the TPC Four Seasons, Las Colinas.

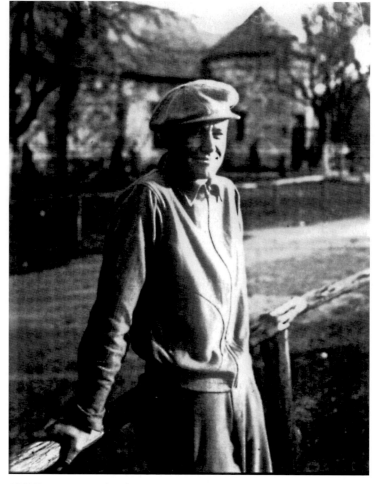

ABOVE: A young Byron Nelson at Brackenridge Park Golf Course in 1934.

I believe golf in Texas is unlike anywhere else in the country and that those who play in our state benefit from that fact.

When I was growing up, the challenges of playing on hard turf and changing weather created a great training ground for those who really wanted to develop their game. Course conditions today might be better, but the variety is still there. We can play all year in different climates and different agronomy without leaving the state.

As golf was beginning to grow in Texas, we were also fortunate to have the Texas Open, which began in 1922. It was a very important tournament and all the best golfers came to play in it. Watching those players heightened Texans' interest in golf and brought more people into the game. And with more players, Texas began to develop into a very competitive golfing area.

In my day, Texas was considered the breeding ground for champions. Consider that Ben Hogan, Lloyd Mangrum, Jimmy Demaret, Ralph Guldahl, and myself were playing at the same time and doing quite well. We especially did well at the Masters. Texans won eight of the first 17 Masters, almost making it a Texas tournament.

Today, with improvement in construction and with so many great designers in the business, there are wonderful new courses and lots of spectacular holes to play. But that's not to say we didn't have challenging holes when I played. They might have been different, but they were still challenging.

I played in the Texas Open eight times in my career and really enjoyed the tournament. Of course, beating Ben Hogan for the championship in 1940 (in a playoff) might have had something to do with it. There was a par-5 on the back nine at Brackenridge Park (which hosted the Texas Open 21 times) that I remember was really tough. The hole was reachable in two wood shots, but there was a little creek in front of the green and trouble behind the green. And just to make it interesting, the green was relatively flat and hard. That made it difficult to keep your second shot onto the green. I have always remembered the challenge of that shot. There are plenty of challenges in today's game, of course. Two of my favorite holes in the state are the 14th and 17th at the TPC-Four Seasons, Las Colinas course (site of the Byron Nelson Classic).

One of them has a narrow landing area off the tee and a difficult second shot over water and the other is a downhill par-3 with water and a tough green. Those holes are beautiful, but they also reward good shots and penalize bad ones.

They are just two of the holes that make golf in Texas so special. In the following pages you might recognize a few more. If you are a golfer who plays in Texas, consider yourself lucky. Enjoy the climate, these courses and the special challenges of the game as it is played in our state.

Byron Nelson

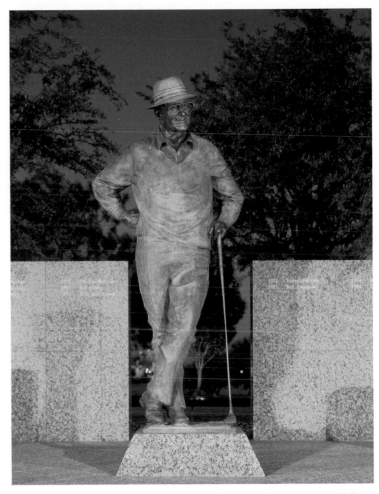

ABOVE: This statue of Byron Nelson greets all golfers at TPC Four Seasons, Las Coliinas, the site of the PGA TOUR's Byron Nelson Classic.

SPECTACULAR GOLF LOCATIONS

TABLE OF

NORTH TEXAS

CONTENTS

After a great round, Bob's Steak & Chop House welcomes you to come in and reflect on the events of the day over a few more rounds and a 20-ounce bone-in ribeye cooked to perfection. Owner Bob Sambol, a golf enthusiast himself, appreciates the opportunity to live in a state that boasts some of the best golf courses in the country and honors those who made them possible, those who have famously conquered them, and those who simply play for the love of the game.

NORTH TEXAS

Presented by Bob's Steak & Chop House

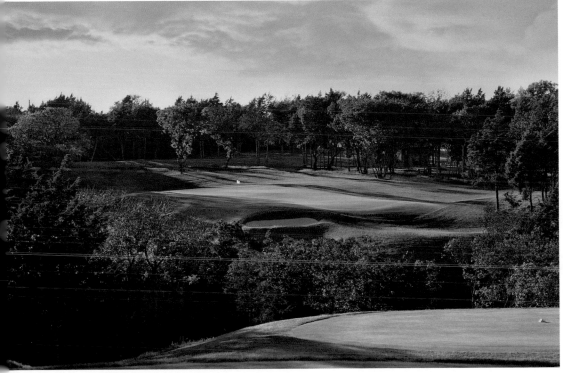

Dallas National 5th Hole

Colonial Country Club 5th Hole

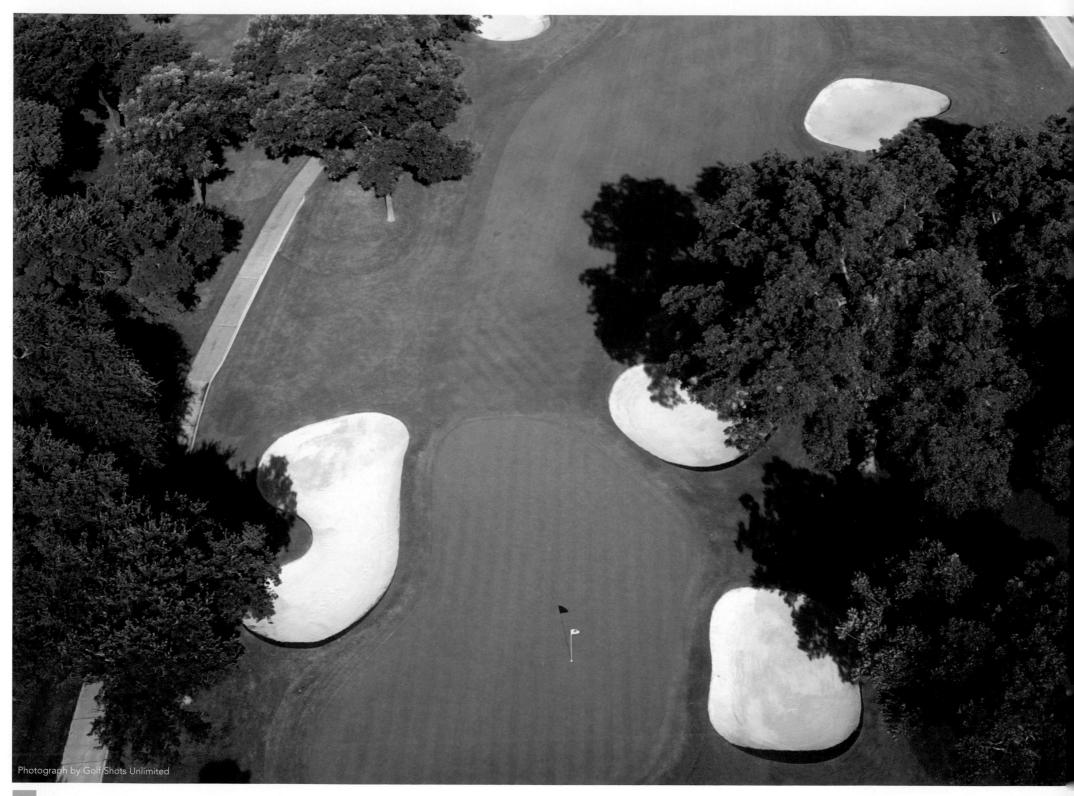

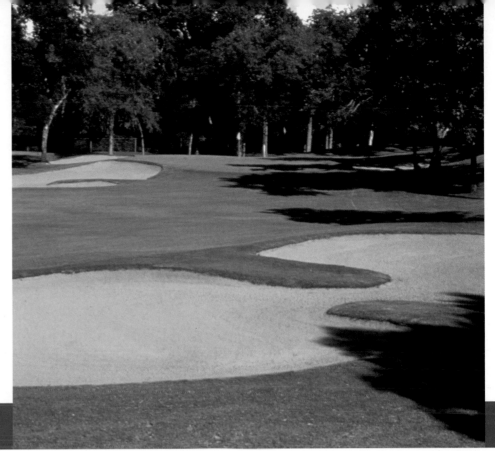

COLONIAL COUNTRY CLUB
1ST HOLE

565 yards • par 5

Fort Worth, TX 817•927•4200 www.colonialfw.com

In describing the renowned Colonial Country Club course, major championship winner turned broadcaster Dave Marr once said that the opening hole was relatively easy but that it was followed, "by the toughest 17 finishing holes in golf."

Colonial's first hole does, indeed, give the player a chance to ease into the round. Through the long history of the PGA TOUR event played along the banks of the Trinity River, the opening test ranks, by far, as the easiest on the course.

There are, however, places that should not be visited on a hole that doglegs to the right.

A pushed tee shot puts the player into a nest of trees and a pulled tee shot usually winds up in one of the huge bunkers on the outside corner of the dogleg.

Even from the middle of the fairway, those hoping to reach the green in two are faced with the need for accuracy.

The green sits in a grove of trees with a deep bunker fronting both sides.

In the third round of the 1985 Colonial tournament, Joey Sindelar started on the back nine and shot a 30. He then began the front nine by reaching the green at the first hole in two shots and holed a putt for eagle en route to what was then a course record 62.

"I hit a great shot on the green and made the putt and hardly anybody applauded. I guess they thought it was routine," Sindelar said after his round. "Gee, I thought it was pretty good."

Alongside the first tee at Colonial can be found the Wall of Champions, where the names of the tournament's winners are etched in black granite.

"Winning the Colonial is a high point for all the tour players who are fortunate enough to do so," said Arnold Palmer, the event's champion in 1962. "I am certainly very proud that I did and would have felt that I had not done as much as I wanted to do had I not won there."

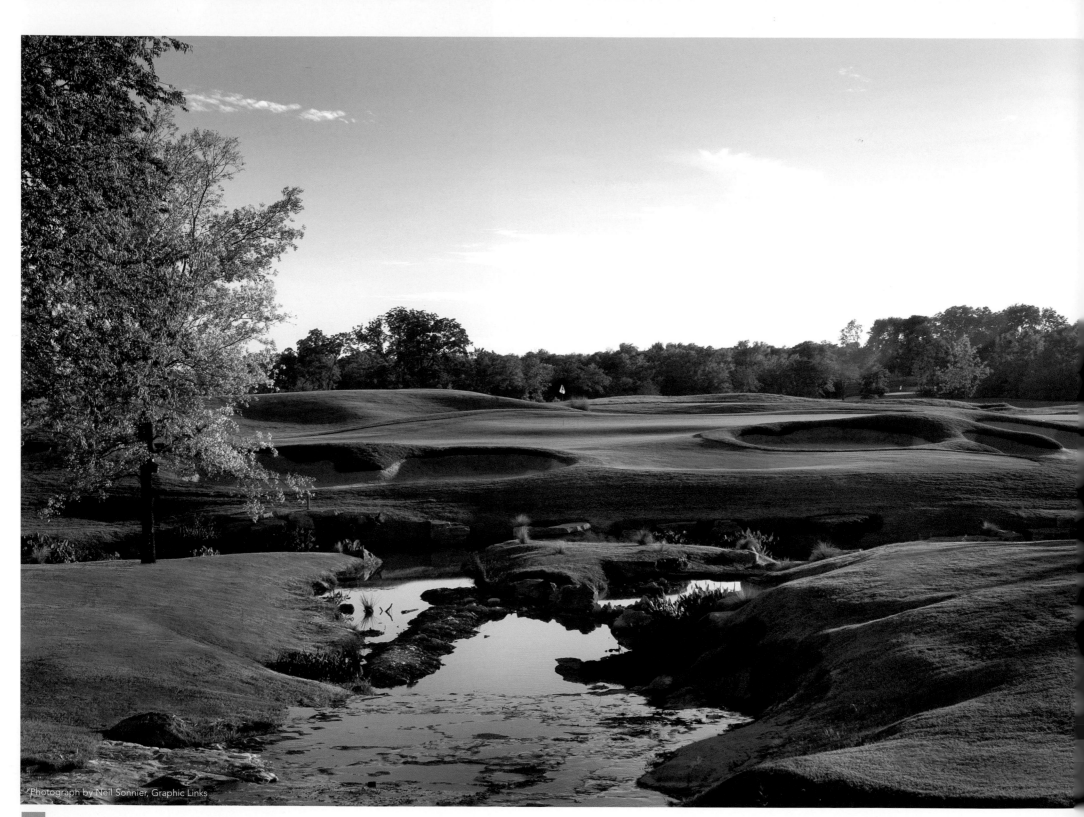

CRAIG RANCH

TOURNAMENT PLAYERS CLUB
AT CRAIG RANCH
18TH HOLE

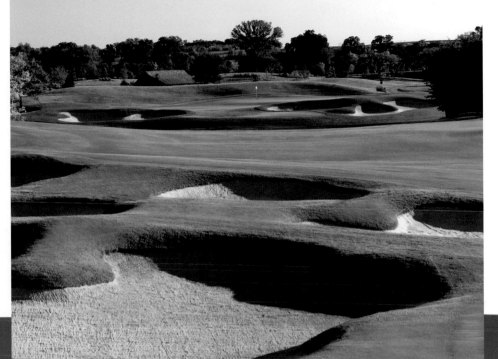

552 yards • par 5

McKinney, TX 972•747•9005 www.tpcatcraigranch.com

The closing hole at Craig Ranch provides the sort of drama one would expect from a course designed to attract big-time players for big-time events.

It is reachable in two by the professionals and gifted amateurs, even though the prevailing wind is against. For the mid-level player, it presents a steady stream of hurdles before a par can be achieved.

On the tee, the player is presented a small sea of sand — six bunkers scattered down the left side of the fairway and three more on the right. The bunkers on the left are very much in play and those seeking to play the hole conservatively will try to be to the right of them and short of the traps that are farther along the fairway on the right.

Those who hit it a very long way and can carry all of the bunkers will have an easy time producing the distance to get home in two. Those with more average skills will attempt to leave their second shot short of Rowlett Creek, which runs across the fairway in front of the green. Waterfalls are built into the creek for aesthetic value and to perhaps take one's mind off golf for a moment.

The green sits at an angle to the fairway and between the creek and the putting surface are bunkers that leave only a small gap through which to bounce the ball.

From the member tees, the hole plays at 490 yards and, with three tidy shots, offers a chance for a routine par or well-earned birdie.

But once a player strays off the intended line, things will likely wind up being far less than tidy.

CROWN COLONY
3RD HOLE

583 yards • par 5

Lufkin, TX 936•637•8811 www.crown-colony.com

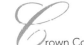

*C*rown Colony is the realization of a golfing dream and it is seldom that a dream can come to such a fabulous conclusion.

Arthur Temple, a major player in the timber world, enjoyed a round of golf in New York so much during the 1970s that he began to consider what it would take to create a mega course in the piney woods of his home state.

The chief ingredient for such a project, naturally, is money. But to do it right, that money must be spent wisely. And it was.

He hired the design duo of Bruce Devlin and Robert von Hagge and before long they had created an attraction that ranks among the state's very best.

It is not just that Crown Colony is surrounded by pines and ponds. It is not just that Crown Colony presents the kind of challenge that the serious golfer loves to face. It is also that the course is and always has been maintained to a pristine level.

Every blade of grass and every grain of sand are in their appointed places. The mowers create stripes in different shades of green on each fairway, although the stripes might not be immediately visible at the par-5 third.

From the back tee on that hole, the start of the fairway is 200 yards away and for the ball to get to the short grass, it must carry over a portion of a long pond.

The water stretches from in front of the championship tee all the way down the left side of the hole. But there is more than water to deal with at Crown Colony's third.

Trees encroach on both sides of the landing area and it takes a shot of 300 yards to get past the trees on the left so that the green can become visible.

Reaching the green in two is virtually out of the question, even for the big blasters. The putting surface is tucked back to the left behind the pond, meaning any second shot hit with intentions of going for it is all carry over the water.

The average second shot must still be struck with precision because there is not much room in the layup area between the water on the left and the trees on the right.

Two solid shots still leave a dangerous third that must skirt the water and avoid the large bunker that eats into the left front of the green.

The third is just one of many big tests at Crown Colony, but they all have one thing in common. Each one is part of an immaculate playing field.

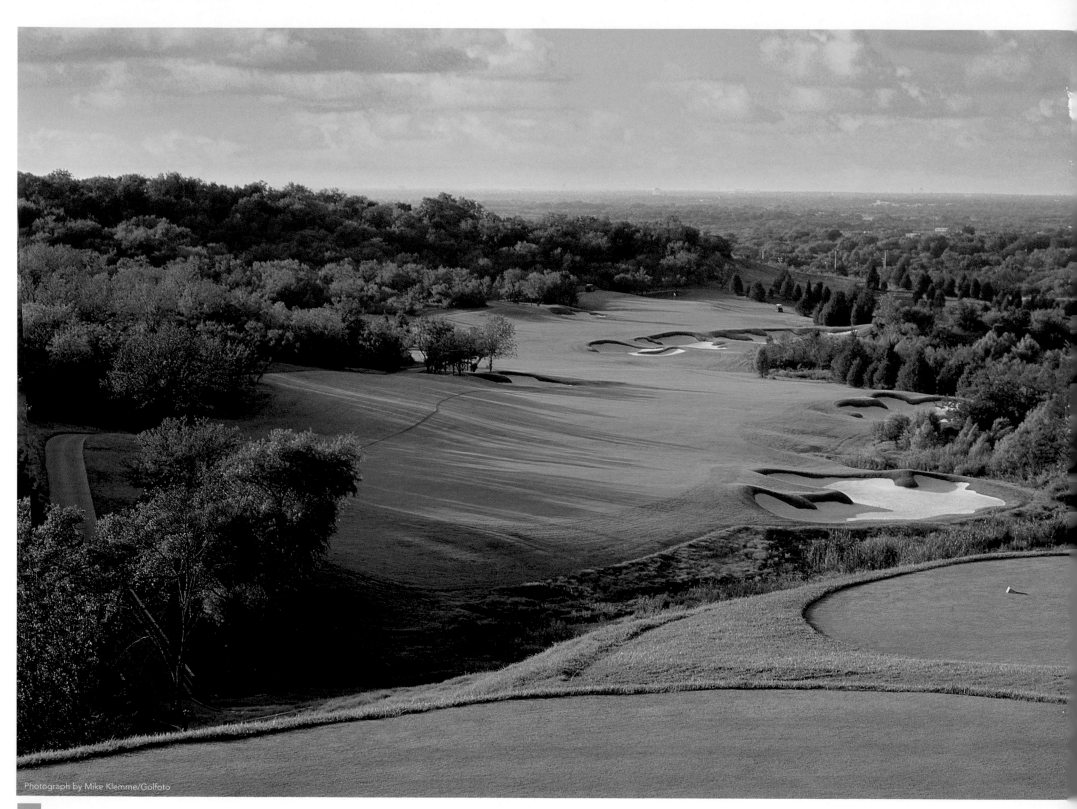

DALLAS NATIONAL GOLF CLUB
10TH HOLE

610 yards • par 5

Dallas, TX 214•331•6144 www.dallasnationalgolfclub.com

*T*he words urban density and panoramic vistas have little in common, but after a while one comes to expect the unexpected at the Dallas National Golf Club.

Each adventure at Tom Fazio's visually stunning course gives the player a different perspective, but the one at the par-5 10th is extraordinary — at least in a metropolitan setting.

There are 610 yards to be covered and each and every one of them is visible from the tee box. Plus a lot more.

The back tee sits 10 feet above the fairway and from that perch it is possible to see all the way to the northern horizon. The view is breathtaking. Playing the hole can leave one gasping.

A brisk prevailing wind can shorten the hole, but whatever the conditions, it will take a drive of about 240 yards to get past the hazard in front of the tee and a large bunker that sits just past the hazard on the right side.

A dense stand of trees runs along both sides of the fairway all the way to the green. But the chief features are enormous bunkers that jut into the fairway in the second-shot landing area.

The bunkers, which envelope the fairway's right side, first appear about 160 yards from the green and come to an end 100 yards out.

There is room to the left of the bunkers, but if the left side has been favored off the tee, there are trees encroaching from that direction that must be factored into the equation.

Having to figure out whether to stay short of the big bunker, or go to the left of it, or to try to blast one over it is enough to make your head hurt. And then there is the 34-yard deep green.

There is a large ridge running across the middle of the putting surface. Short of the ridge, the green runs back to the front. On the other side of the ridge, the green slopes to the back.

If an approach shot does not finish on the same side of the ridge on which the hole is cut, a three-putt can be expected.

The 10th is Dallas National's supreme example of both golf and scenery on a grand scale.

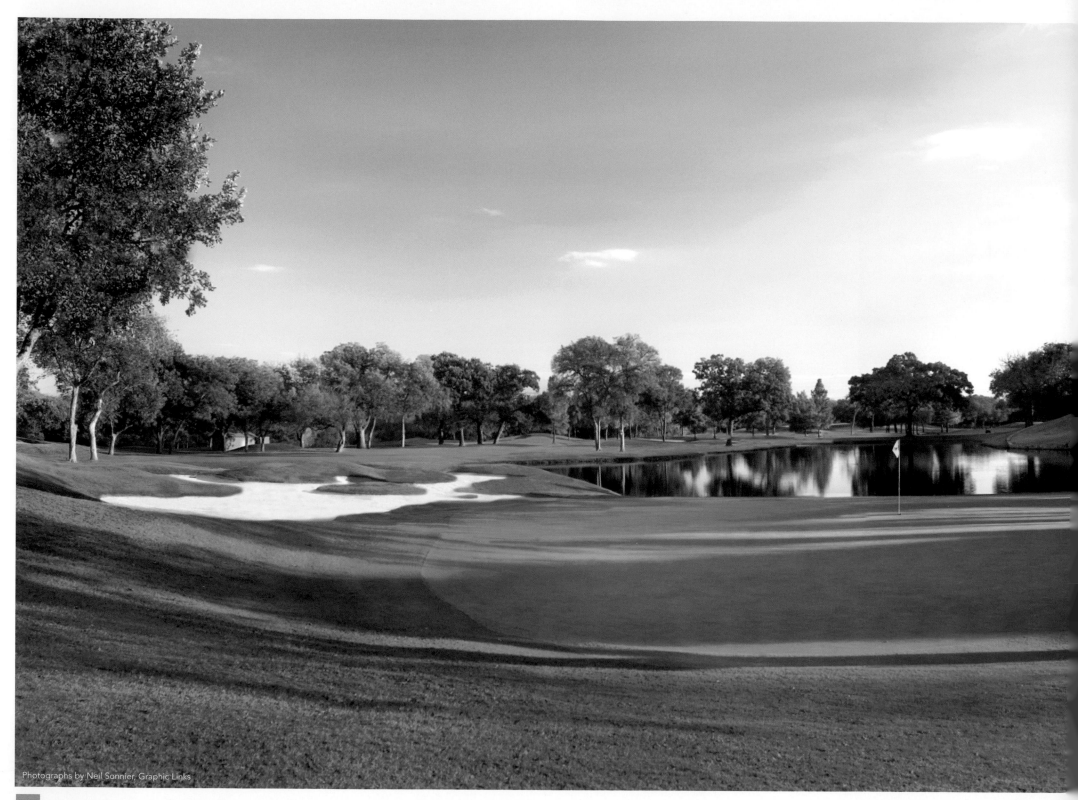

GLENEAGLES

GLENEAGLES COUNTRY CLUB
king's course • 16TH HOLE

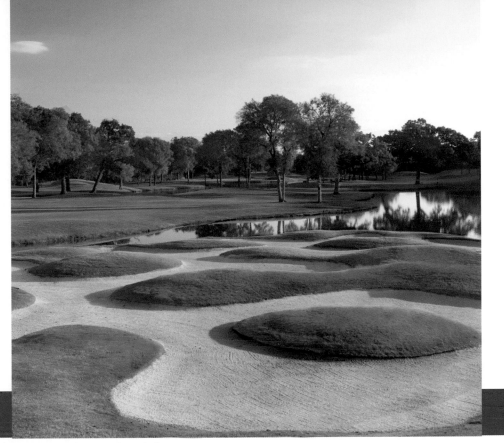

532 yards • par 5

Plano, TX 972•867•6666 www.gleneaglesclub.com

There is a bunker to the right of the 16th green at Gleneagles Country Club King's Course that symbolizes what the hole is all about.

From the air, the trap looks like pieces of a jigsaw puzzle that have been fitted together. But some of the pieces in the middle are missing, leaving little areas of grass where a ball may or may not come to rest.

As it turns out, the entire hole is a puzzle and it needs to be worked quite a few times in order to figure out where each piece goes.

It is a par-5 of only moderate length, so the distance of the hole is not the main concern. It is the placement of each shot that becomes the puzzle.

The dilemma begins immediately with the question as to where to hit the tee shot. The most direct route to the green is blocked by a big tree, behind which is a lake that runs about 200 yards all the way to the green.

To get to the green in two, therefore, a shot has to be played to the right of the big tree and safely away from the water. But the drive cannot go too far right because another lake that parallels the adjacent 12th fairway can easily come into play.

If the tee shot is safely placed past the first big tree and the two bodies of water, the problem becomes the other trees that are placed at intervals along the edge of the lake. The second shot must be lifted over – or around – those trees and over the water as well.

Those playing the 16th as a three-shot hole must determine what club is best off the tee to avoid the initial problems and then what club is best for the second shot so as not to have a third shot that might be blocked by the trees along the lake.

And if the first two shots have been hit far enough to get past all the trees, the bunker that looks like a bunch of pieces put together must be cleared. As a bonus, there are two trees behind the green, and the lake also wraps around the left side of the putting surface.

It is a puzzle of the first order, but like the real ones, it becomes easier the more times it is assembled.

PINE DUNES

PINE DUNES RESORT & GOLF CLUB
11TH HOLE

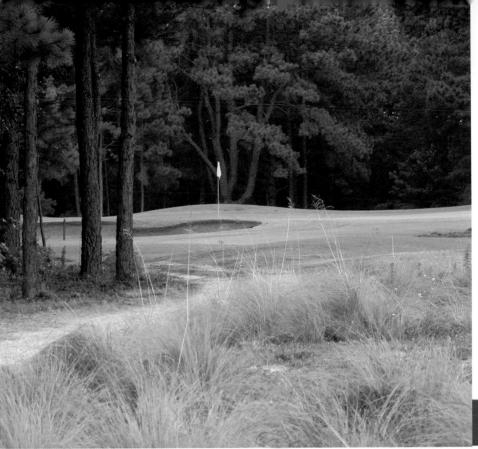

605 yards • par 5

Frankston, TX 903•876•4336 www.pinedunes.com

here are par-5s that are almost impossible to reach in two and then there are par-5s that are absolutely impossible to reach in two.

Number 11 at Pine Dunes gives us the latter — a hole where the green has never been reached in two shots.

The chief feature at the 11th, and the hurdle that prevents anyone from having any kind of chance of getting to the green in two, is a large native area in the middle of the fairway — filled with firm sand and various grasses.

And it can be found with a driver off the tee.

Despite the length of the hole, therefore, the first shot needs to be a lay-up. It is possible to have a full swing and a clean shot from the expanse of sand and grass. But it is also possible that it might take two or three shots to get back to the fairway. Playing into the waste area, in other words, is not a sound strategy.

After laying up short of the natural hazard, the second shot should avoid two bunkers placed in the landing area — one on the right about 150 yards past the waste area and another on the left about 30 yards farther on.

It takes two first-class efforts just to get in position for a relatively routine approach to the green, which is guarded in front and behind by bunkers and slopes from back right to front left.

When standing on the tee of this monster, it is quite plain that making a par is going to be hard golfing work. And once it is achieved, what happens during the rest of the round just might not make any difference.

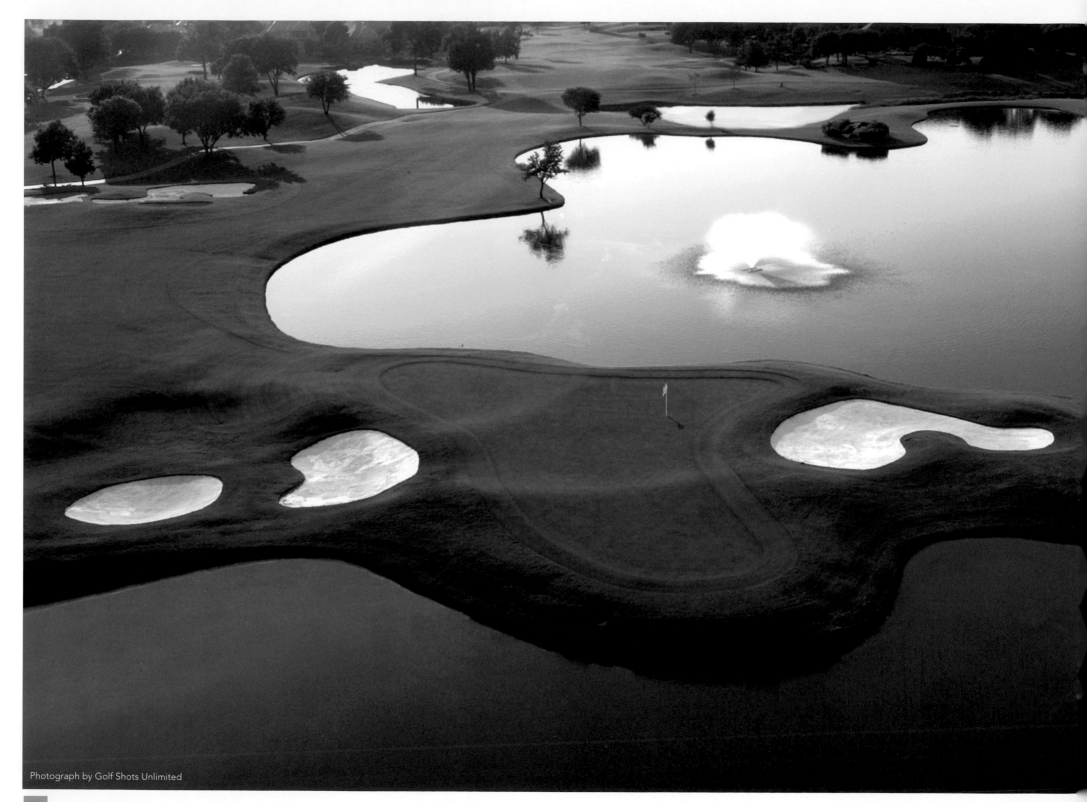

STONEBRIAR COUNTRY CLUB
18TH HOLE

556 yards • par 5

Frisco, TX 972•625•5050 www.stonebriar.com

The view from the tee at the concluding hole of the Stonebriar Country Club is fairly benign.

There are trees scattered along both sides of the fairway, but for the most part the scene is dominated by a reasonably wide fairway that gently rolls along toward a seemingly tame finish to a day's play.

Not exactly.

Stonebriar presents a meaningful challenge from the first tee through the 17th green, so there is no reason to expect anything else from the final hole. After all, no player could manage a score lower than 9-under par during the five years Stonebriar played host to the PGA Senior Tour.

The fun at the 18th starts after the tee shot.

A big blast from the tee, one that gets to the cart path that crosses the fairway about 250 yards from the green, sets up a go-for-broke second.

Reaching the green in two, however, requires an all-carry shot over a body of water that separates the ninth and 18th fairways.

For those with more average skills, the second shot must be played to the right of the water with the primary lay-up position being about 100 yards out in an area where the fairway widens.

That leaves a wedge or short iron that still must sail over the water and land between a bunker on the left and two more on the right.

Two ridges run across the green, separating it into three sections. Any shot landing on a portion of the green — not on the same level as the pin — will bring about a dicey two-putt.

Once the final putt is holed, a look back down the 18th fairway will confirm that the hole turned out to be a lot more difficult than it appeared to be from the tee.

Upon gathering in the clubhouse, which houses what is reputedly one of the larger fireplaces in all of north Texas, it will be possible to look out of the floor-to-ceiling windows and watch those who did not already know just how hard the 18th can be make the same discovery.

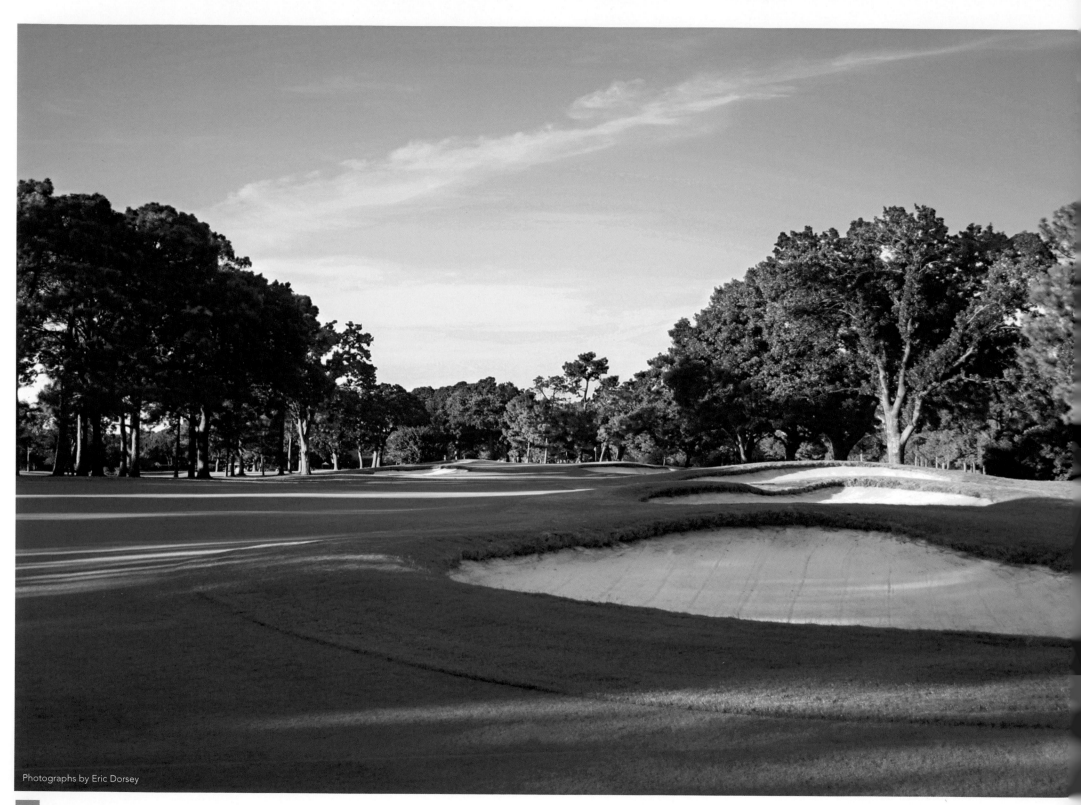

BROOK HOLLOW GOLF CLUB
17TH HOLE

385 yards • par 4

Dallas, TX 214•637•1900

*I*t is always nice in the world of golf to have a pedigree.

The Brook Hollow Golf Club, tucked away deep in the trees just off a busy thoroughfare within minutes of downtown Dallas, has one.

The course was designed by A.W. Tillinghast, who was turning out projects in the same time frame as Pinehurst creator Donald Ross.

That makes Brook Hollow a grandfatherly figure in the sport, the sort of place younger courses look up to and respect for its style, grace and heritage.

It also has championship credentials.

Ben Crenshaw won perhaps his most important amateur title at Brook Hollow in 1972, capturing the Trans-Mississippi championship by rallying from a 3-down deficit at the turn in an 18-hole semifinal match to defeat Gary Koch. He then recorded a 4 & 3 victory over John Paul Cain in the 36-hole finals. Bob Tway won the same tournament on the same course six years later.

Jay Sigel, one of the United States' best amateur players ever, claimed his third U.S. Mid-Amateur at Brook Hollow in 1987.

Crenshaw, devoted golf historian and latter day architect, had a hand in helping refurbish Brook Hollow in 1993. One of the holes that received a facelift was the par-4 17th.

It is not a long hole, but as it is making a slight dogleg to the right, it presents the player with three bunkers that are very much in play.

They run diagonally across the fairway with the one closest to the tee on the left. There is fairway room to the left of that bunker, however, allowing those who do not hit massive tee shots a chance to squeeze the ball into a small landing area.

The big hitters, however, will likely attempt to carry all the sand — keeping in mind that a dense grove of trees is waiting to the left.

The Tillinghast greens are still very much a part of the course and the one at the 17th has a sort of protrusion to the left — a small bit of putting surface that has a bunker both in front and behind it. When the pin is placed on that section of the green and a birdie is needed, the most precise of shots is required.

Brook Hollow serves as something of a time capsule, reminding those who play the course what golf in its earlier years was all about. Those who love the sport can only be grateful such reminders are still available.

BROOK HOLLOW

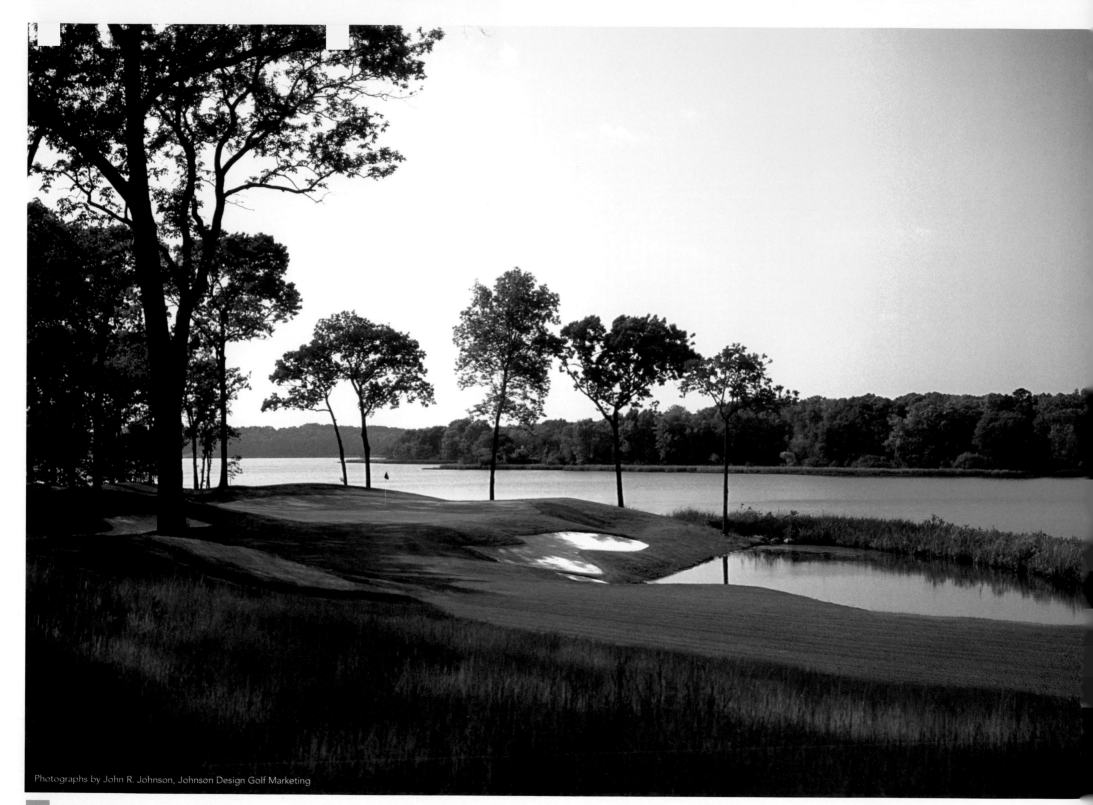

CASCADES

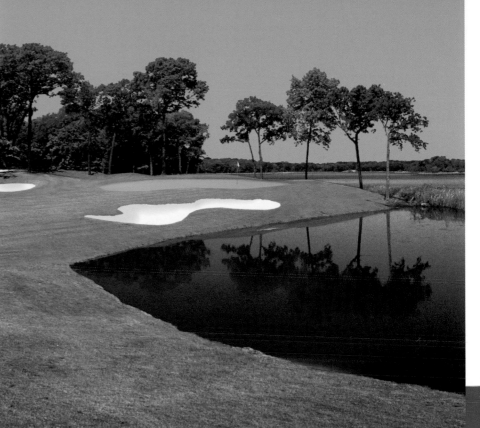

THE CASCADES
1ST HOLE

410 yards • par 4

Tyler, TX 903•593•7345 www.cascadesoftexas.com

On most courses, there is a particular point in the round that is most anticipated. A certain hole receives a majority of the publicity and is the one the players are anxious to see for the first time.

It might come early in the round or, perhaps, at the very end of it.

At The Cascades, that moment arrives immediately. Before a single shot is struck, the course presents the very best it has to offer from a visual standpoint. And the best at The Cascades can rival the best from just about anywhere.

From a tee elevated about 50 feet above the fairway, Lake Bellwood is visible in its pristine glory. Only when trees were cleared from what is now the first tee did anyone realize such a view was there to be seen.

Lake Bellwood is spring fed and the water level has changed no more than eighteen inches in the last century.

The lake is also reputed to have some of the best fishing in the state, so if things are not going well on the course, another outdoor endeavor might be considered.

Adding to the grandeur, sizeable Old-World style homes with timeless architecture adorn the left side of the first hole, with ample space between their majestic walls and the fairway.

Lake Bellwood sits beyond and to the right of the first green, but before getting there the player needs to avoid a bunker about 250 yards off the tee on the fairway's left side. Because the hole is downhill and not especially long, just about any club desired can be used off the tee. An iron will take the bunker out of play or a driver can be lashed at in hopes of having no more than a pitch to the green.

Everything on the green slopes to the right in the Redan style of architecture. If the pin is located on the right side, a shot landing on the left portion of the green can funnel directly to the hole.

A second shot that goes too far right will catch a bunker alongside the green and a shot further right of that, or long, will wind up in the lake. In that case, the view that was so admired from the tee may no longer seem so pleasant.

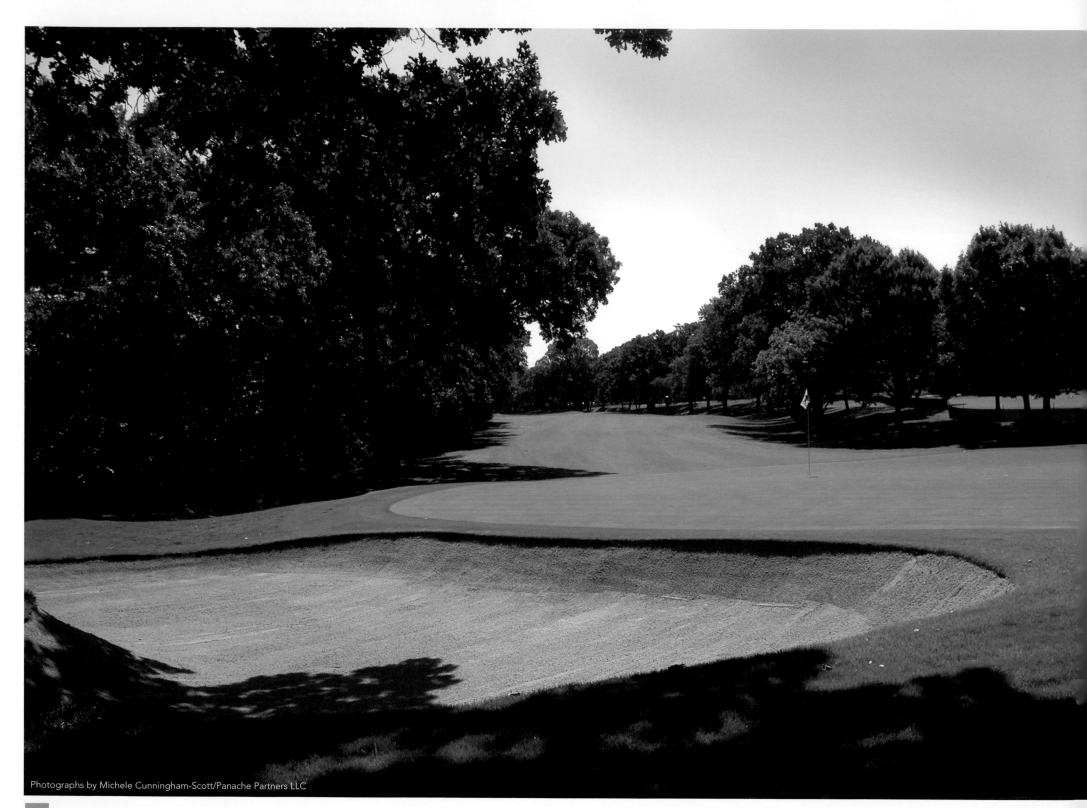

COLONIAL
COLONIAL COUNTRY CLUB
5TH HOLE

470 yards • par 4

Fort Worth, TX 817•927•4200 www.colonialfw.com

*A*ny discussions of the great holes in tournament golf has to include the fifth at Colonial, where the margin for error is minimal and the chance for a round-wrecking score is excellent.

Even the advancement of technology has not reduced the amount of havoc this hole can cause.

The fifth ends a three-hole stretch dubbed, "the Horrible Horseshoe." It has brought an end to title hopes for a legion of challengers at the annual Colonial tournament.

Tom Watson, whose Colonial victory in 1998 was the last of his 39 triumphs on the regular PGA TOUR, summed up the three holes this way:

"I always felt if I could play those holes at a maximum of 1-over par each round, it would be a success."

The critical early-round test ends with a hole that is visually intimidating from the tee.

The Trinity River runs down the entire right side, although a miniature forest blocks the player's view of the water.

To the left of the fairway is a swale that is rough infested and has trees overhanging. The fairway also slopes to the left, so any kind of draw will usually bounce down into a grassy low spot. And the only good thing that can happen to a slice is that it might hit a tree and bounce back onto the short grass.

The green sits close to the river, so a second shot that gets away to the right again invites doom. For those trying to avoid the water, a deep bunker awaits short and left of the putting surface. The green itself slopes hard from the back right to the front left and any putt over 10 feet can be an adventure.

Two-time Colonial champion Ben Crenshaw hit a perfect drive into a strong wind at the fifth one afternoon and decided he needed to hit a full-blooded 2-iron to reach the green. He made solid contact, the ball bore through the wind, landed softly and ran right into the cup for one of only four eagles made on the hole during the first 60 years of the Colonial tournament.

"It is one of the moments I'm most proud of," he said. "I'll always remember that."

COLONIAL
COLONIAL COUNTRY CLUB
18TH HOLE

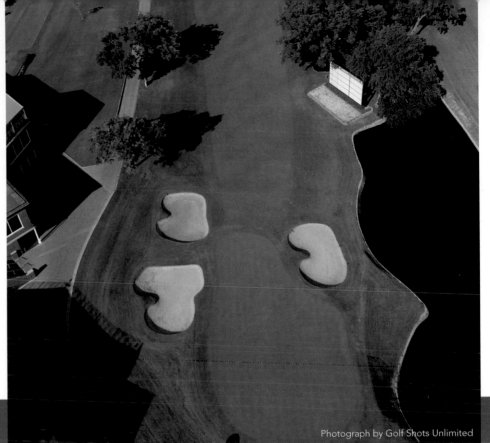

Photograph by Golf Shots Unlimited

427 yards • par 4

Fort Worth, TX 817•927•4200 www.colonialfw.com

*T*ournaments have been won and lost and careers have been shaped by the action that has taken place on the final hole at Colonial.

The 18th calls for a hard draw to take advantage of a downslope that can send the ball scooting along the fairway. When the wind is howling from out of the southwest, as it often is, the big hitters are left with less than 100 yards to the green.

The chief feature of the hole is a pond to the left of the putting surface and even the slightest of miscues can cause the ball to bounce down an embankment and into the water.

In the 1962 Colonial, Bruce Crampton hit his second shot into the water during the third round — leaving him in a tie for second place, three shots behind Arnold Palmer.

Crampton rallied during the final round, however, and needed only a par at the 18th to win the tournament. But he again dumped his second shot in the pond and he finished one shot out of a playoff, which Palmer won over Johnny Pott.

When the water alongside the 18th green began being called Crampton's Lake, the golfer for which it was named was not all that pleased. Crampton gained revenge three years later, though, when he shot a 66 in the closing round and won the event by three shots.

In 1959, Ben Hogan stood over a putt of less than three feet with victory riding on the outcome. His late-career putting woes had become well known by this time and he seemed to freeze over the ball. Finally, he stabbed at it and the ball lipped out — leaving him sharing the lead with Fred Hawkins.

Happily for Hogan fans, he went out and shot 69 in blustery winds the following afternoon to win the playoff by four shots and record what was the final win of his legendary career.

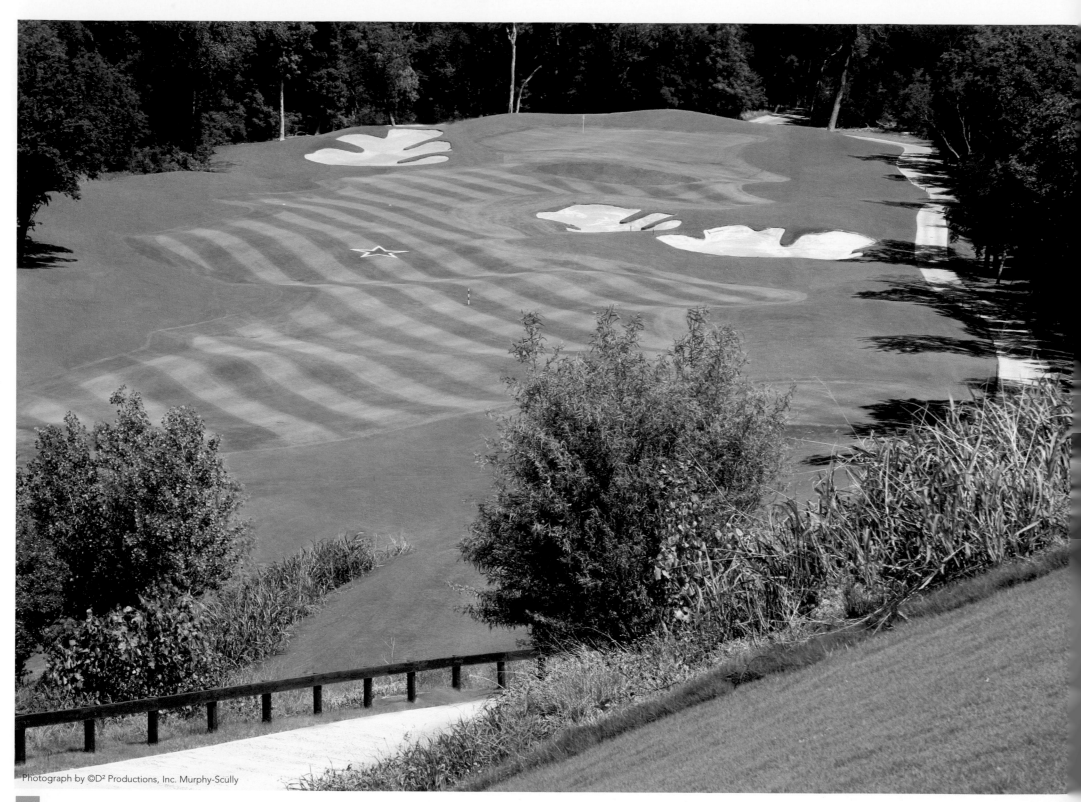

COWBOYS GOLF CLUB
4TH HOLE

366 yards • par 4

Grapevine, TX 817•481•7277 www.cowboysgolfclub.com

*N*ot only is the Cowboys Golf Club an out-of-the-ordinary course because of its ties to a National Football League team, it is an out-of-the-ordinary course because of its setting.

In a state filled with big things, the club sits in the middle of a bunch of them.

Around the corner is one of the largest hotels in the country, adjacent to the course is a very large dam holding back a very large body of water and next door is a shopping mall the size of an auto race track. And an auto race track, by the way, is not far away, either.

But the course holds its own in this unusual location because, despite its connections with the Cowboys, it also has very good connections with golf. Especially the fourth hole.

A memorable aspect of the par-4 fourth is the view. The tee is elevated far above the landing area and a string of three bunkers angle across the fairway.

Of the three bunkers, the one on the extreme right is closest to the tee and is within reach of a well-struck drive. That forces either a lay-up, which is never all that appetizing off the tee, or a shot down the left side that brings an area of native grasses just off the fairway into play even more than it already was.

As an added attraction, there is a blue star painted at the point a perfect drive would come to rest. It is the only such Cowboys star on the course and is often used as a measuring point in long-drive contests.

The greens at the Cowboys Golf Club are a constant challenge and this one is no exception. It has multi levels, a crown in the middle and a false side on the left that, if encountered, will lead to a problematic pitch.

There are far more difficult holes on the course. The 441-yard ninth, for instance, has two fairways from which to choose with a tree separating them. And the 13th is just six yards short of 600 with wetlands on both sides of the fairway.

The fourth, meanwhile, allows for a little relaxation on a course that is constantly reminding the visitor of football but, underneath, is pure golf.

479 yards • par 4

Grapevine, TX 817•481•7277 www.cowboysgolfclub.com

The Cowboys Golf Club not only provides the opportunity for a memorable round, it provides a few conversation starters found nowhere else.

There is, for instance, a putting green in the shape of the team's emblematic star. And for those who want to bring back treasured memories, there are replicas of the team's Super Bowl trophies on display in the clubhouse.

Out at the par-4 fifth, meanwhile, there is a chance to make some new memories because a birdie there would certainly not be forgotten anytime soon.

Other than the length, which is considerable, the chief feature of the fifth hole is the amount of undulation found in the fairway.

There is not much hope of coming away with a flat lie on a fairway that has humps and bumps and swales all over the place. So much so that the fairway would not be out of place on a Scottish links.

Water is also in play in abundance. A native wetlands runs down the left side and finally gives way to a pond. Between the fairway and the pond is a series of deep grass hollows, from which a player will be fortunate just to see the top of the flagstick.

A second pond is on the right side, beginning about halfway down the fairway. It will take a fairly wild shot to reach either of the water hazards, although wild shots have been known to happen.

There is only one bunker on the hole and it is placed in the face of a large mound on the right side of the fairway about 30 yards short of the green.

The putting surface is small, especially for a long par-4. It represents a fairly benign end to a hole that is this course's answer to a roller coaster.

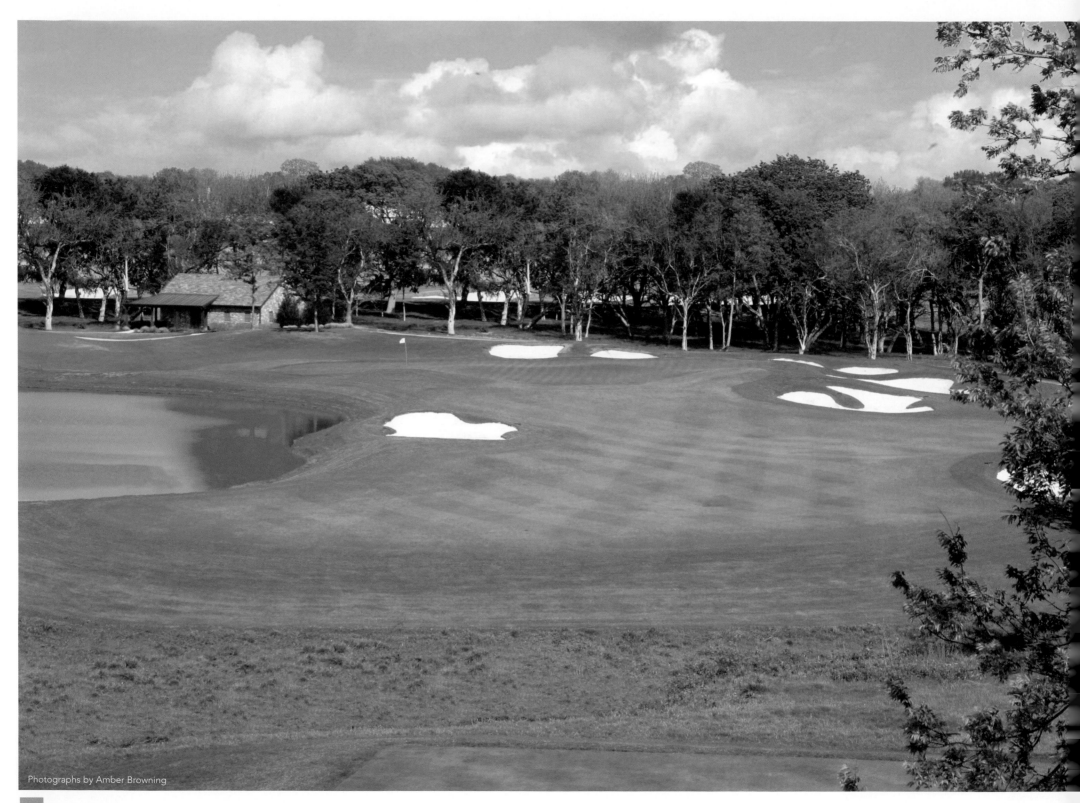

CRAIG RANCH
TOURNAMENT PLAYERS CLUB
AT CRAIG RANCH
14TH HOLE

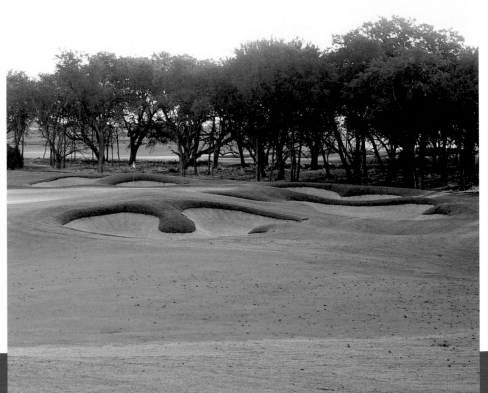

330 yards • par 4

McKinney, TX 972•747•9005 www.tpcatcraigranch.com

The TPC-Craig Ranch course is built for the 21st Century.

In brief, it is big. There are 7,438 yards of it and its course rating of 77.0 makes it clear that only those with first-rate abilities need bother to take on what are referred to as the PGA TOUR tees.

There is room on any course, however, for a short, par-4. Especially if the risk-reward aspect of the hole leans toward the risk side.

Tom Weiskopf will usually include a reachable par-4 in his designs and the 14th at Craig Ranch can, indeed, be driven. Those with marginal talent, however, might ask — why would you want to?

There are nine bunkers on the hole, but the key to reaching the green in one mighty swing is avoiding the hole's water feature. A pond sits to the left of the fairway and then drifts over to protect the left side of the green.

Two bunkers are found just over the green on the right side — exactly in line with a tee shot designed to catch the front portion of the putting surface. If the tee shot scoots into one of those bunkers, getting up and down for birdie will be a chore.

Three fairway bunkers outline a triangle of short grass where the best of the lay-up attempts usually land. From there, it is a mere 80 yards or so to the middle of the green.

The green's right side is raised sharply, creating a difficult pin position.

Getting the ball close to the pin, however, is usually not the primary thought when standing on the tee. What a player is more likely to be thinking is — can I get it on the green from here? And even if I think I can, is it worth the gamble?

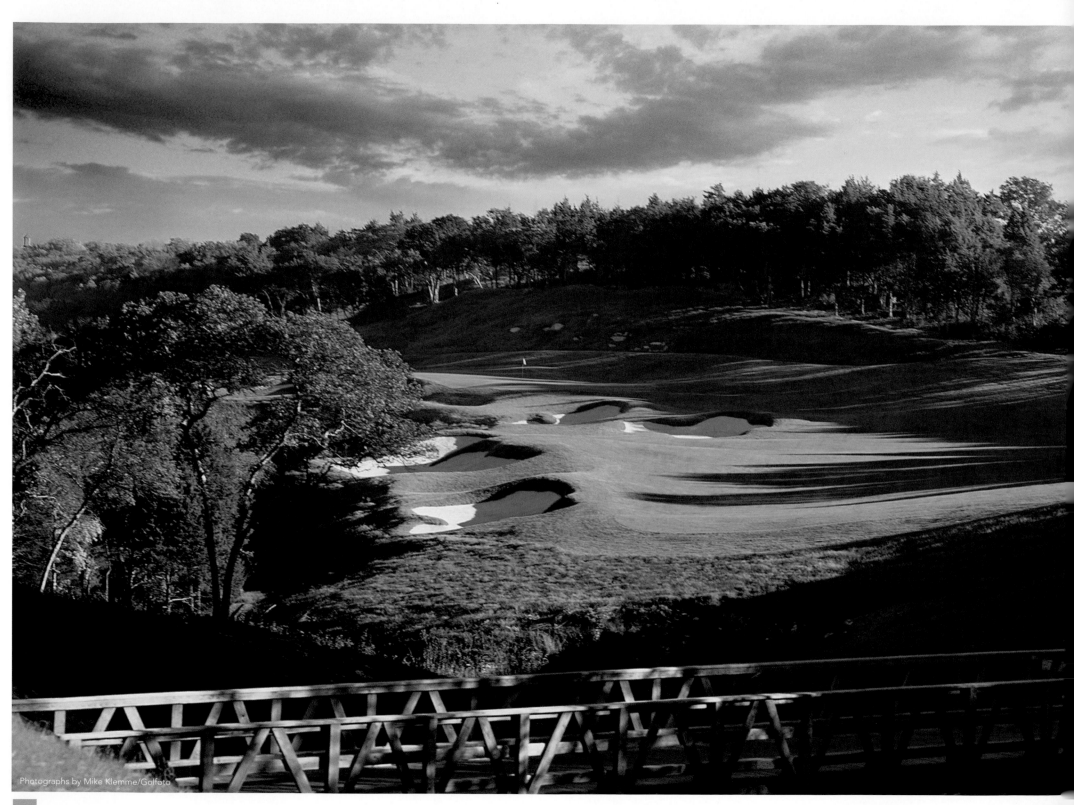

DALLAS NATIONAL GOLF CLUB
9TH HOLE

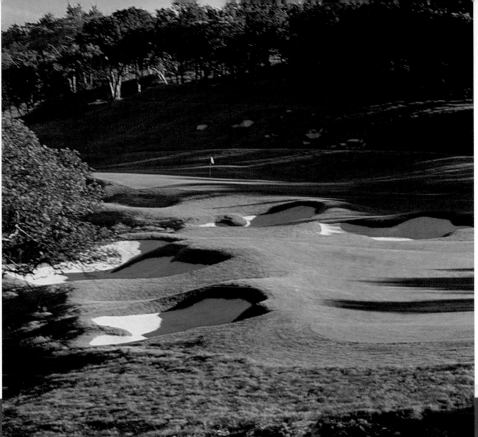

448 yards • par 4

Dallas, TX 214•331•6114 www.dallasnationalgolfclub.com

It is nothing short of shocking that a course such as Dallas National can be found just moments from the city's downtown traffic snarl and noisy pace of commerce.

Once more, it has been demonstrated that land nobody else could figure out what to do with can be turned into a golf course. In this case, a stunning one.

Dallas National architect Tom Fazio offered up this oft-repeated quote after he completed the task of creating 18 holes among the dramatic elevation changes just west of the one of the nation's leading business hubs.

"If Dallas National were the only course I ever designed," he said, "I feel I would have had a great career."

The course winds around and over hills, plateaus and canyons. The native oaks and cedars are everywhere.

The par-4 ninth provides a taste of just about everything Dallas National has to offer. And despite its length, it is also something of a breather considering the previous adventure, which is a par-4 that plays 475 yards from the so-called Texas Tee, is the course's number one handicap hole.

Visible from the ninth tee is a ravine that forces a lengthy carry, a plateau to the right from which the fairway comes sweeping down and a falloff area to the left which is certainly not the place to hit it.

The sloping fairway will cause the ball to bounce left and the shot must avoid bunkers that are cut into the left side of the fairway at the point where it drops away.

After crossing the ravine on one of the course's long, wooden bridges, a second shot is played to a green that is set back to the left as well. It forces an uphill, all-carry shot over two bunkers. Another trap protects the left side.

With the plateau looming to the right, atop which is a stand of trees, the hole looks as if it has been carved out of a huge, green bowl.

At Dallas National, the ninth hole does not come back to the clubhouse. But with this sort of grandeur constantly visible, nobody would want to take a break anyway.

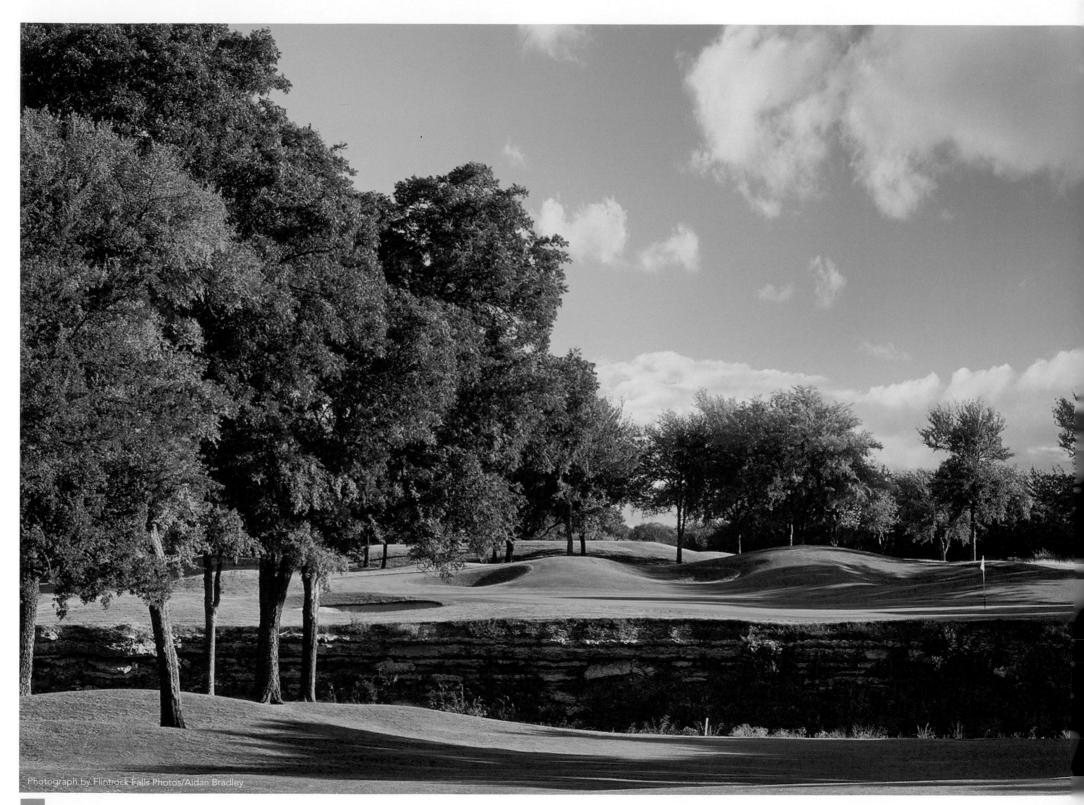

THE GOLF CLUB AT FOSSIL CREEK
6TH HOLE

377 yards • par 4

Fort Worth, TX 817•847•1900 www.thegolfclubatfossilcreek.com

*I*f a dedicated player was blindfolded and placed down in the middle of the Golf Club at Fossil Creek, that player's first guess would likely be that he or she had been brought to one of the Hill Country courses that now dot that section of the state.

Instead, a course that looks likes a Hill Country layout has long been in operation just outside the interstate loop that runs around and through the hustle and bustle of Fort Worth.

Fossil Creek has what one expects from a Central Texas course — ravines, rock ledges, tons of trees and fascinating holes that take full advantage of the landscape.

It carries additional prestige because it was one of the relatively early design projects from Arnold Palmer and it has certainly not lost its charm.

Yes, there really is a Fossil Creek and it very much comes into play at one of the jewels on this course — the par-4 sixth.

The tee is elevated, providing a gorgeous view of a landing area that is protected on both sides by trees.

After an ideal effort from the tee, a short iron will be needed to carry Fossil Creek, which has a layered rock embankment and is littered with bushes and wild grass. If the tee shot strays into the trees, the chances are quite high that the only option will be to play short of the creek in hopes of producing a high-quality pitch on the third shot.

There are two bunkers placed just over the creek and just short of the green, but they are usually the last of your worries.

In days of yore, Fort Worth was known as the spot, "where the West begins." In the golfing language of Texas, Fort Worth turns out to be, "where the Hill Country begins."

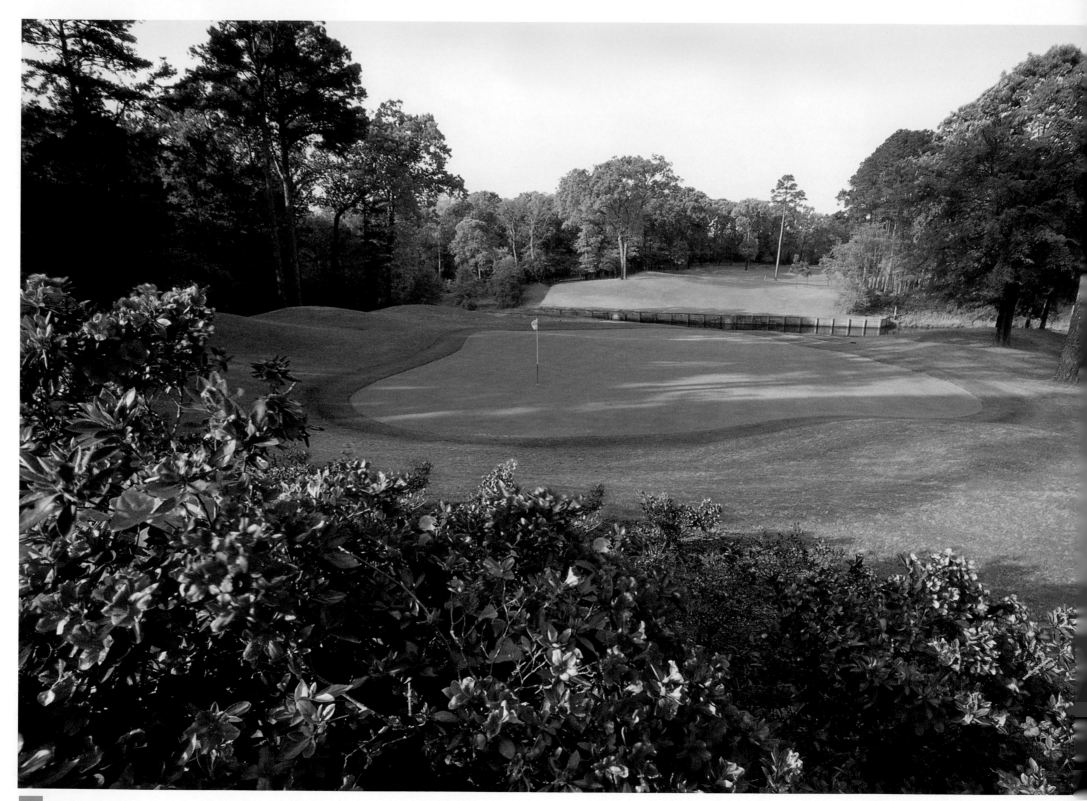

GARDEN VALLEY GOLF CLUB
14TH HOLE

355 yards • par 4

Lindale, TX 800•433•8577 www.gardenvalleytx.com

There is no doubt that the best time to play the Garden Valley Golf Club is in the spring.

Golf among the pines of East Texas can be played just about year round, as is the case in much of the state, but when the azaleas and dogwood are in bloom, the game takes on a different hue and different aroma.

The course went through an extensive refurbishing project in 2003 and now delivers the kind of golfing experience one hopes to find when such serene surroundings are available.

At the 14th hole, serenity is available by the carload. But there is also the need to hit precise shots.

The hole doglegs to the left amidst the trees. But there is a problem. Right at the point of the dogleg and residing in the middle of the fairway is a lone pine tree, its limbs reaching out to take up air space that would ordinarily be used to flight a ball through.

Manipulating a path around the tree is the obvious chore, after which only a short iron will be needed to reach a green that is nestled back in a grove of trees.

On the way to the green, however, the ball must carry over a pond that is an extension of Lake Butler.

There is plenty of room between the water and the green as the ground slopes up to the putting surface. But embedded in that slope are bunkers fronting the green both right and left.

Finally, perched behind the green and slightly raised, is a collection of azaleas. Their blooms are bright pink and the spectacular show of foliage at the 14th and elsewhere around the course will always enhance the day's play.

Alas, that show is available for only a short period. The pine tree in the middle of the 14th fairway, however, is there all year.

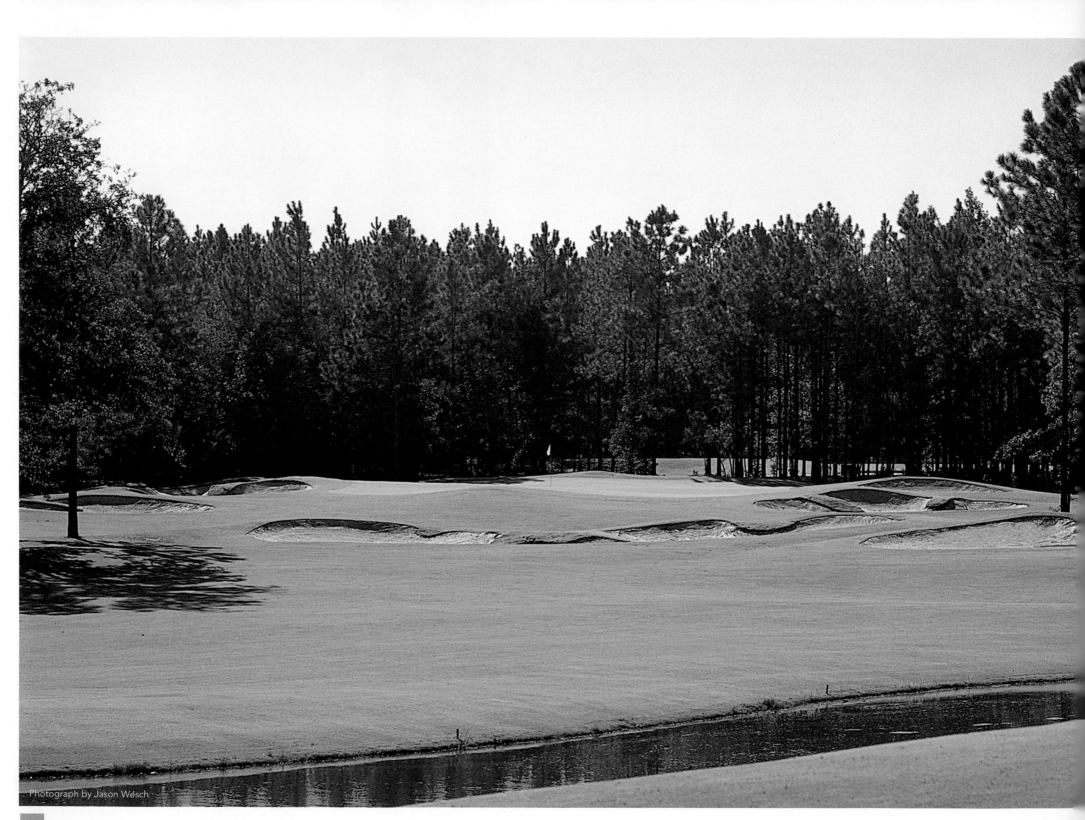

PINE DUNES RESORT & GOLF CLUB
14TH HOLE

434 yards • par 4

Frankston, TX 903•876•4336 www.pinedunes.com

*P*GA TOUR veteran David Frost, one of the driving forces behind the construction of Pine Dunes, knew long before the course was opened that something special had been created.

"There is no need to go all the way to Augusta National," he said. "We have our own right here in Texas."

At the 14th, Pine Dunes does its own imitation of the Augusta National.

Just as is the case at the home of the Masters, the tee boxes at the 14th are merely extensions of the Bermuda Tiff 419 fairway, tightly mown to the same height. There is no demarcation to indicate where the tee box ends and the fairway begins.

The tee shot, as most of them are at Pine Dunes, is framed by the pines. But there is a twist at the 14th.

The stand of trees down the right side comes to an abrupt end and is replaced by a water hazard which is easily within range of the tee shot.

An ideal shot off the tee, however, must challenge the right side of the fairway because of a special feature that is found about 20 paces short of the green.

Standing on the left side of the fairway just short of the putting surface is a lone pine. A tee shot hugging the left side so as to avoid the water leaves the player looking at a huge, natural barrier guarding half of the green.

There are also two bunkers in front, allowing only the most fortunate of shots to hop onto the green.

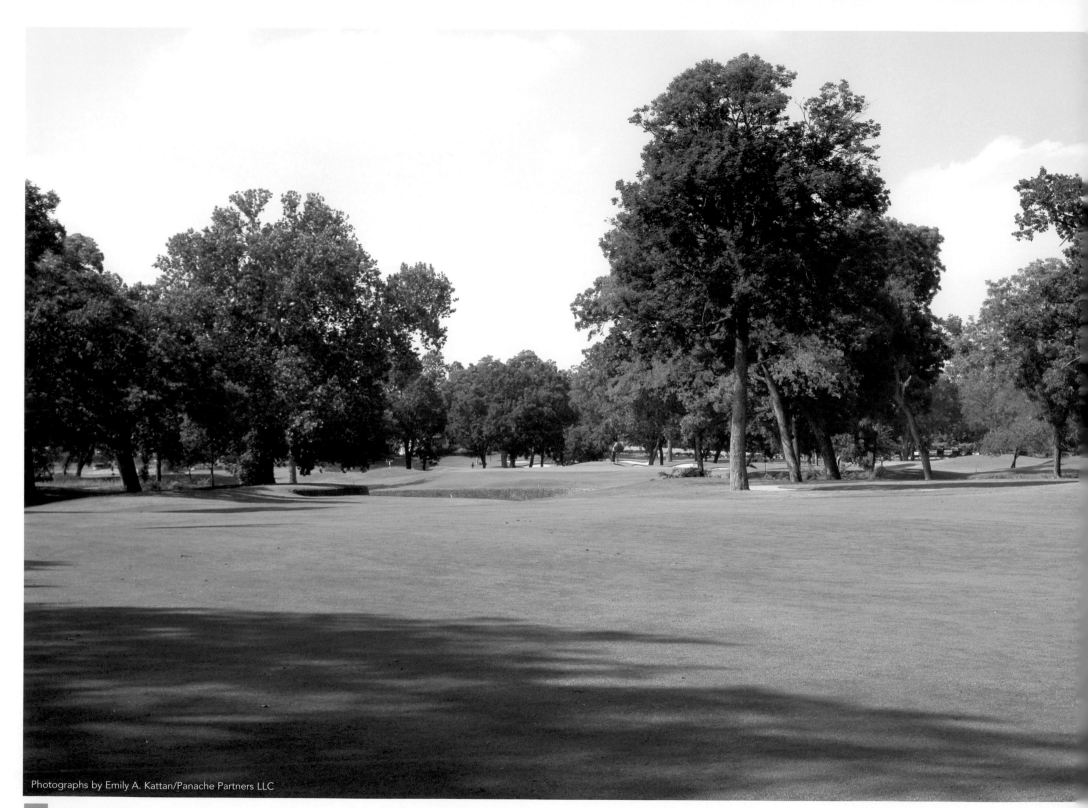

ROYAL OAKS COUNTRY CLUB
13TH HOLE

Hole 13
Par 4

475
455
434
363 Par 5

In its annual statewide course ratings, the Dallas Morning News has consistently rated Royal Oaks Number 13 as one of the best, and most beautiful 18 holes in Texas. In its January 2000 "Millennium Issue" Golf Magazine ranked Number 13 as one of the 500 Best Golf Holes in the world.

2003

475 yards • par 4

Dallas, TX 214•691•6091 www.roccdallas.com

*S*ome of golf's most familiar names are linked to specific courses in Texas.

Colonial Country Club, of course, will be forever known as Hogan's Alley, where the legendary Ben Hogan won five times en route to achieving the career Grand Slam.

Tenison Park, a public facility in the heart of Dallas, was the personal playground of Lee Trevino.

Tom Kite and Ben Crenshaw grew up at the old Austin Country Club, where teaching pro Harvey Penick helped turn them into Hall of Fame players.

And now Royal Oaks Country Club has joined the ranks of courses that have made a significant contribution to the sport.

Justin Leonard honed his skills on the tree-lined fairways of the north Dallas layout and became a member of golf's elite when he won the British Open at Royal Troon.

The course was designed by Don January and Bill Martindale in 1969 and, when it was opened, it was hailed as a place where big-time players would find a big-time proving ground.

The epicenter of that proving ground is the par-4 13th. In the era of high-tech equipment, holes like this are not uncommon at a PGA TOUR event. But in 1969, a hole such as the 13th was usually referred to as a par-5.

Even from the member tees, the 13th is a brute, but from the very back it requires two professional-style shots. And it is not just that the hole is long. The oaks pinch in on both sides of the fairway and a massive tee shot is needed just to be able to see the green — much less be able to reach it.

As an added attraction, White Rock Creek runs across the fairway short of the putting surface.

Once seeing the 13th at Royal Oaks, it is easy to see that if Justin Leonard could consistently par this hole, he could do just about anything in the world of golf.

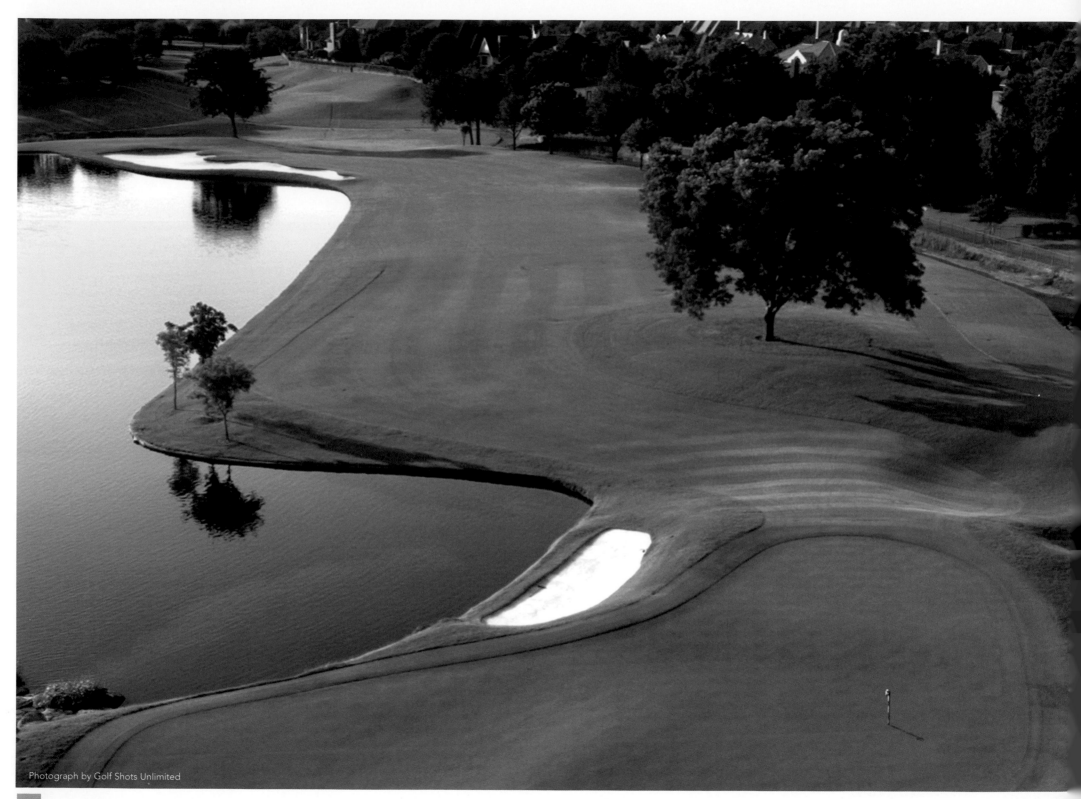

STONEBRIAR COUNTRY CLUB
9TH HOLE

438 yards • par 4

Frisco, TX 972•625•5050 www.stonebriar.com

*A*s March was turning into April in 1989, the Stonebriar Country Club was in the process of turning into a monster.

The winds of spring were howling out of the south and they were present to greet the best senior golfers in the land.

Don Bies was the winner that week on what was then known as the Senior PGA TOUR, but the real champion was the golf course. Along with the winds, of course.

Conditions were particularly extreme during the second round of the three-day tournament as players simply tried to survive. At the end of the day, the average score for the field was 79.420.

That stood for 16 years as the highest average score for any round ever played on what is now referred to as the Champions Tour. The record was broken at the 2005 British Senior Open, when howling winds created an average score of more than 80 during the first round.

The average 18-hole score for the entire tournament played at Stonebriar in 1989 was 78.634. It remains the highest scoring senior event in history.

The hardest hole that week and for the entire five-year run of the senior tour at Stonebriar was the ninth, played as the 18th hole. For the tournament, the nines were reversed for viewing purposes.

From an elevated tee, it is obvious where the ball must be hit. A small lake enters the picture in front of the tee on the right side of the fairway and remains in play all the way to the green — the right half of which is protected by the water.

A lot of fairway is available to the left — although too far left will bring a creek into play. But it soon becomes clear that even the left half of the fairway is no picnic because a ball that lands there will be blocked by a huge tree that sits about 30 yards short of the green and is in line with the left edge of the putting surface.

The distance between the outer reaches of the tree on the left and the water on the right is only about 25 yards.

Stonebriar's greens are challenging on their own and there are four distinct levels on the one at the ninth. The green surface has bunkers on either side of the small entrance and the most difficult pin position is on the extreme right, tucked in behind the water.

In 1989, the ninth was the hardest hole on the hardest course the seniors have ever played. The numbers are there to prove it.

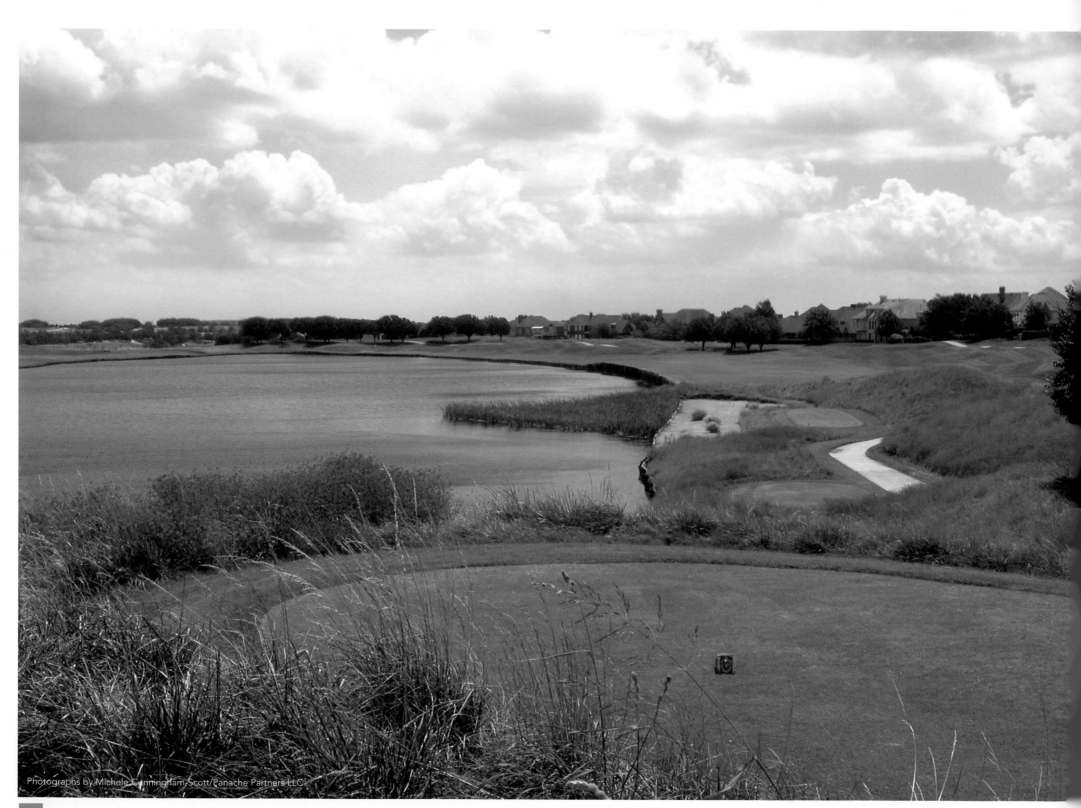

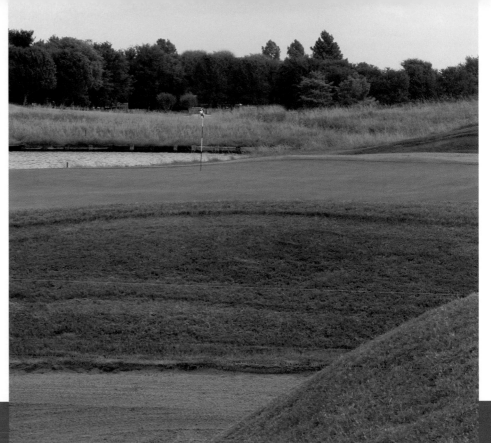

STONEBRIDGE

STONEBRIDGE RANCH
COUNTRY CLUB
dye course • 18TH HOLE

467 yards • par 4

McKinney, TX 972•529•5992 www.stonebridgeranch.com

As a tournament test, Stonebridge Ranch certainly ranks among the best in Texas.

Three of its par-3 holes measure at least 200 yards. Four of the par-4s extend more than 450. And even the longest of hitters will find the 613-yard 16th hole a trial.

Any course built with tournaments in mind, however, must have a championship finish.

Those who have found the 18th standing in their way of a title at the Texas State Amateur, Texas State Open or NCAA Championship will certainly testify to its worth. And there will also be those who will say it has a familiar look to it.

While it is not a carbon copy, the 18th at Stonebridge Ranch bears a very close resemblance to the 18th at TPC-Sawgrass. Pete Dye designed them both.

As is the case at its famous cousin in Florida, the closing hole at Stonebridge Ranch has water down the entire left side. There is a fair amount of room out to the right in which to play safe, but anything that merely hints at being a right-to-left shot is automatically in trouble.

That is especially the case when the prevailing winds are blowing at a brisk pace because those winds will push a ball toward the lake.

The green extends slightly into the lake so that the water comes into play short of the putting surface as well as being everpresent to the left. Two bunkers have been placed to the right of the green and two more behind it.

The word "finesse" usually does not apply when it comes to Pete Dye's familiar works — among the most overwhelming of them being the Kiawah Island Ocean Course (which has hosted the Ryder Cup matches) and Whistling Straits (where Vijay Singh won a PGA crown).

Instead, brute force is usually recommended. That is certainly the case at Stonebridge Ranch and especially so at its concluding hole.

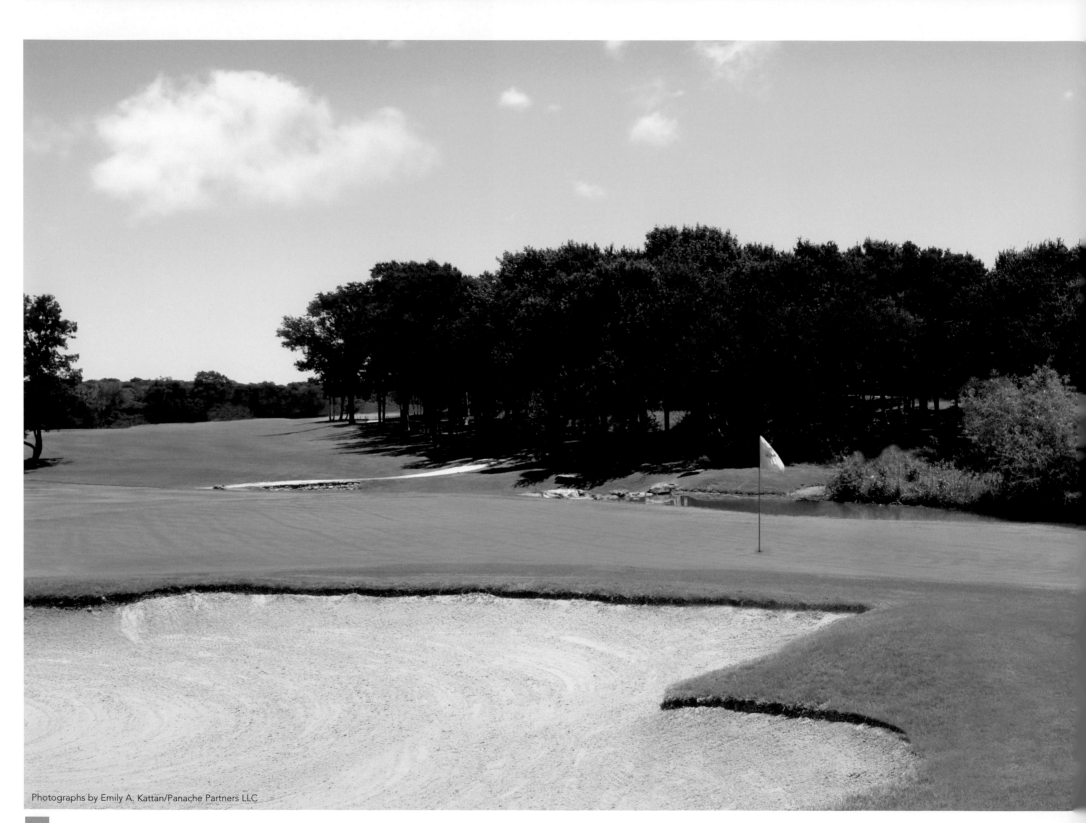

WOODBRIDGE GOLF CLUB
5TH HOLE

426 yards • par 4

Wylie, TX 972•429•5100 www.wbgolfclub.com

What the average golfer is always looking for is a place where it is possible to put down an affordable amount of money, walk onto the first tee and play away.

The Woodbridge Golf Club, located north and east of Dallas just across the Dallas-Collin county line, provides just such an opportunity.

It has all the features that make a round of golf both fun and challenging. Creeks wind around and across many of the fairways. The bunkering provides a complete test. There are short holes and long holes.

There is a par-4 of less than 300 yards, the catch being that there is a giant tree sitting right where most folks would like to hit their tee shot. On a much longer par-4 the player has to cross the same creek twice and then will encounter it again if the second shot sails over the green.

There is even a touch of Scotland with a replica of the Spectacle Bunkers from Carnoustie taking up residence in the 18th fairway.

It is generally accepted, however, that the best hole on the course is the fifth, a par-4 that runs slightly uphill and where water is constantly in play.

The hole is at the outer edge of the property and the fairway slopes from left to right, causing the ball to bounce in the direction of what begins alongside the tee as a stream and then becomes, near the landing area, a good-sized pond.

The second shot is as attractive as it is difficult.

Water must be carried short of the green, which is fairly flat but protected all along the right side by a series of bunkers.

And to the left of the putting surface is a babbling brook that trickles over a collection of large, flat stones arranged into the form of an understated, but very appealing waterfall — one that would be well received on any course in the state.

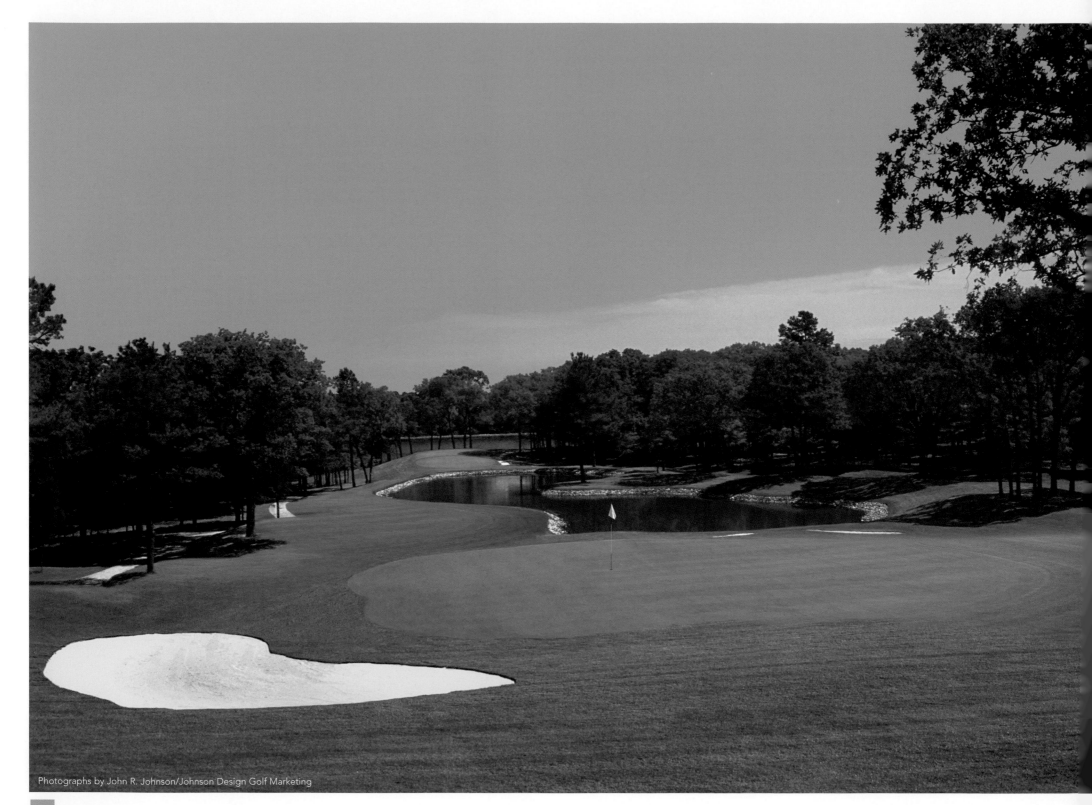

CASCADES
THE CASCADES
2ND HOLE

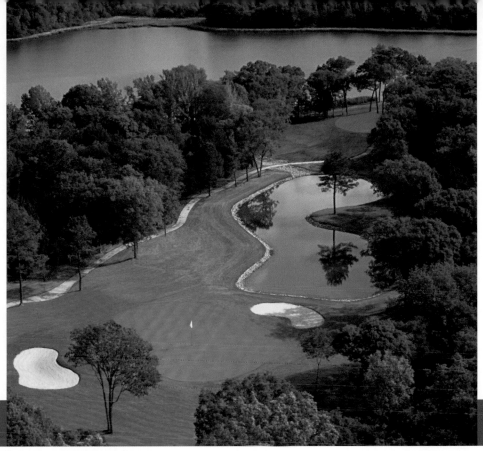

195 yards • par 3

Tyler, TX 903•593•7345 www.cascadesoftexas.com

*T*he Cascades is named for a stream that tumbles in stages down a rock formation in the middle of the East Texas woods. While it is not visible from the golf course, a hike through the eight miles of nature trails that twist their way through the trees will lead you to this golf community's namesake.

For those satisfied with seeing water that is sitting still rather than moving along briskly, the views available early in a round at The Cascades should do nicely.

After playing the gorgeous opening hole, another treat for the eye awaits.

The par-3 second begins with Lake Bellwood lapping at the back of the tee box. It continues over a man-made, rock-bordered pond and finishes with a green surrounded by a set of bothersome hazards.

This hole was carved out of the trees, plenty of which still remain to cast their morning and afternoon shadows across the green. Also nestled in the trees are the stately homes that share the most prestigious address in East Texas: Cascades Shoreline Drive.

The tee shot does not have to stay in the air all the way if it is aimed at the right edge of the green. Along that line, the pond stops well short of the green. And even when trying to hit the center of the putting surface, the water gives way several feet shy of the green and is replaced by a bunker that gets a lot of action.

There is another bunker on the back right corner, so a shot over the green to that side will result in a difficult up and down. With the green sloping from back to front, very few pars are made from that bunker.

A collection area awaits to the left of the green and a shot over the back edge will leave a chip that goes straight downhill.

For a par three that seems so innocent from the tee, the second at The Cascades can produce plenty of woe. So much so in fact, that it might cause some players to embark on a nature hike and seek out the spot that gave the course its name.

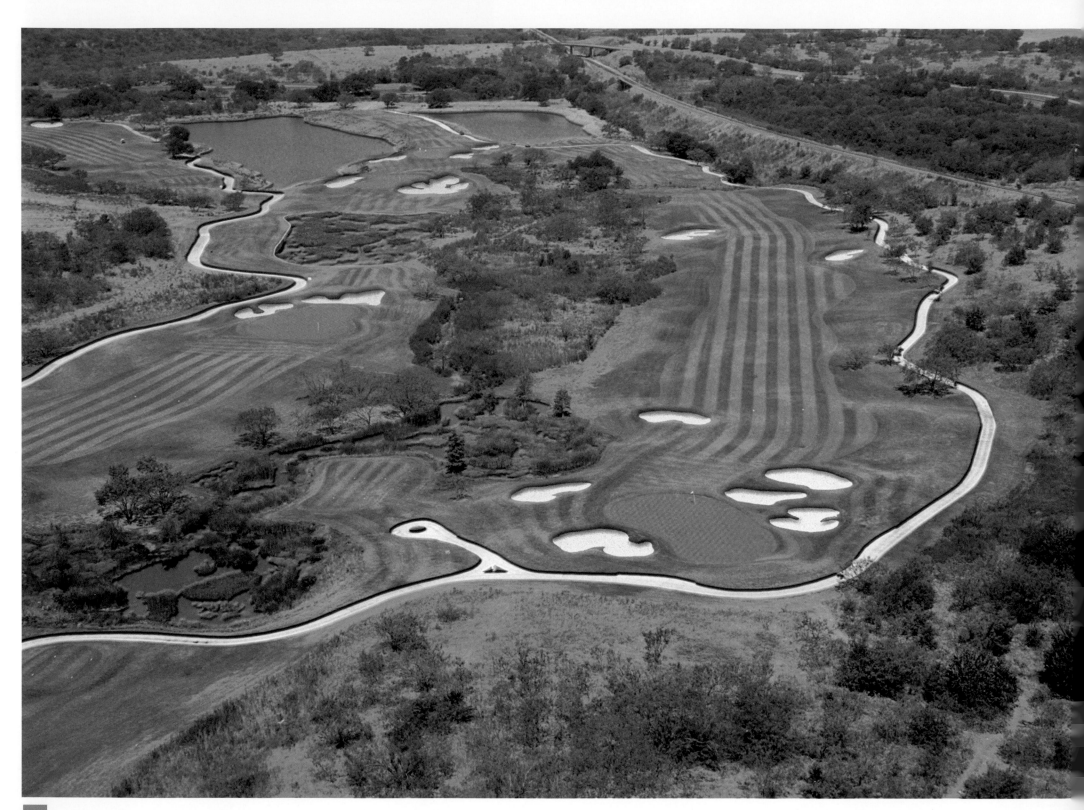

CASTLE HILLS

THE GOLF CLUB AT CASTLE HILLS
4TH HOLE

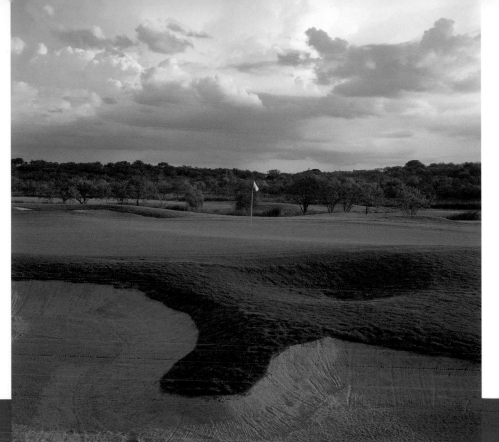

242 yards • par 3

Lewisville, TX 972•899•7400 www.castlehillsgolfclub.com

For those who are fanatical about golf, and anybody who plays can probably be listed in that category, it is not a bad idea to occasionally give the swing a little tune-up.

There are golf academies associated with various courses around Texas and one can be found on the grounds of the Golf Club at Castle Hills.

In the rolling hills north of Dallas and Fort Worth, the dedicated player can come under the guidance of a PGA of America professional and then go out and put into practice what has been learned on the practice tee.

When in need of some assistance, a player can spend a few hours with a teaching pro, receive video swing analysis, arrange for a nine-hole playing lesson or even go to the limit and experience a three-day package that includes time dedicated to the mental aspects of the game.

As it turns out, professional tutelage is a pretty good idea when tackling the Castle Hills course, especially the very long, par-3 fourth.

It was originally the 13th hole, but the nines were switched to allow for a better flow of play early in the round.

That makes the fourth the first encounter the player has with a par-3 and what an encounter it is.

A creek with accompanying trees runs down the right side of the hole, but the distinctive feature is a large bunker placed about 30 yards short and just to the left of the intended flight path.

A bunker that far short of the green on a par-3 will usually not come into play, but because of the length of this hole, the sand is a factor. And nobody wants to have a 30 yard bunker shot.

The green has a ridge running across its middle, creating lower and upper levels. And a miss to the right will send the ball scurrying down a slope.

There are no real tricks to deal with on the hole. Just a lot of distance, thus allowing a poorly hit shot all sorts of time to find trouble. It is the kind of trouble that might be avoided by spending a few hours — or days — honing the golfing skills.

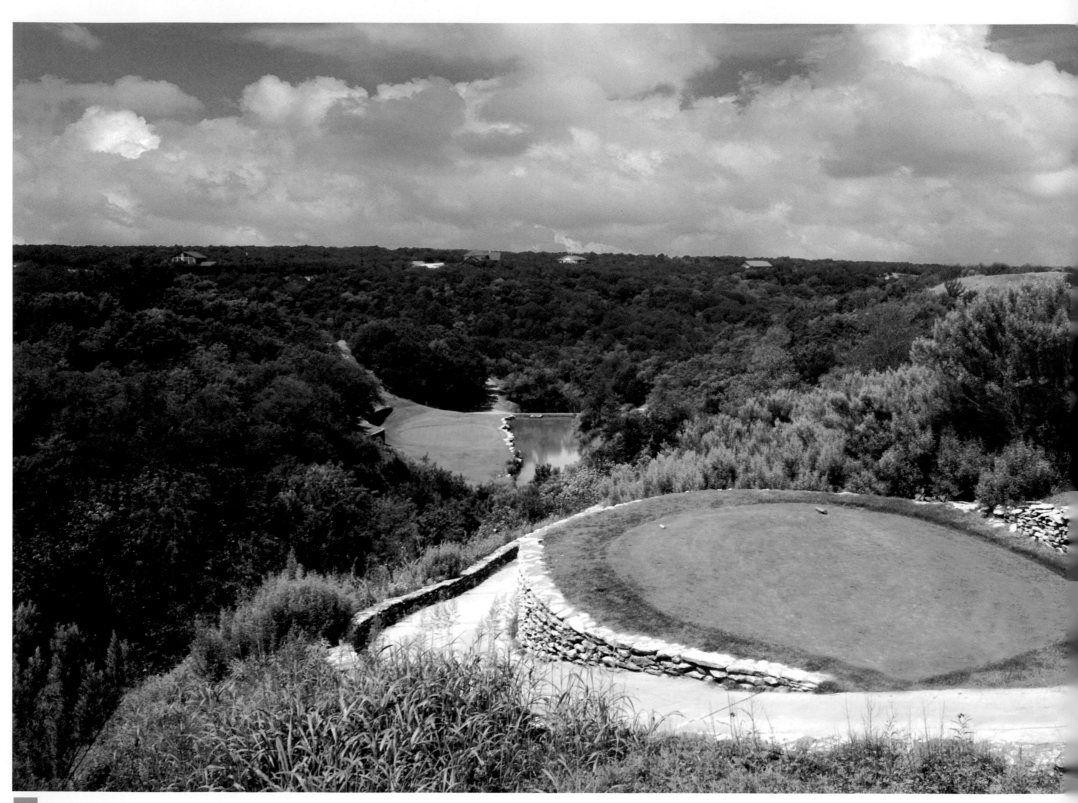

THE CLIFFS

THE CLIFFS AT POSSUM KINGDOM
15TH HOLE

162 yards • par 3

Graford, TX 940•779•4040 www.ddresorts.com

*M*ake no mistake about it. The Cliffs at Possum Kingdom Lake is an appropriately named golf course.

There are geological features for every taste and they are all of the rugged variety.

Greens can be found tucked in rock ridges. There are ravines filled with cedar trees along with cactus and natural grasses. Massive rock outcroppings are typical throughout the course and then there are "the cliffs" 150 feet above Possum Kingdom Lake, created by the Brazos River.

It is unlikely one will find a course in Texas that ranks higher on the intimidation meter, especially when covering all 6,808 of the back-tee yardage. It may not be as long as some other courses in Texas but with the narrow, tree lined fairways, canyons and ravines to sail your ball over, it is a course that will challenge any level of golfer.

An early taste of the ruggedness of the course comes on the third hole, a par-3 with the green sitting atop a ledge. If the tee shot is just a hair short of the green, it falls into one of the canyons that brings the words, "Jurassic Period," to mind.

The ninth hole is another par-3, where the waters of Possum Kingdom Lake come into full view. It is, however, a 150-foot drop down the face of a cliff to the water.

After seeing the short holes on the front nine, it is hard to believe that there could be another one just as majestic. But the 15th is just that.

The green is far below the tee - so far down that it is almost like you are playing into the mouth of a small volcano.

There is water to the right and an immense cliff wall to the left loaded with heavy underbrush, cactus and trees typical of the entire course. The green, at least from the tees, looks to be about the size of a picture frame.

Which is appropriate, of course, because there are picturesque views to remember from your first tee-shot to your last putt at The Cliffs Resort.

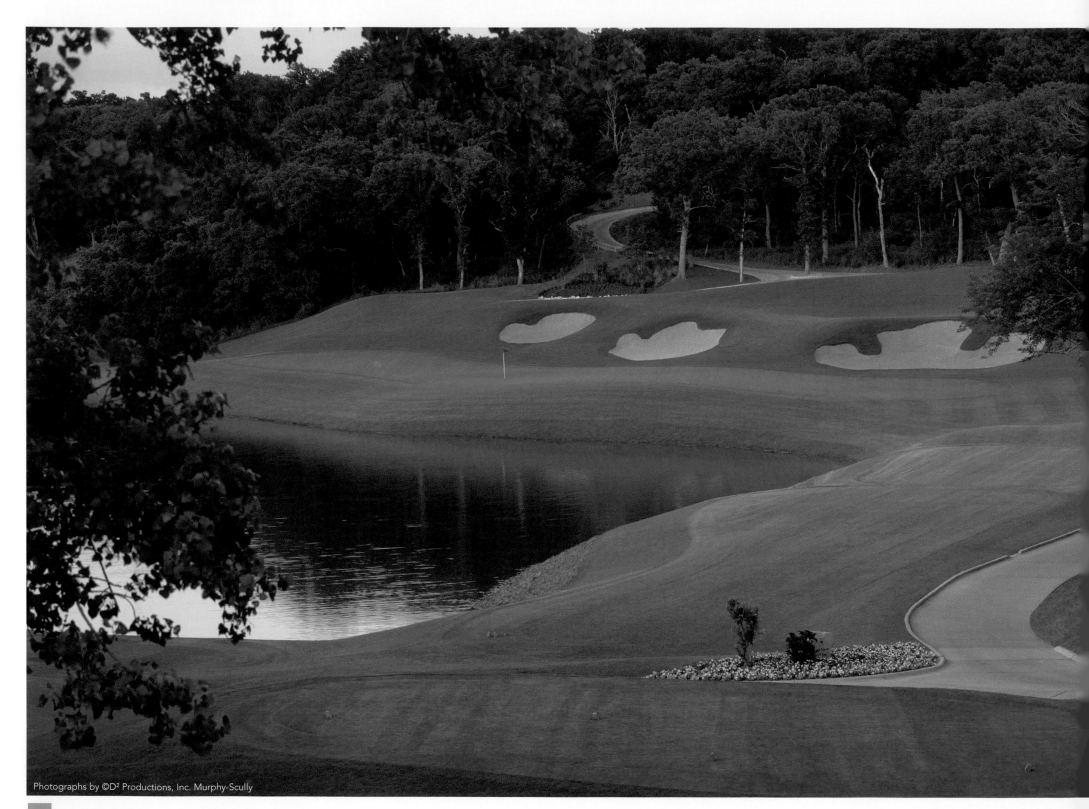

COWBOYS

COWBOYS GOLF CLUB
3RD HOLE

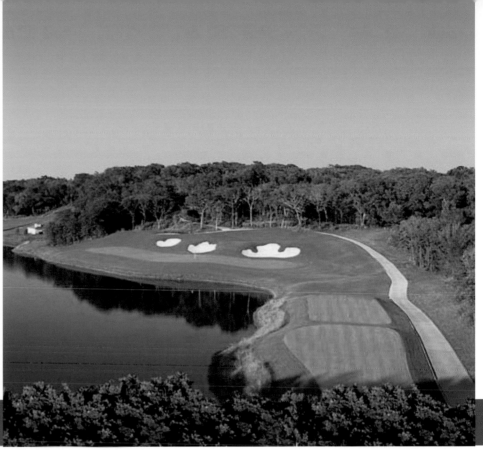

176 yards • par 3

Grapevine, TX 817•481•7277 www.cowboysgolfclub.com

*J*ust up the road from the Dallas Cowboys' football headquarters is the Dallas Cowboys' golf headquarters.

One of the world's most recognizable sports franchises likes to branch out wherever possible and the Cowboys Golf Club has turned out to be a special marketing device.

Billed as the first National Football League-themed golf course, it delivers a Cowboys history lesson as well as an enjoyable day's play.

At each tee there is a large stone with a cast iron plaque embedded in it. And on each plaque is etched a brief mention of one of the team's key moments.

Instead of numbers on the golf carts, there are names of star players. The carts, of course, are painted in the team's colors.

All of those items would be mere novelties if not for the fact that the course is striking and a treat to play. It spreads out below Grapevine Dam and provides a few unusual design features.

One of those is found at the par-3 third, placed in a lovely setting with trees to the right and beyond the hole and a lake that not only dominates the scene but must be carried in order to reach the green.

And it is the green that causes this par-3 to be different from most others.

It is not very deep, but it is an enormous 75 yards wide. It also angles away from the player so that the farther left the pin is placed, the farther it is from the tee. Which, in turn, means there is more water to carry.

There could be a difference of three or four clubs called for depending on the hole location. Behind the green are three bunkers set into the side of an incline. A shot from any of them involves the prospect of sending the ball skittering across the green, down a slope and into the lake.

The green also slopes sharply from back to front and there is a severe undulation right in the middle. If the pin is located to the extreme left of the green and the tee shot winds up on the extreme right, the player faces a 200-foot putt. It would be easier to avoid a blitzing linebacker than it would be to get such a putt close to the hole.

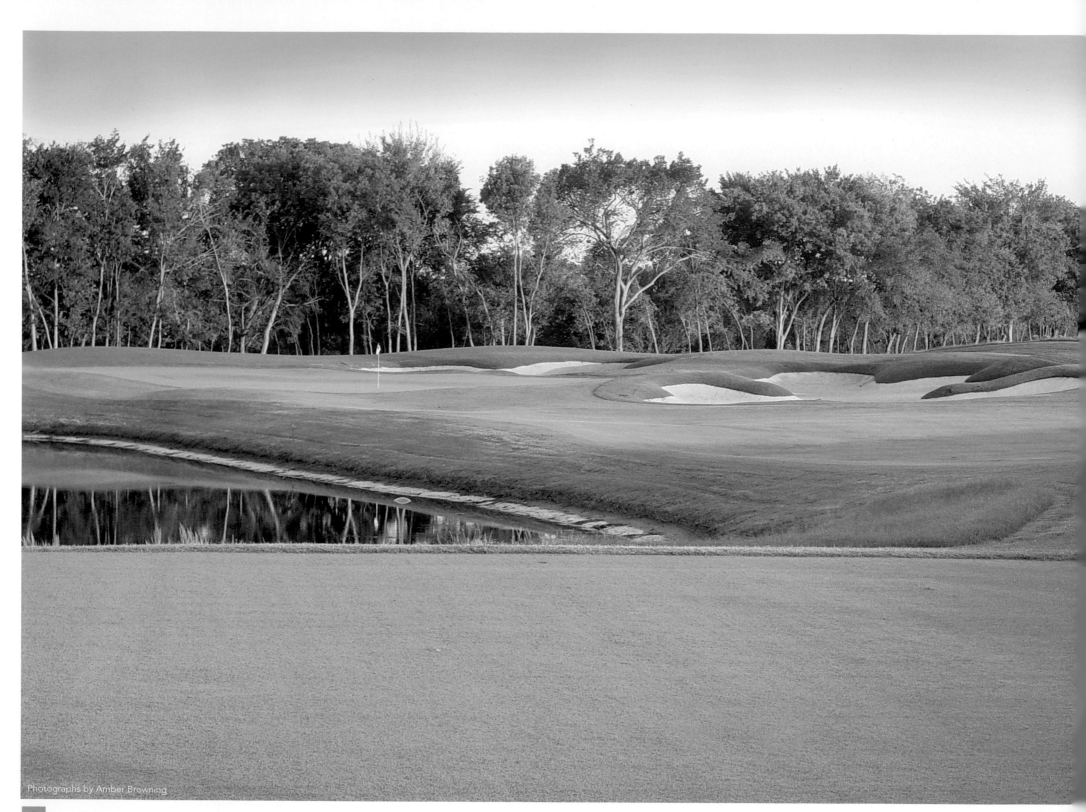

CRAIG RANCH
TOURNAMENT PLAYERS CLUB
AT CRAIG RANCH
15TH HOLE

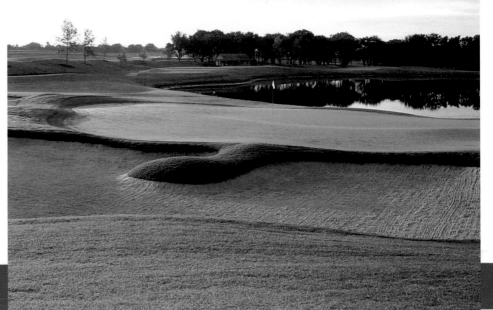

216 yards • par 3

McKinney, TX 972•747•9005 www.tpcatcraigranch.com

The TPC at Craig Ranch has designs on hosting national tournaments and a course with that sort of ambition needs to have championship-style par-3s.

They have them on this course, especially the 15th.

Prevailing south winds will be at the player's back here and there is also quite a bit of green at which to fire. The chief problem, as is obvious from the tee, is that if the ball does not land on the green, it will more than likely land in either water or sand.

Late in the round, the tee shot at Number 15 is a true nerve tester. It can also be a round wrecker.

An enormous bunker guards the green's right front and only a tiny spit of land separates the bunker from the lake that juts in from the left and must be carried from the tee.

Another bunker is placed behind the green in order to catch those who might use one club too many as a precaution against the water.

The big bunker on the right has a high lip that only adds to the problems faced on this hole. And any shot hit a little thin from either bunker faces the daunting prospect of scurrying across the green and into the water that was originally avoided.

Despite the pond and the bunkers, some might remember this hole chiefly because of the green.

It is actually three greens. There are separate raised areas in the back half of the green, divided by a ridge. The front portion is much lower than the two back sections.

If the ball winds up in an area of the green where the hole is not, an up, down and around putt will be faced.

The green is not unfair or particularly quirky. It is just a little different and, combined with the difficulty of the tee shot, makes birdies a hard-to-come-by commodity.

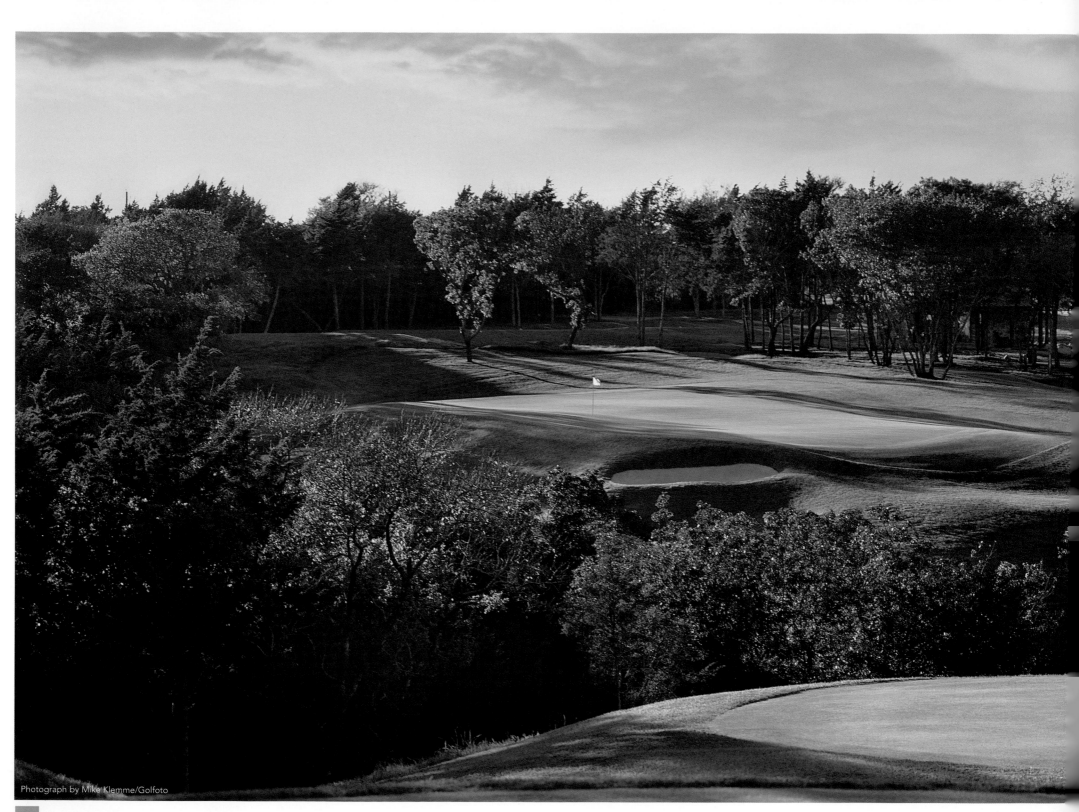

DALLAS NATIONAL GOLF CLUB
5TH HOLE

225 yards • par 3

Dallas, TX 214•331•6144 www.dallasnationalgolfclub.com

*A*ll of golf's one-shot holes are linked by the obvious fact that they have a designated area from which to strike the ball and, not far away, a place where the ball is supposed to land.

What separates the countless number of par-3s is what surrounds them. And when it comes to Dallas National, the surroundings are sublime.

The marvel of golfing architecture created near downtown Dallas by Tom Fazio consists of what might be considered 18 works of sculpture.

Especially, the par-3 fifth. One almost expects to find art students sitting alongside the tee box recreating the image on canvas.

Fazio has created a short hole that assaults the eye with its major features, but also presents subtle movements in the land that can easily be compared with brushstrokes.

It is, in short, an example of why Dallas National is held in such high regard.

The biggest eye-catcher on the hole is the ravine in front of the tee, one that is so deep that the tops of the huge oaks and cedars growing in it barely reach ground level.

The tee shot thus carries over those trees, the accompanying undergrowth and one of the attractive bridges that span the course's various hazards.

Clearing the ravine, however, needs to be a foregone conclusion if the player hopes to record a decent score.

The real hazards are found around the green, which sits on a plateau above the carefully manicured grass.

A shot that comes up short will either wind up in an oversized pot bunker or will likely roll back down toward the hazard. To the left is a sharp dropoff down to a pair of bunkers.

There are swales to the right and beyond with only small ridges sitting at green level where a ball might hang up and provide an outside chance to save par.

There are plenty of one-shot holes that allow a chance to make a three even after a poorly struck tee ball. Such is not the case here, where the artistically magnificent surroundings simply prevent it.

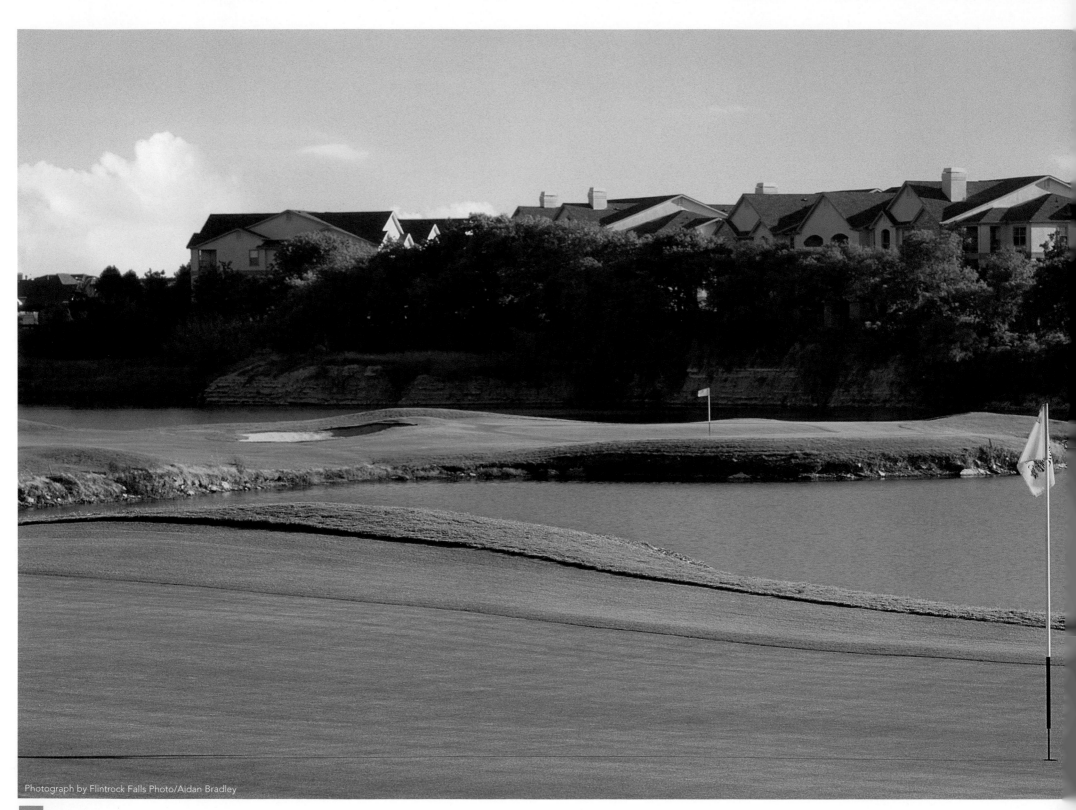

THE GOLF CLUB AT FOSSIL CREEK
13TH HOLE

194 yards • par 3

Fort Worth, TX 817•847•1900 www.thegolfclubatfossilcreek.com

When putting a course onto the kind of ground that is occupied by the Golf Club at Fossil Creek, it seems that it would be easy to create a dazzling par-3.

The architect, in this case Arnold Palmer, simply has to look around for the most forbidding piece of real estate and then declare that the tee should go here and the green should go there. And leave everything else alone.

It is no doubt more complicated than that, but the 13th at Fossil Creek does sit in the middle of a menacing spot. Like many other memorable short holes, this one does not tolerate a ho-hum shot.

The inevitable water is found not only in front of the green, but around to the right side and behind as well.

Between the water in front and the green itself, there is a rocky embankment that rises up to the putting surface. A ball that lands on the hard, bumpy ground might go anywhere. It might even bounce up onto the green, but don't count on it.

Behind the green there is a rocky mesa that, along with the underbrush and trees that populate it, towers over the scene. But there is water behind the green that separates the short grass from the large, rock outcropping.

Just getting over the water does not mean the party is over.

The wide green creates the opportunity for an equally wide assortment of pin placements, some of them altering the type of shot required off the tee. When getting ready to hit the tee shot on this hole, it is critical to make sure you are in proper alignment.

The most difficult of the pin placements is way back and way right, one tucked into an extension of the green that brings the various dangers of this hole into play.

Something in the middle of the green should always be the goal on a hole that can be every bit as mean as it looks.

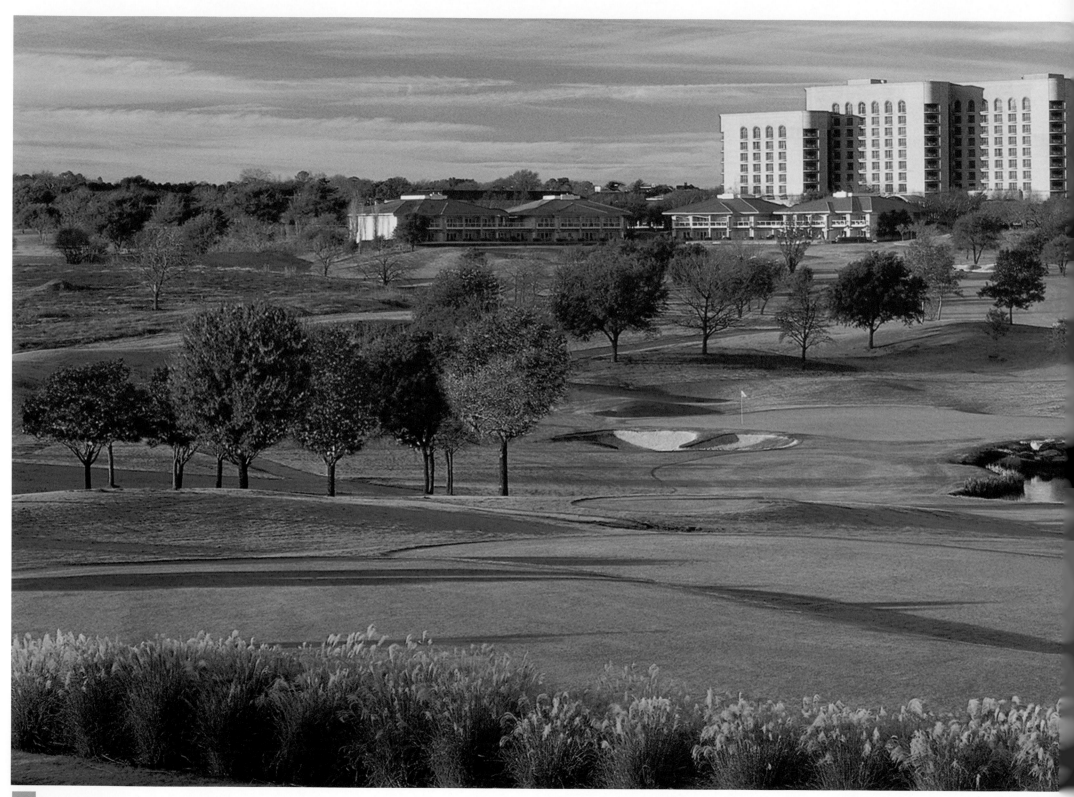

FOUR SEASON RESORT AND CLUB
tpc-four seasons, las colinas • 17TH HOLE

196 yards • par 3

Irving, TX 972•727•2530 www.fourseasons.com/dallas

For one week each spring, the city of Irving serves a centerpiece for big-time golf.

The tournament named for Byron Nelson, played at the TPC-Four Seasons, draws a stellar field, huge crowds and raises more money for charity by far than any other PGA TOUR event.

Payne Stewart won on this course. Ernie Els, Phil Mickelson and Tiger Woods, a golfing triumvirate of historic proportions, won in successive years on the Jay Morrish-designed layout. Woods' victory in 1997 came one month after he reached cult status by running away with the Masters for his first major title.

Vijay Singh and Sergio Garcia were back-to-back winners in Irving.

And before any of them could emerge as champions, they had to get past the 17th hole. That's not easy.

For those who watch a lot of golf on television, the 17th has become one of the more familiar holes in the country.

It offers an intimidating view from the elevated tee — with the rock-bordered pond protecting the right front of the green and the enormous bunker guarding the left front.

A shot that sails long will wind up in a swale, which then brings about a delicate pitch shot to a green sloping away from the player.

At tournament time, the television cameras make visible the thousands of people gathered on the hillside behind the green. And, off in the distance, the sprawling Four Seasons Resort and Club rises up to create a commanding presence.

A unique scene, indeed, and in the midst of all that the players contending for the title must pull off a no nonsense shot. That is especially so in the final round, when the hole is usually cut on the smallish right hand portion of the green just a few paces from the water.

When the prevailing south wind is blowing, things become even more troublesome. From the elevated tee there is virtually no way to keep the ball from being affected by the breezes.

The 17th at the TPC-Four Seasons has become no less than one of golf's great amphitheaters and the performances staged there often go a long way in determining who walks away as champion.

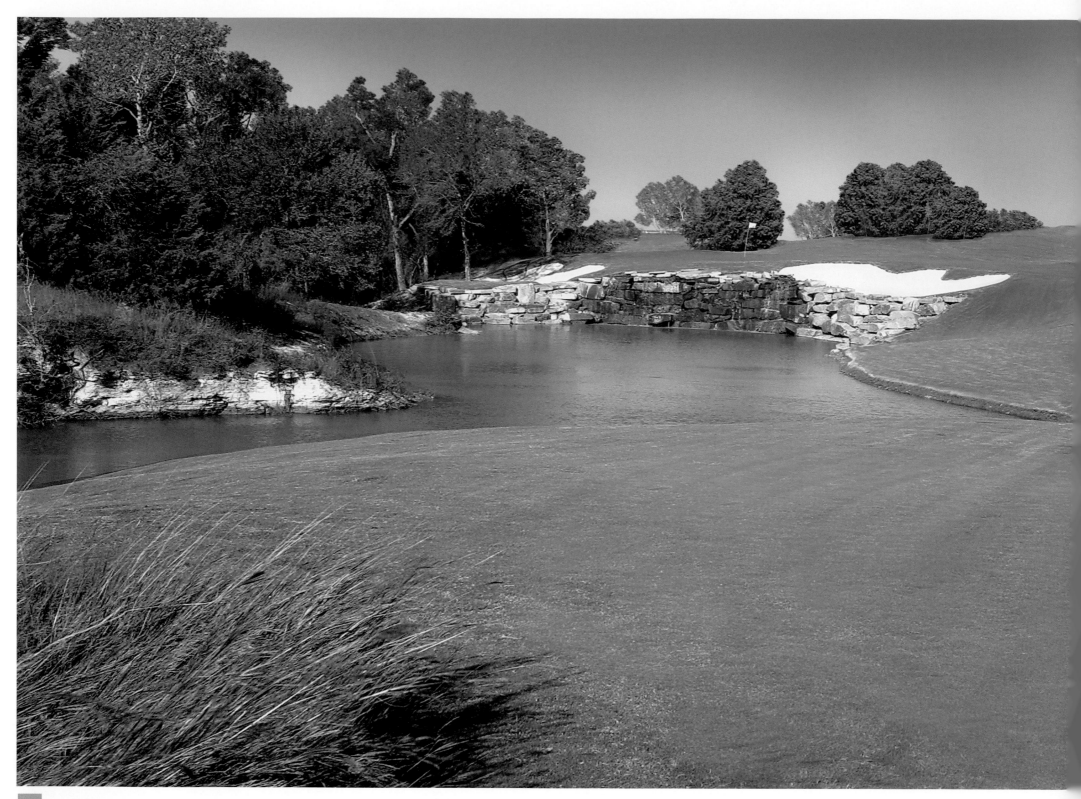

GENTLE CREEK GOLF CLUB
9TH HOLE

193 yards • par 3

Prosper, TX 972•346•2500 www.gentlecreek.com

Golf, when it first came along centuries ago, was played along the ground. For the most part in today's world, golf is played through the air.

From time to time an architect comes along who likes to pay homage to the sport's origins and D.A. Weibring is among them.

Weibring, one of the few PGA TOUR players to have designed a course that hosts a tour event, returned to golf's roots when he put together the Gentle Creek Golf Club in the northern reaches of the Dallas-Fort Worth metropolitan area.

"We wanted to allow for golf on the ground," Weibring said when the course was opened. "We want to encourage the golfer to make the choices on how they want to play the course."

Even at the par-3 ninth, which has a water hazard reminiscent of the Hill Country, it is possible to skirt the trouble with a low, running shot that can finish pin high to the right and set up a potential up-and-down for par.

To reach the green in a single shot, however, the ball must carry over a pond, a rock wall that has water bubbling out of it and a set of bunkers that takes up the space between the putting surface and the hazard.

A wilderness of trees and underbrush guards the area left of the green, but all the room in the world is out to the right, giving the player an obvious safety net.

"It may be one of the prettiest par-3s in the Metroplex," Weibring justifiably bragged.

Weibring, a native of Illinois but a long-time resident of Texas, has turned into one of the most prolific golf course designers in the country with projects sprouting up all over the land.

And in the highly competitive world of golf architecture, it is nice to have someone who likes to harken back to the beginnings of the game.

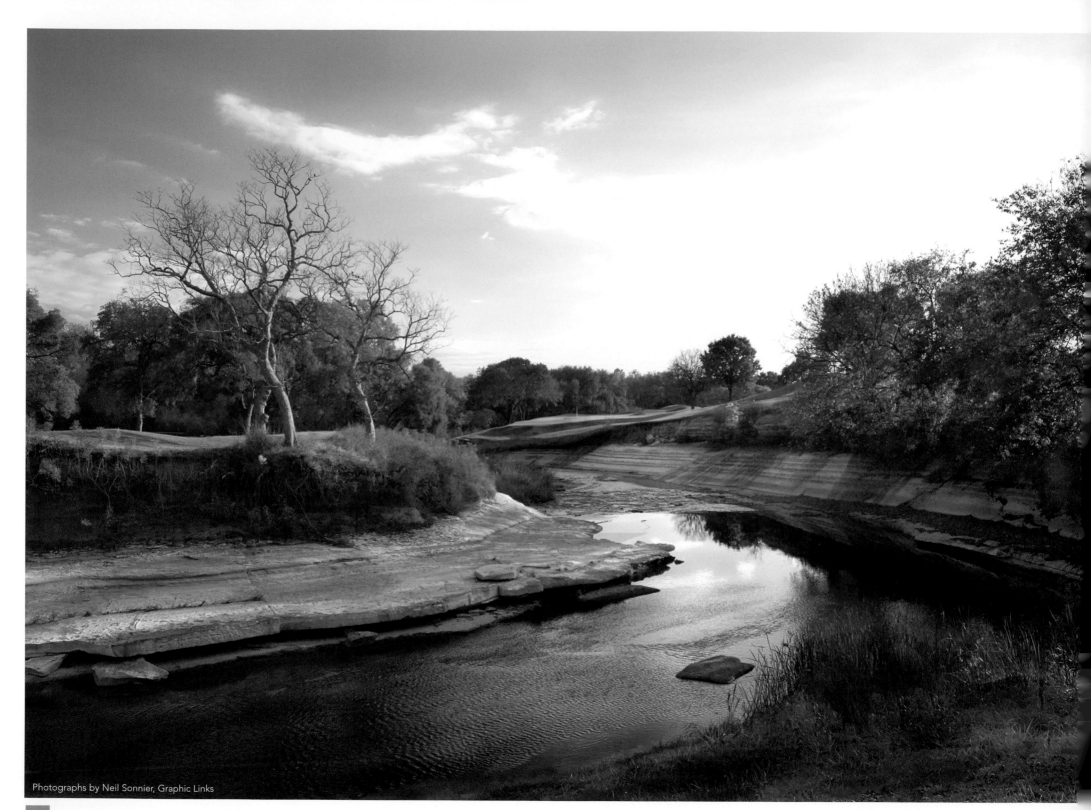

GLENEAGLES

GLENEAGLES COUNTRY CLUB
king's course • 11TH HOLE

218 yards • par 3

Plano, TX 972•867•6666 www.gleneaglesclub.com

*B*ruce Devlin and Robert von Hagge formed one of the most prolific and successful golf design partnerships of all time.

Golf courses sprang up in their wake around the world. They could be considered the Johnny Appleseeds of the sport.

They developed a host of courses in Texas, including the two at Gleneagles Country Club north of Dallas.

No sooner had it opened in 1985 than tournaments and qualifying events began to gravitate to the King's Course. Included among them was the 1988 Southwest Conference championship, during which a University of Texas team led by soon-to-be tour professional Bob Estes was upset by Southern Methodist University.

Anyone who plays the King's Course, be they future pro or struggling amateur, will find the par-3 11th a hole to remember — especially if they can get past it without encountering a disaster.

White Rock Creek meanders through a number of golf courses and as it makes its way down to White Rock Lake in Dallas, the creek leaves in its wake some majestic views. One is found at the 11th.

The creek has cut a deep enough channel so that steep banks of shale have been revealed, accompanied by large boulders. Tall grasses have grown up around the edges of the creek and a thick stand of trees surrounds the whole scene.

Perched in the middle of all that is the green, one that sits atop the creek bank and can be reached only with a shot that is total carry. The green slopes sharply from right to left and if the tee shot goes too far left, it will almost inevitably bound down the embankment and into the water.

Hole Number 11 uses the natural landscape to its fullest, which is and always has been the ultimate goal of any golf designer.

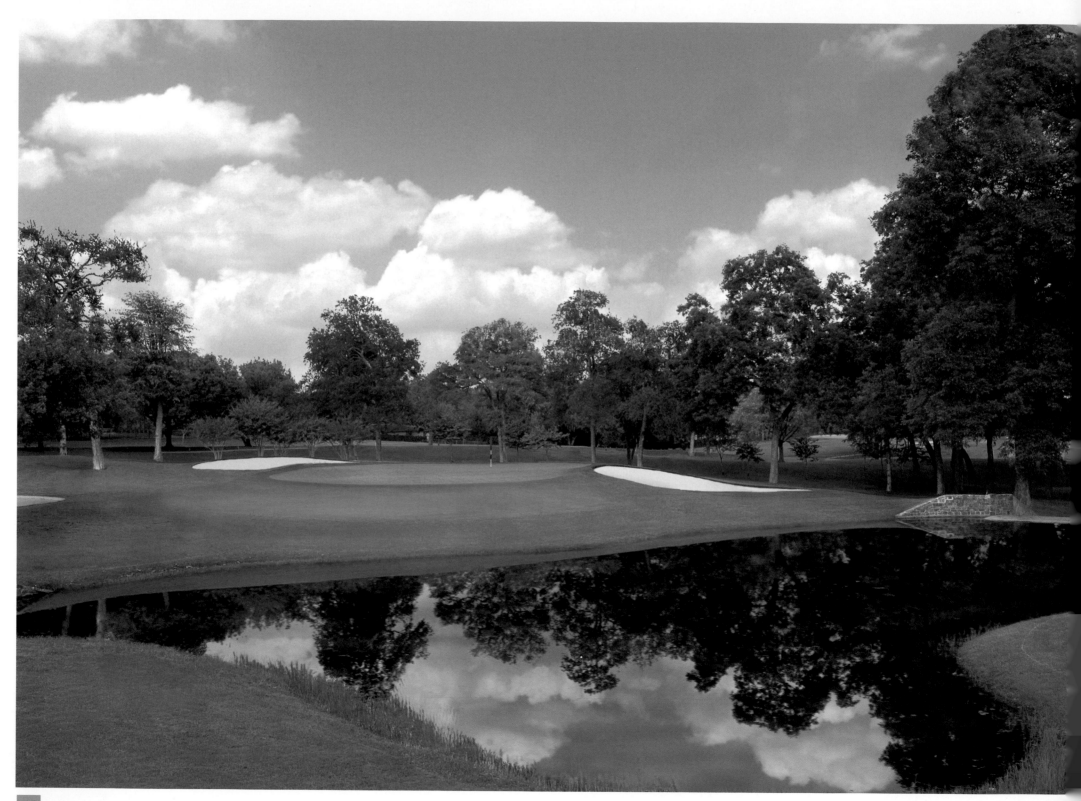

LAKEWOOD COUNTRY CLUB
7TH HOLE

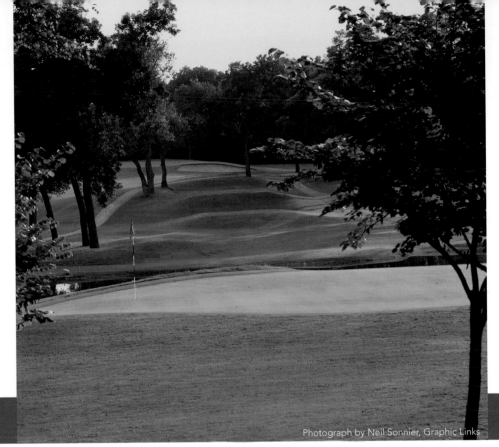

201 yards • par 3

Dallas, TX 214•821•7690 www.lakewoodcc.com

PGA TOUR records credit Byron Nelson with 52 career victories, 18 of which came in 1945 with 11 of those coming in succession.

Five of those 52 wins were collected in Nelson's native state — those triumphs having been recorded in Corpus Christi, San Antonio, Fort Worth, Houston and Dallas.

The one in Dallas came at Lakewood Country Club, which was founded in 1912 and still serves as a calm sanctuary less than 10 minutes from downtown (depending on whether the traffic lights are red or green).

In mid-June of 1944, Nelson won the New York Red Cross Tournament in New Rochelle and then drove to Chicago, where he finished third shots behind good friends Harold McSpaden and Ben Hogan.

Next he went to Minnesota, where he teamed with McSpaden to win the Minneapolis Four-Ball. Nelson then motored back to Chicago and won the Tam O'Shanter Open, which at the time was the richest event on the tour.

Then it was down to Nashville, where he emerged with a one-shot victory over McSpaden. Finally, at Lakewood, he defeated McSpaden by 10 shots — one of three times in his career that Nelson scored a double-digit victory.

Nelson had won five times in the span of six tournaments, although that was merely a tune-up for what he had in store the next year.

Lakewood is squeezed into a relatively small piece of ground, sitting in the midst of one of the city's more trendy neighborhoods. But there is nothing small about the par-3 seventh, which features a carry over a pond to a challenging green. If the pin is all the way back, the hole can play as long as 220 yards.

Bunkers protect the front right and the back left and the green slopes sharply from back to front. A 30-foot putt down a front hole location has bogey written all over it.

The water in front of the green once stretched all the way to the edge of the putting surface, but now a carry of only 165 to 170 yards is needed to keep the ball dry.

So the hole plays a little easier than it once did. Actually, nothing is ever really easy in the world of golf, although once upon a time Nelson made it look that way.

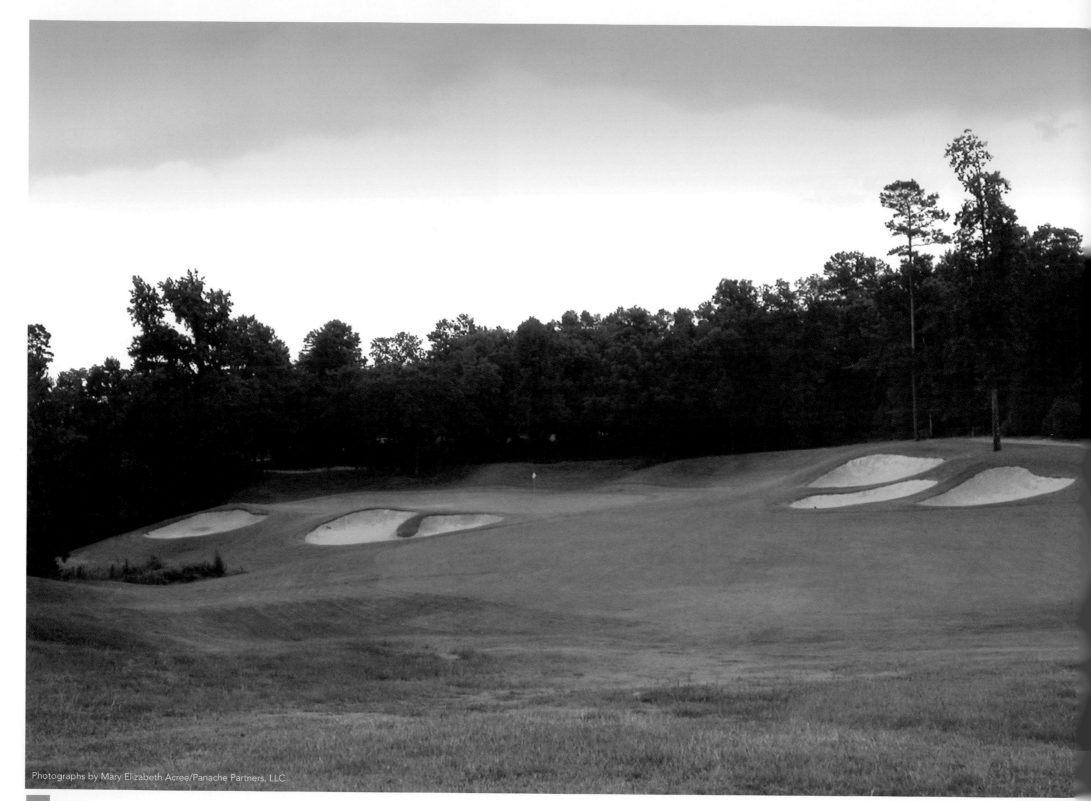

PINE DUNES RESORT & GOLF CLUB
6TH HOLE

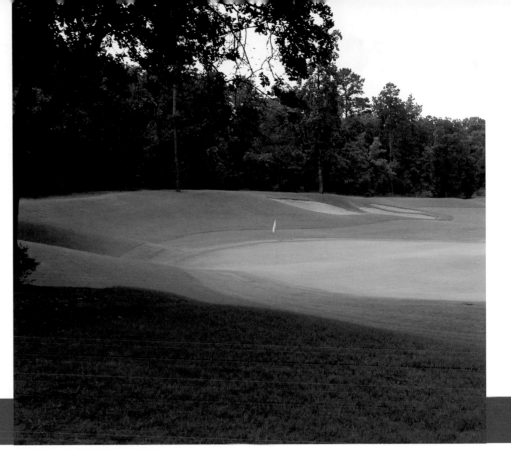

254 yards • par 3

Frankston, TX 903•876•4336 www.pinedunes.com

It is, perhaps, a surprising place to find what has become a golfing destination of the first order.

To locate the Pine Dunes Resort and Golf Club, one first travels to the town of Frankston, which is located between Poynor and Cuney and just south of Coffee City and Berryville.

Then one heads south a few miles, where serenity and 18 gorgeous golf holes await.

The 1,500 full-time residents of Frankston have seen traffic in their community increase since Pine Dunes became a finished product in the year 2000.

"There is nothing like it in Texas," proclaimed *Golf Digest* when the course was opened. And it is hard to argue.

Designers Jay and Carter Morrish took what was a ragged, nine-hole course and converted it into a gem that is carved out of the native pines.

Picture-postcard views abound and one of the best comes at the sixth tee. Number 6 is a long, downhill par-3 where the player has a chance to take advantage of the shape of the landscape.

At 254 yards from the back tee, it is a monster one-shot hole. Even from the less-daunting tees, it is a longer par-3 than normal. There are also three bunkers running around the front of the green with only the smallest of gaps through which the ball can be bounced.

On top of all that, the ground falls away left of the green down to a small pond, although it takes a severe pull to get to the water. Thick grass along the incline will often stop a ball prior to its reaching the hazard.

With all those obstacles, the player needs some relief. And there is some to be found to the right of the green.

The ground sweeps up from the right side so that a ball landing on the slope stands a very good chance of bounding down the hill and onto the green. The right side of the putting surface will get a lot of action, no matter where the pin is located.

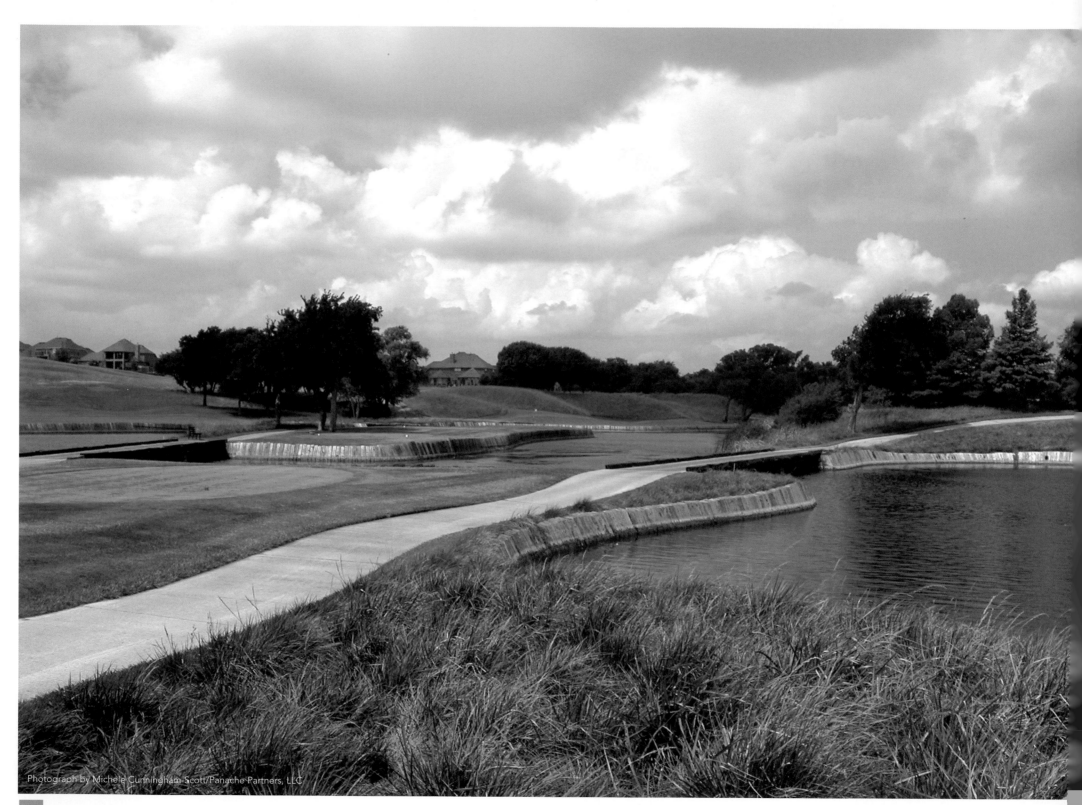

Photograph by Michele Cunningham-Scott/Panache Partners, LLC

STONEBRIDGE

STONEBRIDGE RANCH
COUNTRY CLUB
dye course • 12TH HOLE

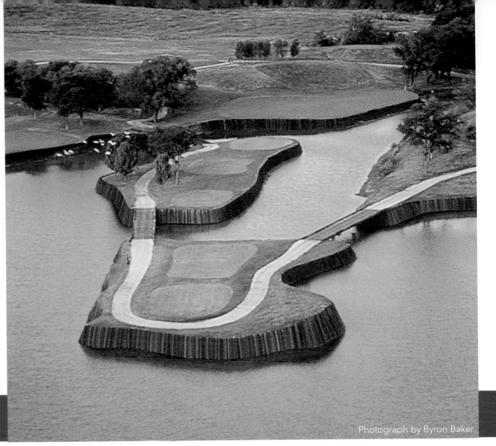

Photograph by Byron Baker

200 yards • par 3

McKinney, TX 972•529•5993 www.stonebridgeranch.com

A course designed by Pete Dye is just about guaranteed to be a conversation piece in addition to being troublesome to play.

The one he designed at Stonebridge Ranch is both of those. He has called it his favorite and probably toughest design. In fact, it has become even more troublesome since it was opened in 1988.

Because it has been adopted by the PGA TOUR as one of its favorite places to conduct qualifying events, Stonebridge Ranch has undergone a gradual toughening process to meet the consistent onslaught of golf technology.

As the Tour has returned year after year for one of its second-stage qualifying tournaments, length has been added and other alterations made so that the course rating has been increased from 75.9 to 77.6.

In the sport's steady march toward an eventual course rating of 80, the works of Pete Dye seem to be leading the way.

Dye's most publicized design is the TPC-Sawgrass layout in Florida, where the 17th hole and its island green takes its toll on the best players in the world.

At Stonebridge Ranch, Dye has brought a little twist to that theme. He has created an island tee. In fact, there are two of them on the par-3 12th.

There are two teeing areas on one of the islands and three more on the other. But no matter from where the tee shot is struck, it must carry water.

The green sits on more of a peninsula than an island and features the Dye trademark railroad ties to prevent any hint of erosion.

For those hoping to play their way onto the PGA TOUR, the 12th hole, played from 200 yards with the prevailing wind quite possibly howling from right to left, has become a major impediment as well.

For generations, renowned golf architects Jay Morrish (Jay Morrish & Associates), and son, Carter (Morrish & Associates), have designed the legend rich venues on which Texas golf history has been made, including the TPC Las Colinas, Pine Dunes and more. No one appreciates "the lay of the land" more than Jay and Carter, who especially enjoyed cultivating the natural beauty of the Hill Country to create such pristine courses as La Cantera and Circle C.

HILL COUNTRY

Presented by Jay Morrish & Associates Ltd.,
Morrish & Associates, L.L.C.

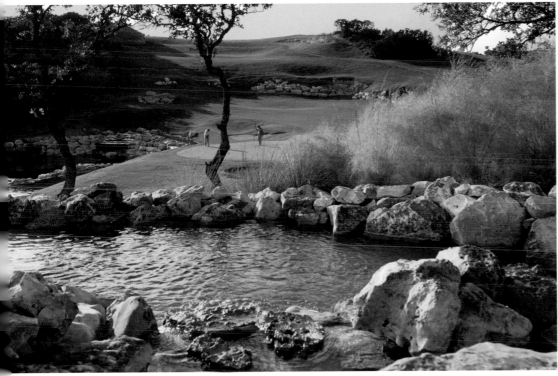

18th Hole, The Resort Course at La Cantera Resort (Jay Morrish, architect)

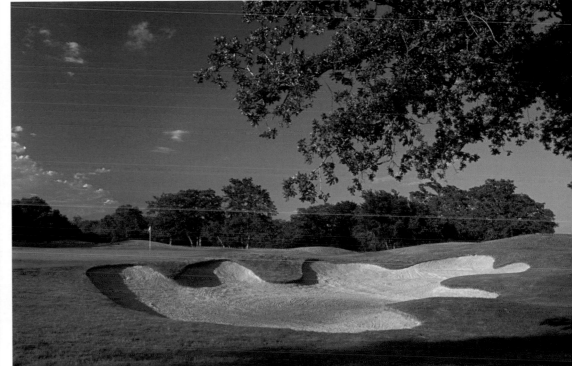

The 5th Hole at The Golf Club at Circle C (Jay Morrish, architect)

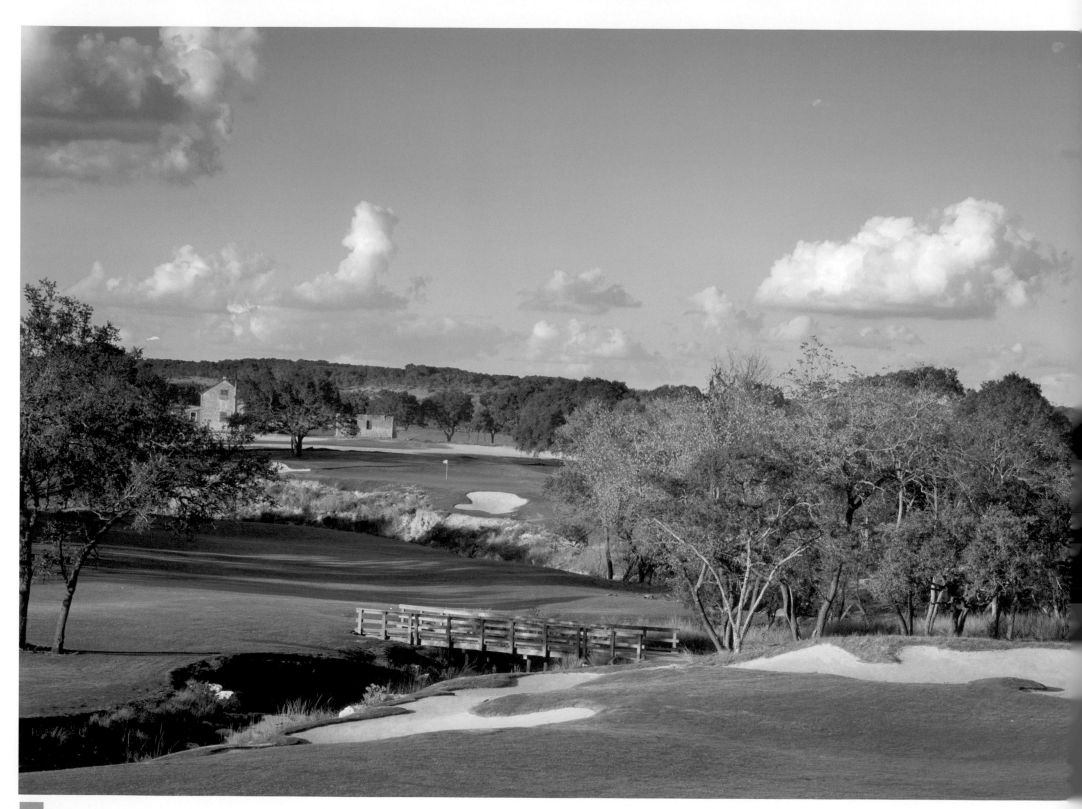

BOOT RANCH
BOOT RANCH GOLF CLUB
8TH HOLE

545 yards • par 5

Fredericksburg, TX 830•997•6200 www.bootranch.com

One of the significant victories in the career of Boot Ranch designer Hal Sutton came at The Players Championship, which is contested each year on what may be the ultimate example of target golf.

Sutton has created a hole that would fit right in at the TPC-Sawgrass course — except for the fact the Florida layout is flat and the eighth hole at Boot Ranch is carved out of rugged hills.

The par-5 eighth gives the player some options, but each of those options involves a specific target.

A creek crosses in front of the tee, doubles back on itself, then makes a left-hand turn so that it slices the fairway in two. A decision has to be made on the tee whether to stay left or right of the creek and there is no margin for error on either side.

The creek eventually turns directly in front of the green.

The long hitters will choose the most direct path to the green, which would involve the fairway to the left of the creek. The tee shot must actually carry the creek twice as it makes its initial u-turn and it must also carry a bunker which has been placed where the left-hand portion of the fairway begins.

Once safely in the target area, the second shot will be of about 180 yards over the deep hazard formed as the creek travels in front of the green. The putting surface is also elevated, so the shot plays a little longer than the actual yardage.

The safest play from the tee is a drive into the right-hand fairway, a second shot over the creek to the left-hand fairway and then a pitch of about 100 yards to the green.

The green is not all that large, a commonplace occurrence at Boot Ranch. There is a lot of closely mown grass around this and many other greens on the course, giving the player a chance to execute a chip or even pull out the putter from a considerable distance.

Different methods can be used to get the ball close to the final target on a hole that is all about targets from start to finish.

CIMARRON HILLS GOLF & COUNTRY CLUB
1ST HOLE

585 yards • par 5

Georgetown, TX 512•763•1800 www.cimarronhills.com

A few weeks after he won the 1986 Masters for his 20th and final major championship on the PGA TOUR, Jack Nicklaus played an exhibition round at a course he had just refurbished.

It was the Dallas Athletic Country Club's Blue Course, site of his first PGA Championship victory in 1963.

As he stood on the Number One tee, with several hundred club members in attendance, he explained one of his architectural philosophies.

"We like to give you a fairly easy start," Nicklaus said. "The opening hole should be one where you have a chance to make a birdie."

The opener at Cimarron Hills may not be the easiest first hole Nicklaus has ever designed, but it still fits in with his belief that the golfer should be able to ease into the round without having to hit the shot of a lifetime just to find the fairway.

Giving the player something pleasant to look at while standing on the first tee is also a goal of any golf architect and the view is first rate at Cimarron's Number One.

Trees line both sides of the fairway to give the opening shot plenty of definition. It is a long hole from the back, but from the member tees a short-iron approach can be set up with two reasonably straight and reasonably solid shots.

There is a bunker 260 yards from the green that needs to be avoided along with a pair of traps about 25 yards short of the green. Another bunker is placed to the right of the putting surface, which is not all that undulating, but which does slope slightly from left to right and from back to front.

It is a hole that fits very nicely into Nicklaus' architectural tenet that the opening test of any course should cause the avid golfer to be enticed rather than repelled.

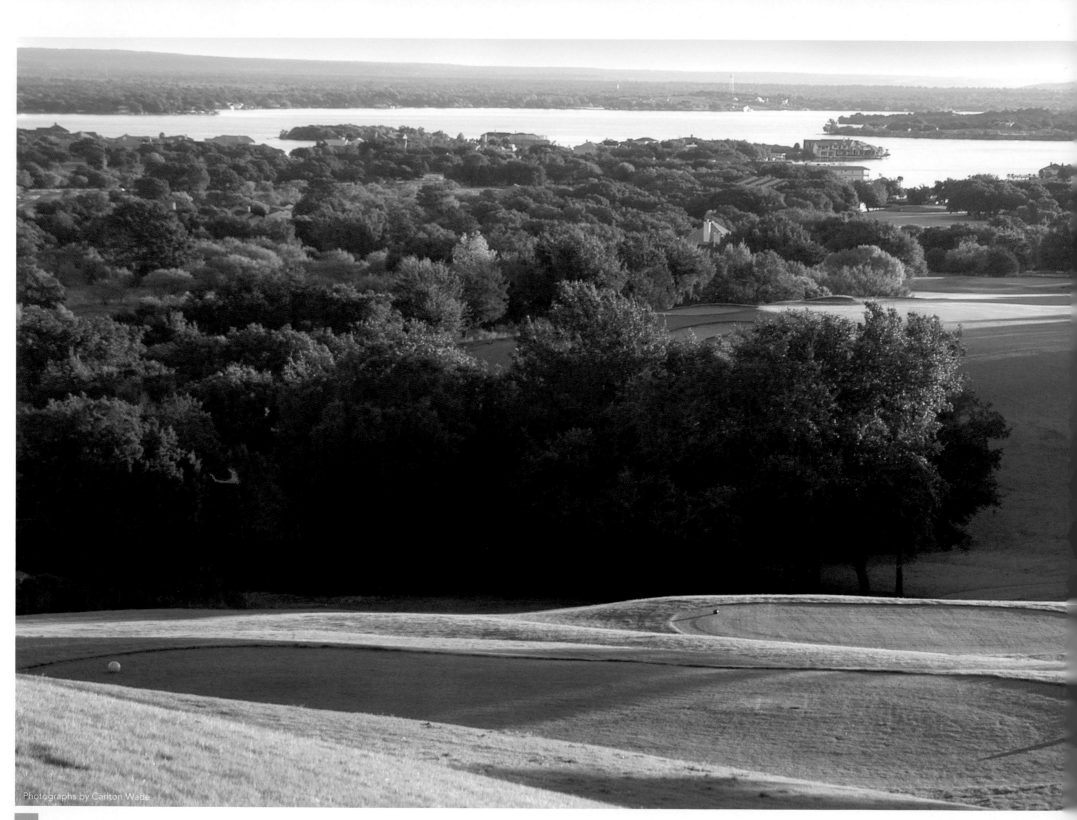

HORSESHOE BAY RESORT

apple rock course • 10TH HOLE

567 yards • par 5

Marble Falls, TX 830•598•2511 www.hsbresort.com

Apple Rock, the newest of the three Horseshoe Bay Resort courses, is built on high, craggy ground.

That makes it easier to take in the vistas that are commonplace and one of the best of the views overwhelms the senses while standing on the 10th tee.

It is a downhill, par-5 that has a ravine right in front of the tee box. Off in the distance, however, is the real eye grabber. Lake LBJ dominates the scene and, a few holes later, comes into play.

Getting past the ravine is the first order of business and it takes a carry of close to 180 yards to do so. The task is made a little easier by the fact the tee is elevated, giving the player a clear view of the ball bounding safely along the fairway or, if things do not go quite as planned, disappearing into the hazard.

Because the surrounding landscape can be so penal, the landing areas at Apple Rock are fairly generous and that is the case at the 10th.

There are, however, boundary stakes all along both sides of the fairway, which continues its downward tilt for the second shot.

A string of bunkers enters the picture along the right side and they run for about 60 yards beginning 100 yards from the green.

Bunkers are placed in front of and to the right of the green. The putting surface is also affected by the general downhill slope of the land and falls away from the player.

Golfers who like to travel fully realize that in their sport, there is beauty. And then there is rugged beauty. Apple Rock in general and its 10th hole in particular, provide the latter.

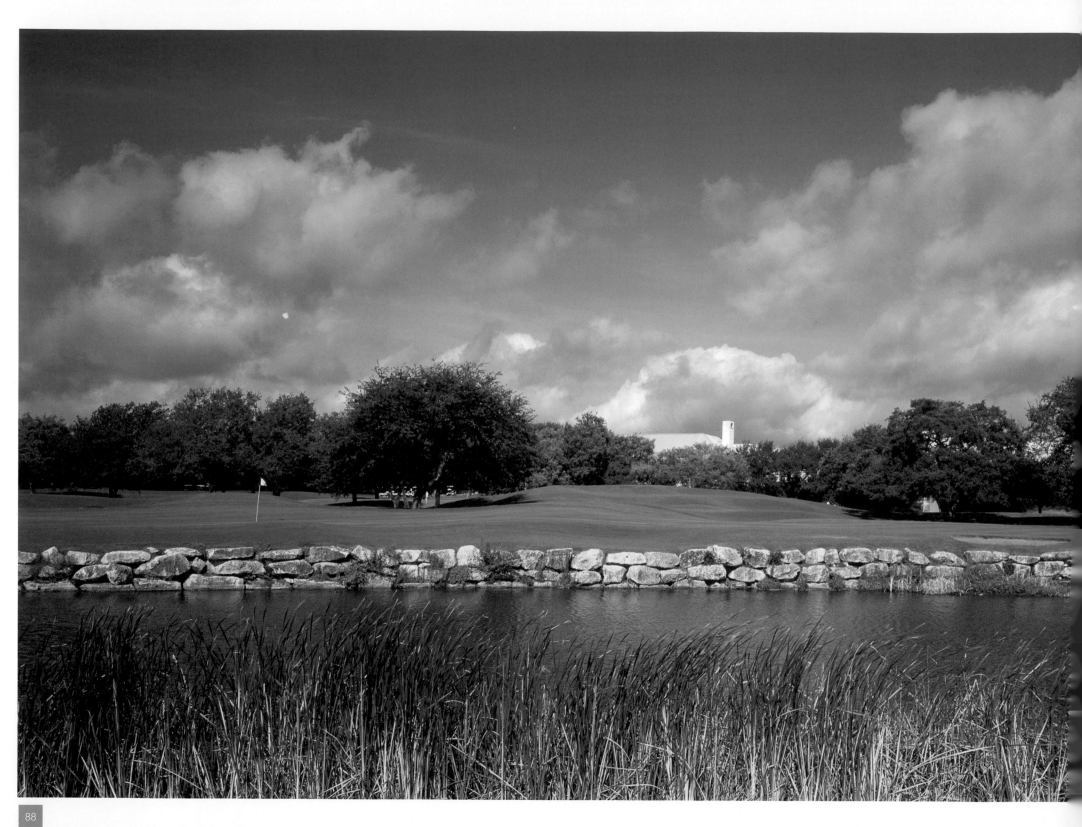

HYATT REGENCY HILL COUNTRY GOLF CLUB

creeks course • 9TH HOLE

554 yards • par 5

San Antonio, TX 210•647•1234 www.hillcountry.hyatt.com

One of the growing trends in travel over the past generation has been the creation of places where the family can go, the business meeting can be held, the weekend escape can be conducted and the overwhelming desire to play a lot of golf can be fulfilled.

The Hyatt Hill Country Resort is just such a place.

All the comforts of home, and then some, have been placed in the middle of 27 holes that feature all of the typical Hill Country attractions.

Those attractions abound at the par-5 ninth on the Creeks Nine, which provides the kind of challenges that, when met, bring about the kind of satisfying feeling that makes the sport so special.

The tee shot must be threaded through a fairly narrow opening in the trees and the fairway then makes a slight turn to the left.

If an attempt is made to reach the green in two, the player must continue to contend with the trees that pinch in on both sides. In addition, a dry creekbed runs across the fairway 100 yards in front of the putting surface and a pond protects the front and right side of the green.

The no-risk play for the second shot is a layup shy of the creekbed, after which the third shot will be with a short iron or wedge to the green.

And there is a lot more to the green than initially meets the eye. It actually extends on and on and on until it becomes the ninth green of the Oaks Nine.

The double green can present a big problem if the approach shot scurries onto that portion used by the other hole. A putt approaching 100 feet is conceivable, in which case there would be one more reason to remember the trip to one of Texas' popular travel destinations.

OAK HILLS COUNTRY CLUB
10TH HOLE

513 yards • par 5

San Antonio, TX 210•349•5151 www.oakhillscc.com

When Tom Kite captained the United States Ryder Cup team in Spain, he told those who had come to chronicle the event that the host Valderrama course reminded him of one back in his native Texas.

That course, he said, was Oak Hills in San Antonio.

It is a venerable locale that has served as a test for the sport's upper echelon. Twenty-three times it was home to the Texas Open.

Arnold Palmer won at Oak Hills in both 1960 and 1961, years in which he was the unquestioned number one player in the world. Hale Irwin, Lee Trevino, Ben Crenshaw, Corey Pavin and Nick Price have also been winners on the narrow fairways and small greens at Oak Hills.

And when the course became the site for the first Tour Championship, the winner was Tom Watson.

Oak Hills is known best for, what else, its oaks. A seemingly endless supply of wonderfully gnarled trees are found everywhere, especially in the way.

That is never more evident than on the tee at the par-5 10th. The trees overhang the tee box. The trees are on both sides of the fairway. And the trees pinch in on the landing area, causing it to look about as big as a keyhole.

The fairway makes a turn to the right and to reach the 10th green in two, a player will have to go over the trees at the corner of the dogleg.

The greens make up another fabulous feature on this course. Crenshaw has always said that those who think greens cannot be world class if they consist of Bermuda grass need to see those at Oak Hills.

They can run as fast as 13 on the universally used device that measures the speed of greens. Translated, that means it is about the same as putting on a well-polished hardwood floor.

The 10th green has a ridge running across it, a bunker protecting the entire left side and another one in the right front. It provides the finishing touch to a classic hole on a classic course that probably has not received its just due in the world of golf.

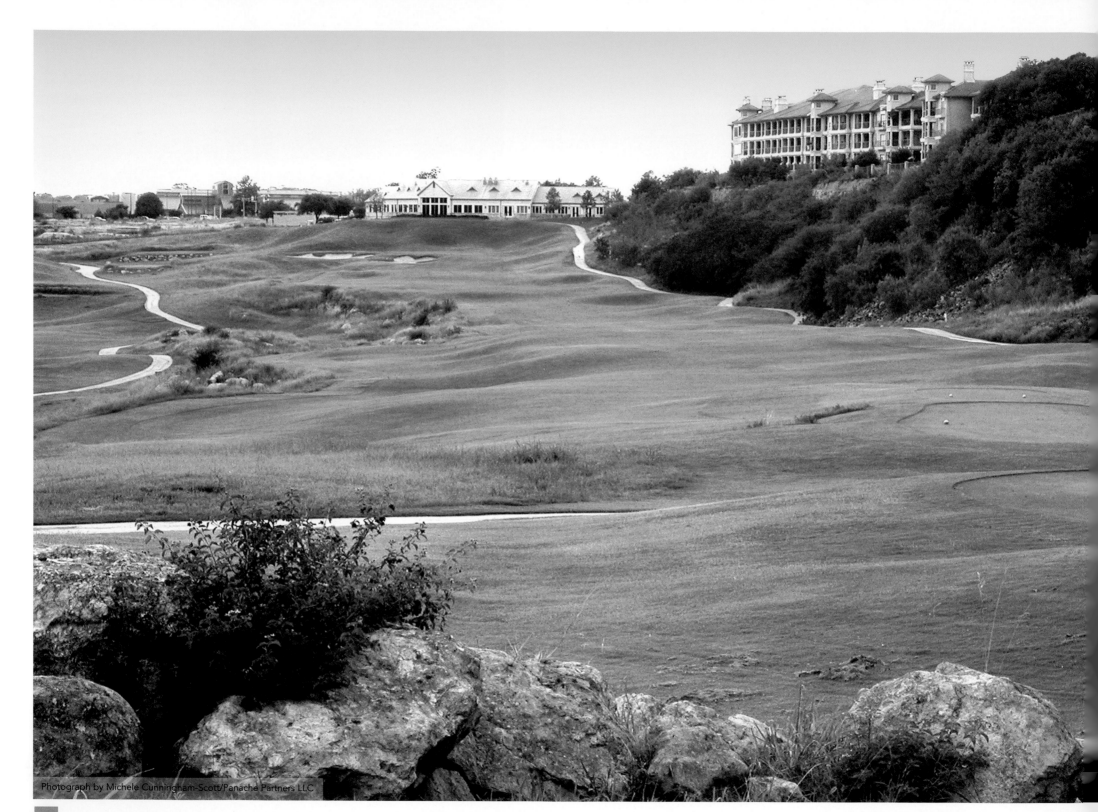

THE QUARRY

THE QUARRY GOLF CLUB
18TH HOLE

564 yards • par 5

San Antonio, TX 210•824•4500 www.quarrygolf.com

A visually stunning golf course comes to a visually stunning end with a par-5 that hugs a jagged wall of the quarry that gives the layout its name and its uniqueness.

The Quarry Golf Club is pretty much unlike any other, even in a state filled with courses that take advantage of natural beauty. The scenery around this course, in fact, looks almost unnatural.

The area into which the tee shot on the 18th must be placed is narrow, confined on the left by rough and on the right by the wall that feels as if it is only an arm's length away.

And, if a shot drifts to the right, that is exactly how far away it might be.

An honest-to-goodness, right-handed slice will slam into the quarry wall and there is always a chance the ball will ricochet back onto the fairway. But that is not the recommended way to play the hole.

The wall is not straight up and down. It angels slightly away from the fairway and it is loaded with bushy plants and grasses that cling to life in the rocky ground. After bouncing around a bit, a ball can easily become stuck in one of the pieces of vegetation or become lodged in a nook or cranny in the wall.

In that case, common sense suggests that another ball be brought into play.

"Please do not climb on quarry walls," reads the gentle reminder on the scorecard.

There are no bunkers to be found along the fairway of a hole that needs no hazards other than the big one looming on the right. And even though there is a little more landing area for the second shot than there is for the first, the wall continues to loom.

Two laser-straight shots set up a routine pitch to a green protected in front by two bunkers.

At the completion of play, those who have withstood the challenge, and even those who have not, can repair to the clubhouse. The resting place sits well above the quarry and it is possible to enjoy food and drink while gazing down on the entire field of the recent battle.

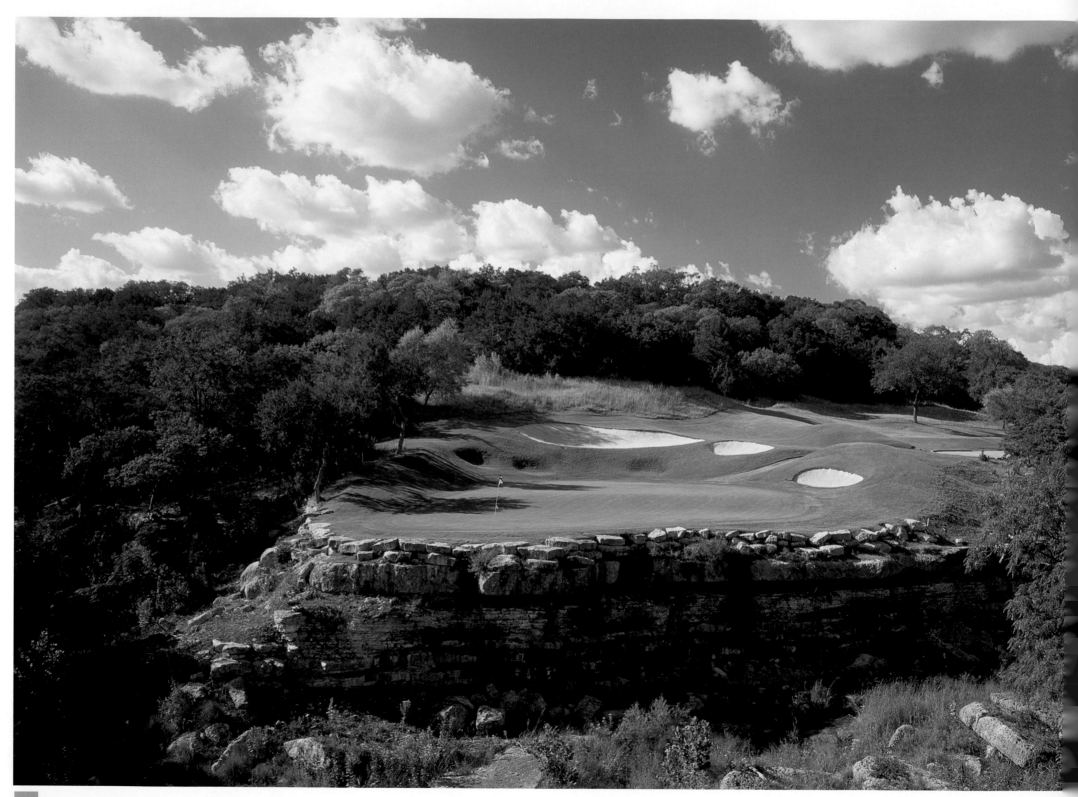

RIVER PLACE COUNTRY CLUB
4TH HOLE

561 yards • par 5

Austin, TX 512•346•6487 www.riverplaceclub.com

Long before he won the U.S. Open in 1992, Texan Tom Kite was neck deep in golf design work and it was inevitable that he would produce a course in his home town.

It is River Place, which sits in the steeply rolling terrain west of Austin just north of the Colorado River.

The course sweeps around and over the canyons which time has etched into the hills with 10 of the holes featuring a carry over one type of hazard or another.

One of those is the fourth, a par-5 that twists and turns along the outskirts of the property. It does not involve a great deal of elevation change, but it does involve some thoughtful planning.

A creekbed lined with trees runs down the entire left side of the hole and individual trees appear with regularity at the left edge of the fairway.

To the right, there is an area of native growth along with a slope that tends to kick the tee shot back to the left. A gentle fade off the tee will take some of the sting away from the slope and keep those trees on the left from playing havoc with the second shot.

On the assumption one does not go for the green in two, and not many will try to do so because of all the trouble awaiting, the second shot should favor the right side and needs to stop short of a hazard that begins just under 100 yards from the green.

Being on the right side sets up a better angle for the approach, which must carry over the hazard to a green that is set back to the left just enough to add to the thought process.

Those familiar with the kind of game played by Kite will no doubt appreciate the hole. It takes two accurate shots, followed by a pitching wedge or short iron into a small target. And the designer of this hole has perhaps set up as more birdies with his wedge game than any player in the history of the sport.

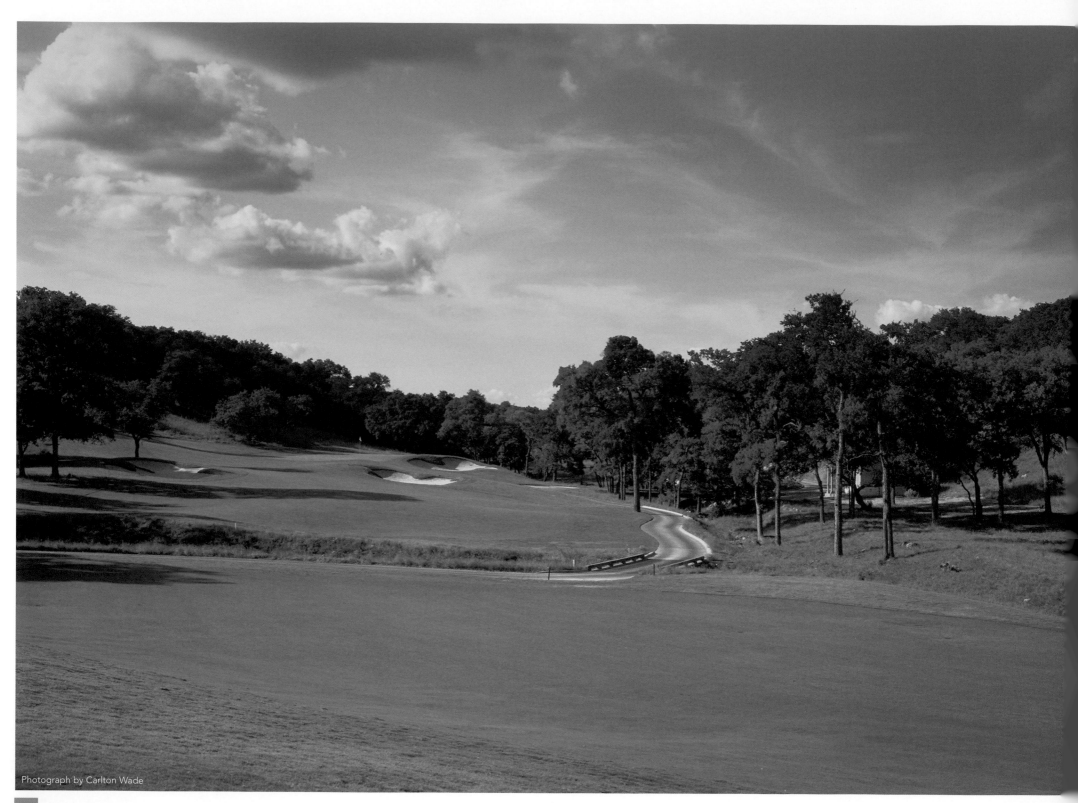

TWIN CREEKS

TWIN CREEKS COUNTRY CLUB
5TH HOLE

593 yards • par 5

Cedar Park, TX 512•331•5900 www.twincreekscountryclub.com

As the city of Austin spreads out in all directions, one of the city's passions goes with it.

Wonderful courses in wonderful settings are found around just about every corner to the point that those who happen to trip and fall will probably land on a golf course.

One such golf oasis is found in the burgeoning suburb of Cedar Park, north and west of the city. It is the Twin Creeks Country Club, on which former Masters champion Fred Couples consulted, and the result is similar to his silky smooth swing. It's easy on the eye.

All the Hill Country characteristics are present. The ravines are there, as are vistas from elevated tees. Rocky crags give way to tall trees and they, in turn, give way to more rocky crags.

With this course, the longer the hole the more there is to enjoy. Which means the fifth should be very enjoyable.

It plays 593 yards from the back, but there are seven tees spread out over 180 yards to accommodate those who are not interested in the maximum amount of pleasure. Or punishment, as the case may be.

The various tees are scattered through rock outcroppings, which must be carried to reach an expansive fairway.

The hole makes a turn to the right, after which the second shot must sail over a narrow, brush-filled ravine. Once over that inconvenience, it is less than 100 yards to an elongated and elevated green that has a bunker down the right side. Another bunker well short of the green could create depth perception problems.

A ridge to the left, topped by trees, forms a barrier that gives this hole an isolated feeling. That feeling is a common one around Twin Creeks, which more than holds its own against the area's ever-growing competition.

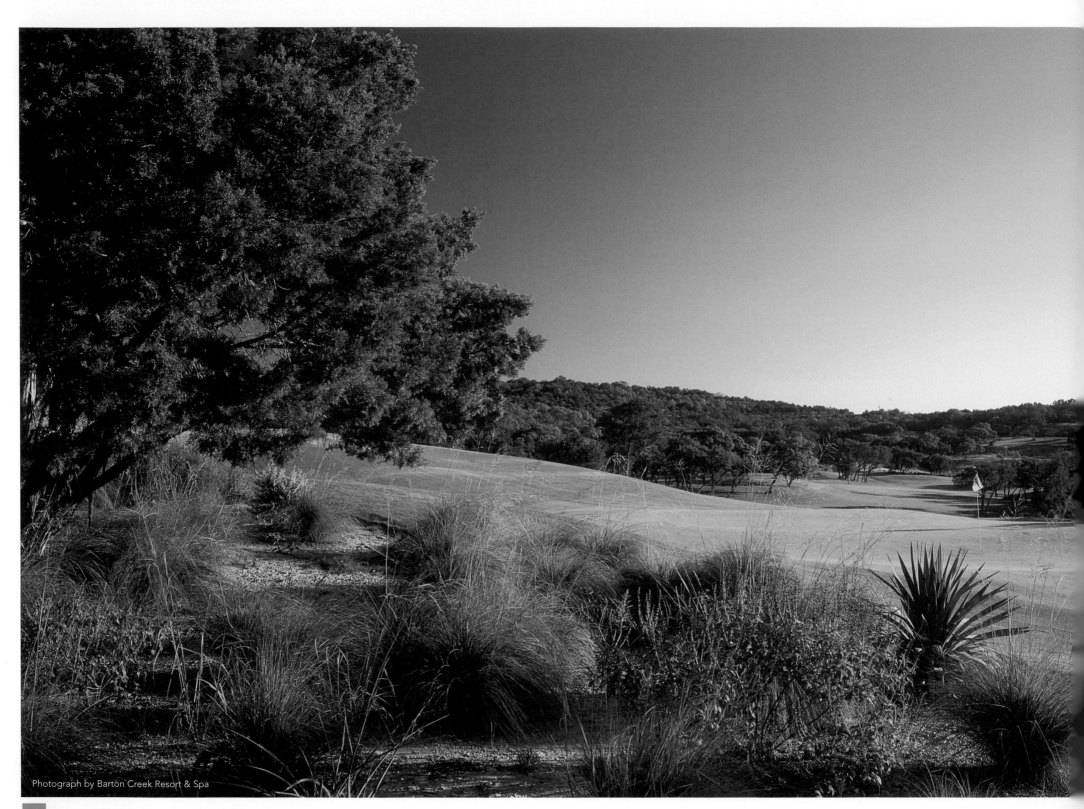

Photograph by Barton Creek Resort & Spa

BARTON CREEK RESORT & SPA

canyons course • 16TH HOLE

452 yards • par 4

Austin, TX 512•329•4000 www.bartoncreek.com

One of Texas' top travel destinations became even more of an attraction with the addition of a second course from extraordinary designer Tom Fazio.

Ben Crenshaw and Arnold Palmer have also produced courses at Barton Creek, giving the fanatical golfer a little something of everything.

Attempting to list the best of anything in the world of golf can touch off a good-sized argument, but there are those whose opinions are solicited in various polls around the state who have come to believe Fazio's Canyons Course is the number one layout in Texas.

That debate aside, there is no questioning the fact that it is a grand course laid out on a grand scale.

Enormous rock outcroppings abound, dry creek beds lined with limestone wander about and a variety of trees native to the Hill Country border the fairways. For the most part, however, one plays between all the scenic features and not over them.

A small exception can be found at the par-4 16th, a brutish hole that obviously requires two big shots in order to have any chance for a par.

The tee shot must make a minimal carry over a waste area of grasses out to a relatively abundant fairway that is pinched on both sides by strategically located trees.

The green is enormous — almost half a football field deep. Two bunkers, a small one at the left front corner and a big one along the left side, will catch their share of action.

There is a large runoff area behind the green and another one to the right. In addition, the green has a false front so that any shot not carried well onto the putting surface will steadily trickle back into the fairway.

The 16th, as it turns out, is emblematic of the entire course, one that is very fair, very stern and planted in the midst of a steady stream of natural wonders.

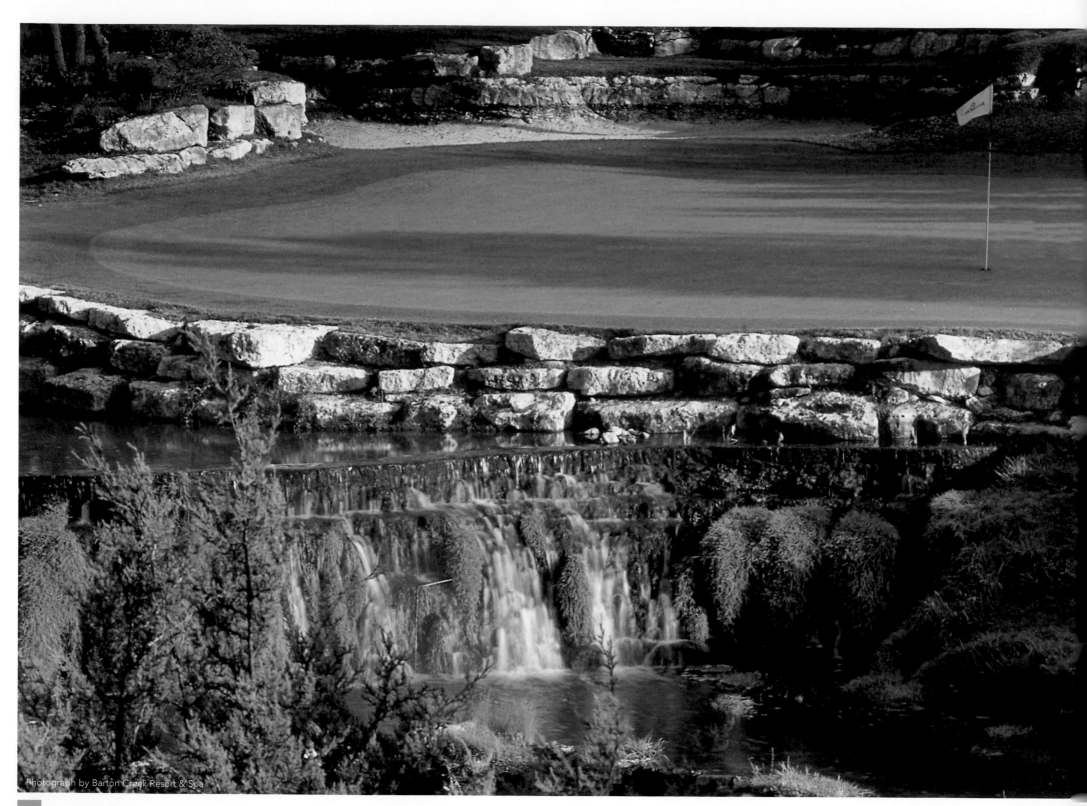

Photograph by Barton Creek Resort & Spa

BARTON CREEK RESORT & SPA
foothills course • 16TH HOLE

452 yards • par 4

Austin, TX 512•329•4000 www.bartoncreek.com

With 72 holes of golf on the property, it is virtually impossible to pick a favorite vista at the Barton Creek Resort.

Around each turn and over each rise lies yet another view that forces the player to consider whether this one is the best or whether it is that one just over there.

One really can't go wrong, of course, in such a subjective exercise. The best thing to do is just hit the shots and relish the scenery — although it does not have to be in that order.

The first of Tom Fazio's two courses at Barton Creek is known as The Foothills and it underwent something of a facelift in 2004. It was lengthened about 200 yards, new grass was planted on the tees and greens and it was generally upgraded to meet the continual challenge presented by newly opened layouts in the region.

No changes were needed, however, in the grandeur department. After all, that aspect of the course was all but impossible to improve.

One of the stunning visual presentations comes at the par-4 16th, a hole that is medium in length and long in aesthetic value.

The tee shot is fairly straightforward as it tumbles slightly downhill, although the ever-present live oaks line both sides of the fairway. There

is also a nest of bunkers down the left side and that is the favored side because a second shot from there sets up a better angle to the green.

Actually, the fairway slopes a little to the left, so a well-struck ball will likely wind up in a favorable position.

But things such as angles and wind direction and club selection will quickly be placed on the back burner once it becomes clear what is in store en route to the green.

It is as fine a natural setting as man can create. The second shot must carry over most everything the Hill Country can throw at a player. There is a ravine with a waterfall, limestone ledges, pools of water on different levels and trees of different varieties growing out of the depths below.

A rock face fronts a very, very wide green and beyond the putting surface the ground rises up with outcroppings of boulders framing the whole picture.

The 16th at Barton Creek's Foothills Course usually makes the various listings of the most beautiful holes in the state. And when it comes to beauty, it has plenty of competition in its own backyard.

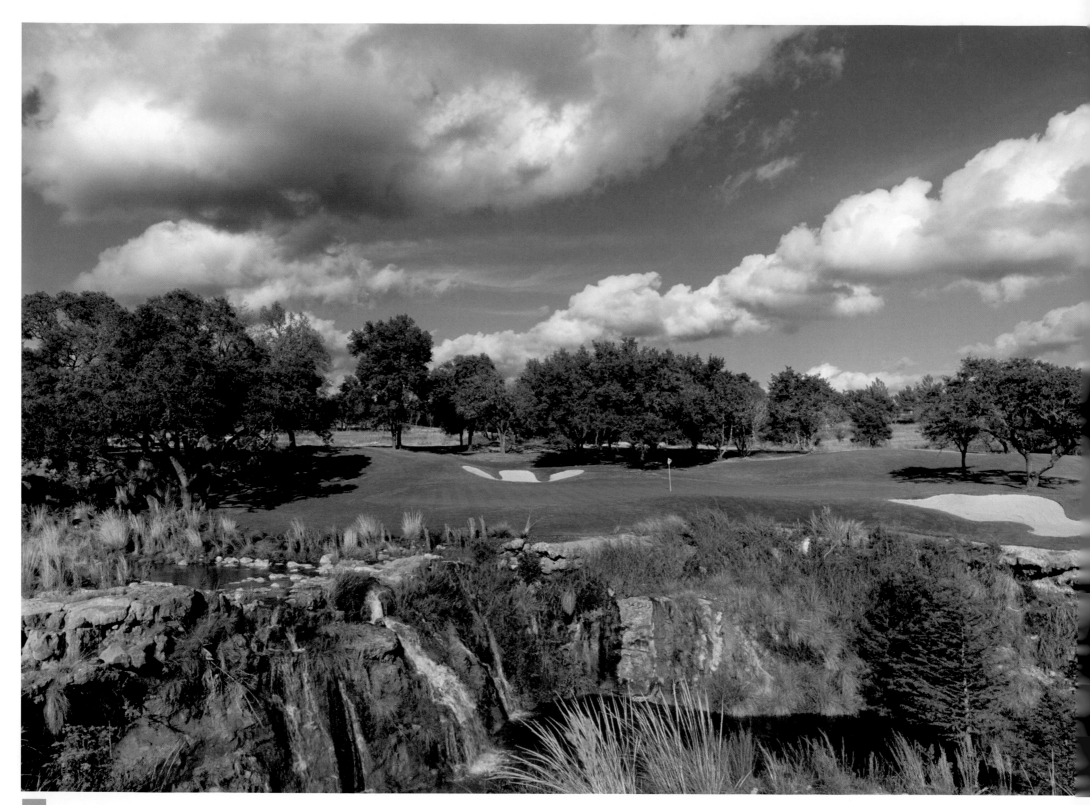

BOOT RANCH
BOOT RANCH GOLF CLUB
10TH HOLE

364 yards • par 4

Fredericksburg, TX 830•997•6200 www.bootranch.com

When playing in the Hill Country, distractions are commonplace. Anything from phenomenal rock formations to a deer bounding across the fairway might be seen.

At Boot Ranch, however, there is a distraction that can be heard.

It comes at the short, par-4 10th, a hole that underwent an alteration even before the course was officially opened.

A typically stunning view awaits at the 10th, where the drive must carry over a hazard just in front of the tee out to what was originally a very ample landing area.

But after construction was completed, it was decided that a bunker should be placed in the middle of the fairway—about 260 yards from the back tee. It is, therefore, very much in play.

Most will take a club that will ensure the tee shot will remain short of the bunker because the reward for being past the trap is not really worth the risk.

The bunker is fairly flat and does not have a lip, so even the mid-handicap player will find it possible to advance the ball to the green from the sand. But the fairway is far preferable.

Although the bunker adds some spice to the tee shot, it is the approach to the green that gives this hole its character.

In front of the green is a 40-foot wide cascade, over which 2,500 gallons of water flow every minute.

And when standing on the green, what began as a visual distraction becomes an audible one. The sound of the water tumbling down into a pool is so loud that the Director of Golf, Emil Hale, says it is difficult to even carry on a conversation while on the green.

Not that it matters. The view is so remarkable that no one could do it justice with words anyway.

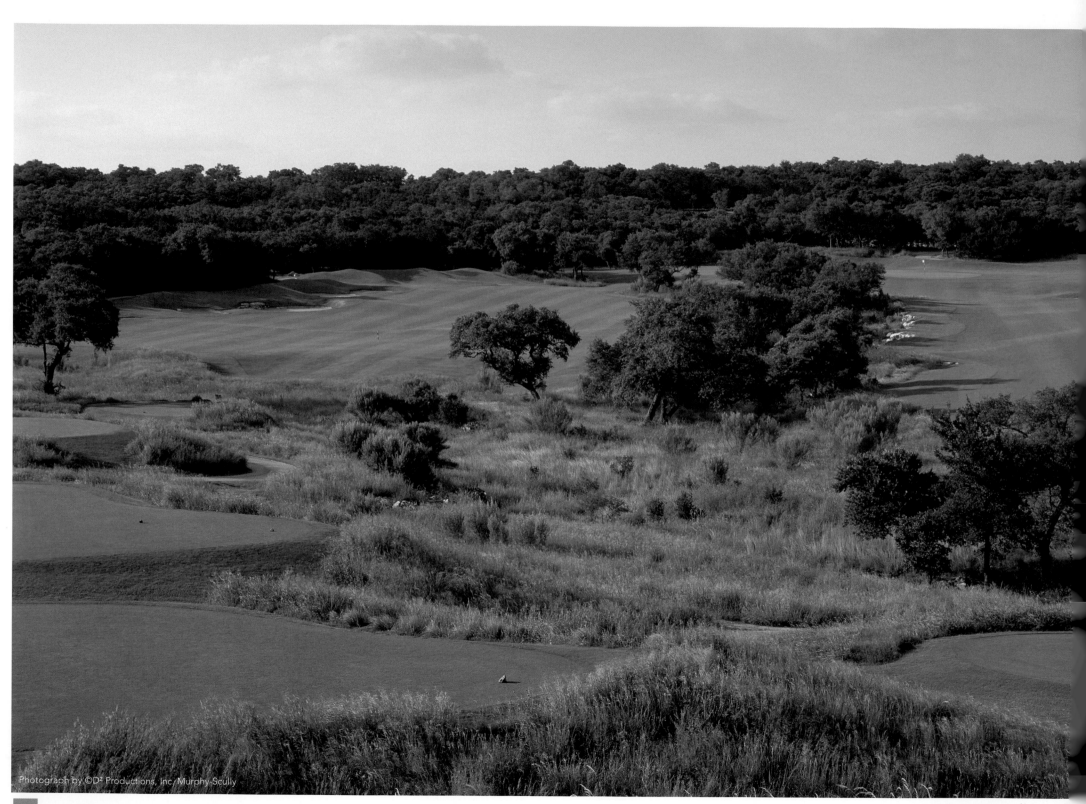

CANYON SPRINGS GOLF CLUB
6TH HOLE

375 yards • par 4

San Antonio, TX 210•497•1770 www.canyonspringsgc.com

*H*istory and golf are often intertwined and they certainly are at the Canyon Springs Golf Club.

The course is built on a pioneer family's ranch. A stagecoach line ran through the property and a concrete watering trough used by stagecoach horses sits near the pro shop. In a cave close by, bones from a saber-toothed tiger were found.

And now, in the midst of all that, there is a golf course consistently presenting the challenge of forced carries over wild terrain.

One of those carries must be made at the most talked-about hole on the course, the par-4 sixth. It is not all that long, but it provides an out-of-the-ordinary experience.

The first order of business from the elevated sixth tee is to determine on which side of the green the hole has been cut that day.

That bit of knowledge is needed to decide which of the two fairways available should be the aiming point for the tee shot.

If the pin is on the left side, the drive should carry into the left fairways. Same with the right.

To reach the left fairway, a carry of 180 yards is needed from the back tee. The carry to the right fairway is 170 yards. And between the fairways is a creekbed, native grasses and trees — a forbidding area that travels to within 40 yards of the green.

Should the tee shot happen to wind up in the wrong fairway, the hazard must be crossed in order to reach the green, which is almost 60 yards in width.

There are bunkers along the outside of the left fairway and there is a pot bunker about 80 yards from the green on the right.

No bunkers are around the green, just a lot of short grass that allows the player a chance to save par with a decent chip. A second shot that flies the green, however, can wind up in the native grass.

The hole is never cut on the same side of the green two days in a row, so it presents a different examination on a Tuesday than it did the day before or will the day after.

The good news is that the players no longer have to dodge the stagecoaches bouncing across their path. Not to mention the saber-toothed tigers.

105

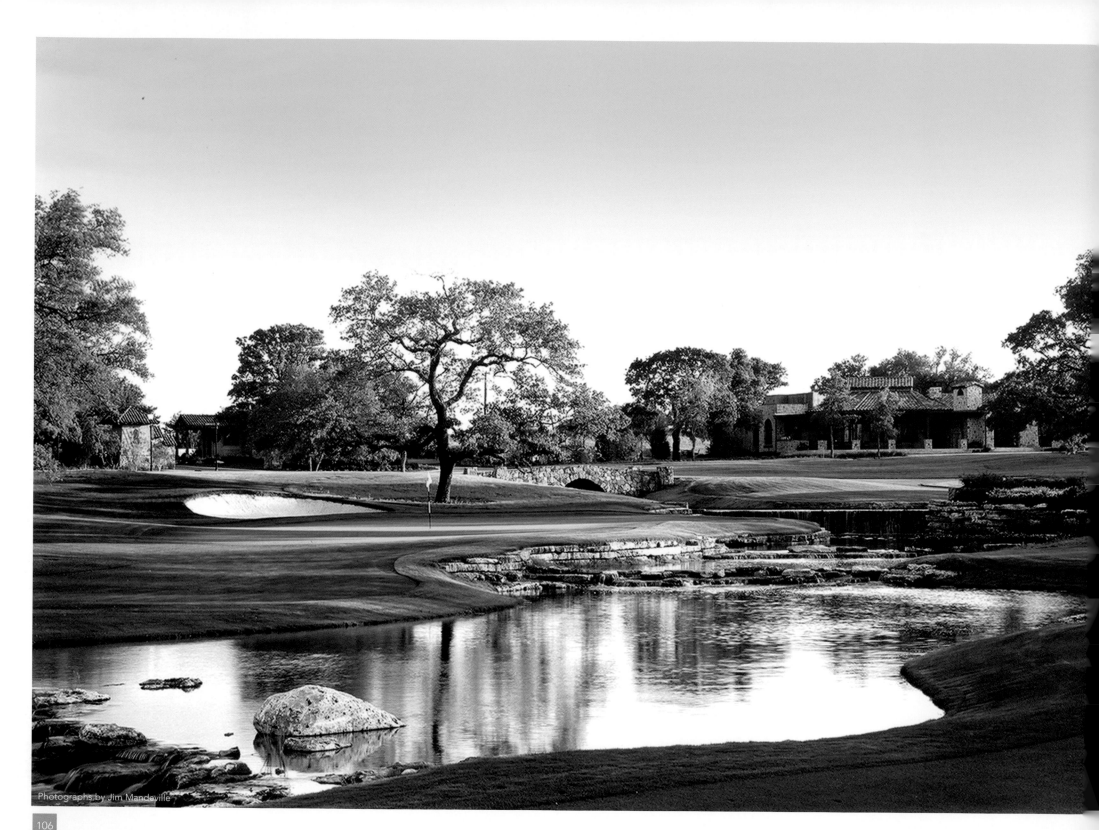

CIMARRON
CIMARRON HILLS
GOLF & COUNTRY CLUB
18TH HOLE

439 yards • par 4

Georgetown, TX 512•763•1800 www.cimarronhills.com

One of the best known holes in Texas involves Jack Nicklaus and a spectacular water hazard.

Now there is another that brings together the same combination.

The seventh at the Hills Country Club near Austin, with its magnificent waterfall, is perhaps the most recognized hole in the state.

The finishing hole at the Nicklaus-designed Cimarron Hills Golf and Country Club brings water into play around the green and the hazard accomplishes the mission that any man-made golfing feature should. It looks like it has always been there.

Number 18 at Cimarron Hills begins with a tee shot that must carry over a small, ground-level stream and then find a landing spot out among the oaks.

The hole doglegs to the left with trees encroaching on both sides of the fairway bend and another group of strategically located oaks lies in wait just through the dogleg. A sizeable

tee shot is needed to reach the point at which the fairway makes it turn, but if the ball goes bounding through the fairway, the second shot could easily be blocked.

And the second shot needs to be wide open because of the dangers that are waiting around the green.

Just to the right of the long, narrow green is a large tree with spreading limbs and just past that is a bunker. To the left is the water in the form of a pond that trickles through layers of rocks and then, just beyond the green, falls over a rock ledge that forms a small-scale waterfall.

As is often the case on a Nicklaus course, little expense has been spared to make an already remarkable example of nature even more-so.

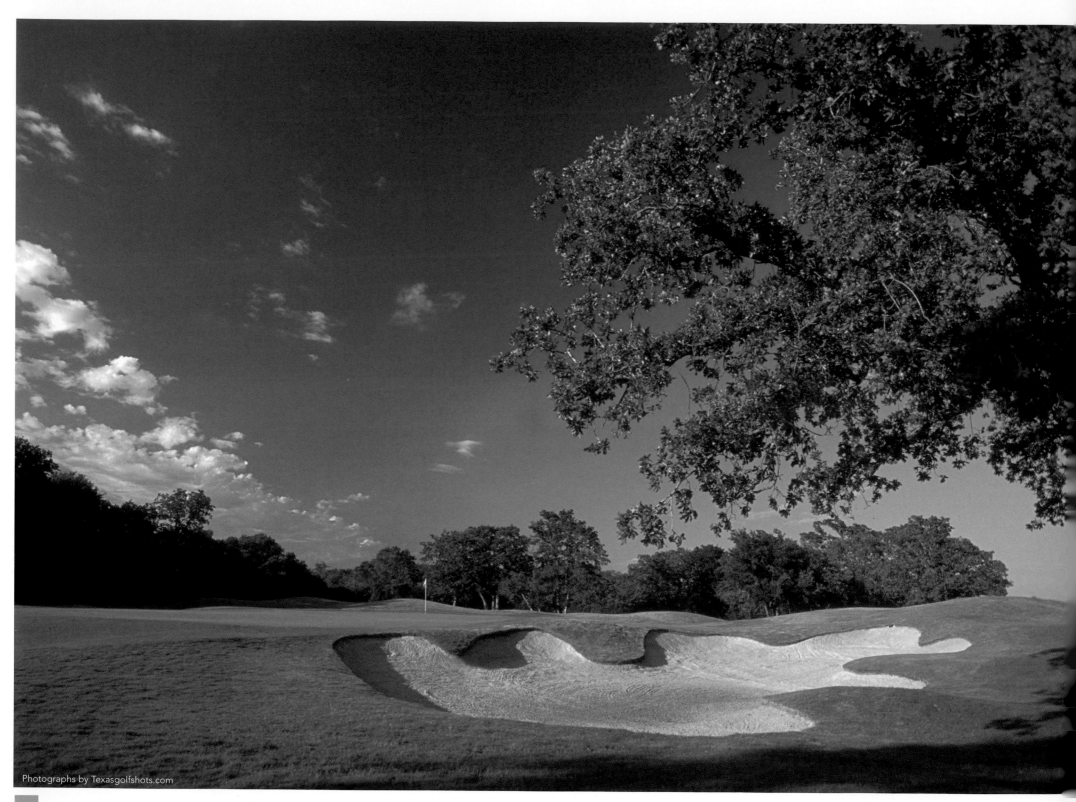

CIRCLE C
THE GOLF CLUB AT CIRCLE C
5TH HOLE

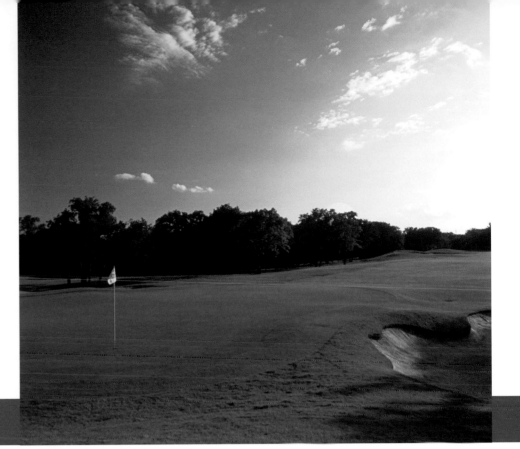

380 yards • par 4

Austin, TX 512•288•4297 www.thegolfclubatcirclec.com

Conservation and beautification are major elements in the Austin lifestyle, especially in the southern part of the city.

It is there that one is made aware of the Edwards Aquifer, the underground water system that eventually runs into the Colorado River. And it is also there one can find the Lady Bird Johnson Wildflower Center, where beautiful things grow and are nurtured.

Just around the corner from the wildflower center and right on top of the aquifer is the The Golf Club at Circle C — a bastion of peace and quiet amid much hustle and bustle.

The course, designed by Jay Morrish and once used as a stop on the Canadian PGA TOUR, twists its way through a forest of native vegetation.

For the most part, the trees are far enough removed from the fairways to give the straight hitter plenty of room. But woe to those who hit it sideways because just finding the ball will be a challenge, much less getting it back to safety.

There is not all that much driving room, however, at the par-4 fifth, where the long hitter can try to bite off a little extra yardage but where accuracy is paramount.

It is not a long hole and the tee shot is everything.

The fifth at Circle C makes a turn to the left and there are two bunkers at the corner of the dogleg — a big one and a little one. Another bunker has been placed on the outside of the dogleg.

The safe play is a fairway wood or a long iron to find the smallish landing area. But those who can carry the ball about 280 yards with right-to-left action, can get past all the sand.

If that sort of shot is pulled off, the second will be of less than 100 yards. But because only a wedge or 9-iron is left even with a safe tee ball, the idea of taking a gamble on this hole is probably not all that wise.

The green has a bunker on either side and is not all that taxing, except for the back-right pin placement. A hump in that portion of the green can make a long first putt tough to figure.

But it is easy to figure that Circle C is located in a special region of the state — one dedicated to protecting and enjoying the environment.

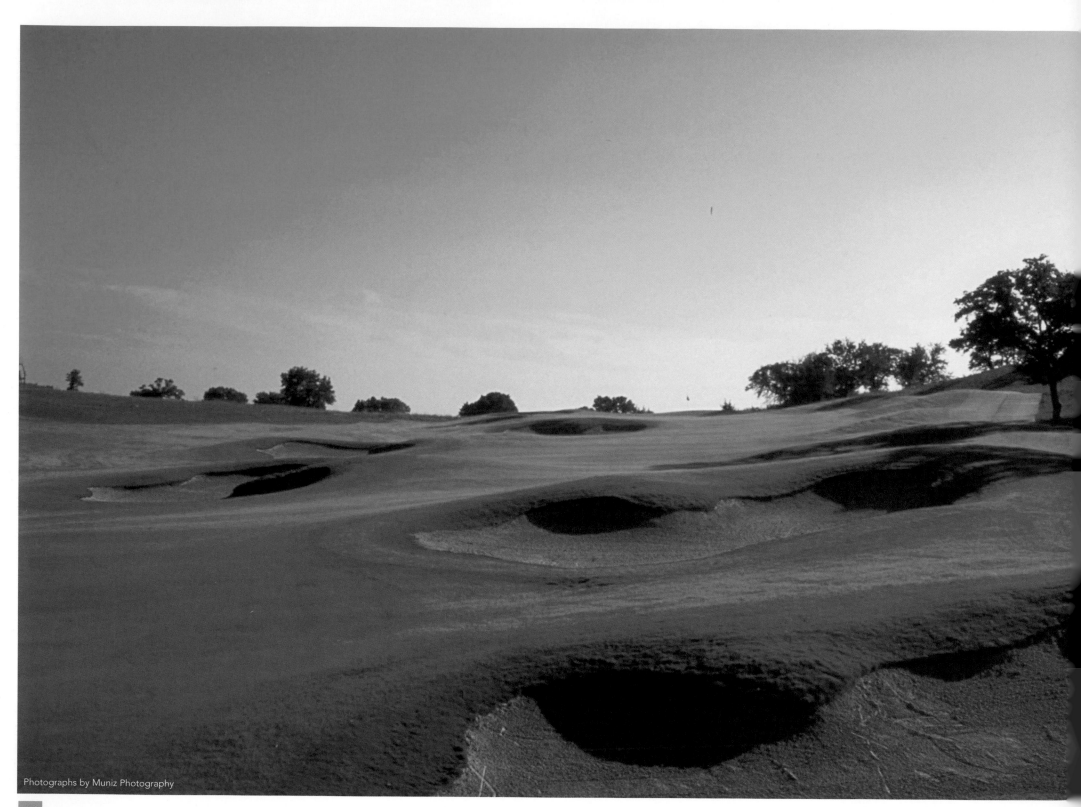

COMANCHE

COMANCHE TRACE
9TH HOLE

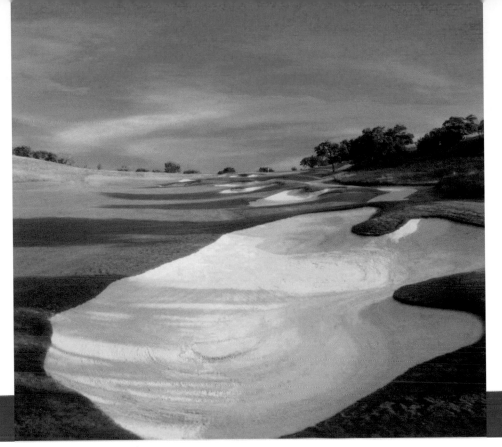

448 yards • par 4

Kerrville, TX 877•467•6282 www.comanchetrace.com

There is something about playing a long, downhill, par-4 that fills a player with confidence. A properly hit tee shot, after all, will carry and carry and then roll and roll.

Standing on the tee of a decidedly uphill, par-4, however, can bring about a feeling of dread.

The urge to overswing creeps into the psyche, often ending one's bid for a par as soon as it begins.

The ninth at Comanche Trace is just such a hole. It is not as if the player is going to have to climb Mt. Everest. But the ground moves steadily uphill from the very front of the tee box to the very back of the 126-foot deep green.

Texas native and U.S. Open champion Tom Kite had a major hand in designing the course, which takes full advantage of the natural wonders that are synonymous with the Hill Country.

The ninth is one of Kite's most challenging offerings.

Because of a series of bunkers that meander up the right side, cross into the fairway and run right up to the green, the hole is known as, "the string of pearls."

Two thoughts enter the mind on the tee. The bunkers must be avoided and the ball must be struck solidly because no matter what the yardage says on the scorecard, the hole is going to play a lot longer than advertised.

Even the prevailing wind works against the player on the uphill trek.

If the tee shot comes up shorter than had been hoped, the bunkers in the middle of the fairway become a factor. A player unable to reach the green in two then must place the second shot to the right of those bunkers to set up a relatively easy pitch.

Because the green is so massive, the work is often just beginning once the putting surface is reached. A 30-footer, be it uphill or downhill, is an instant invitation for a three-putt.

Upon finally holing out, a look back down the hill provides a full appreciation of the completed chore.

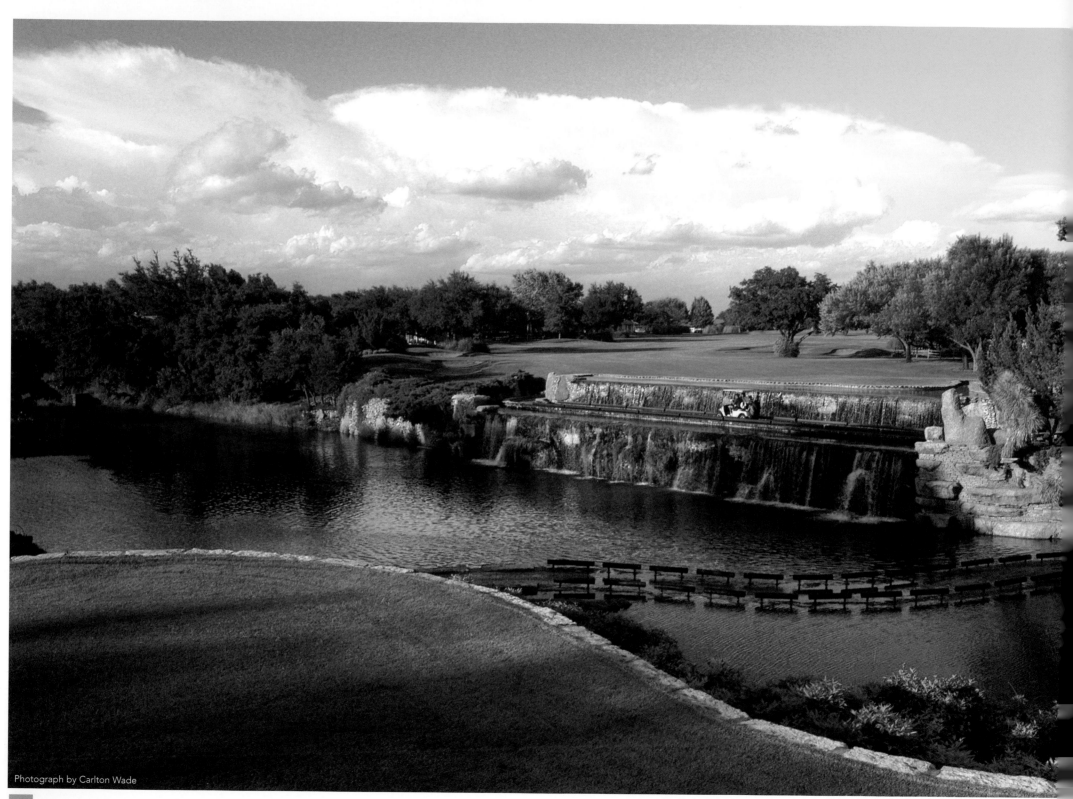

Photograph by Carlton Wade

HORSESHOE BAY RESORT
slick rock course • 14TH HOLE

361 yards • par 4

Horseshoe Bay, TX 830•598•2511 www.hsbresort.com

Of the three courses at Horseshoe Bay, all designed by the legendary Robert Trent Jones, Sr., Slick Rock is the oldest.

It is a product of Jones at his best with 71 bunkers plus water in play on 12 holes. Each of the three courses uses a distinctive horticultural method of creating yardage markers and those at Slick Rock are Hollywood junipers mixed with purple sage.

The front nine plays through a large variety of trees, including oak, cedar, pines and even cork. The back nine is much more open, but is no less hazardous.

As one steps to the tee at the short, par-4 14th, one of those hazards dominates the scene — a man-made work of art that is simultaneously beautiful and terrifying.

It is a wide, spectacular and very expensive multi-level waterfall that cascades from fairway level to the pool below. From the back tee, the ball must stay in the air for close to 180 yards to find the fairway and even though the shot is slightly downhill, it still provides the sort of visual intimidation that plays on the golfer's mind.

Bunkers both right and left guard the fairway and another bunker is on the outside corner of the dogleg of a hole that makes a slight turn to the right. Trees frame the hole on both sides, but if a player has enough ability to successfully negotiate the waterfall, the trees should not pose much of a problem.

Once over the water, a short-iron is all that is left. But it needs to be a precise one.

The green is wide, but fairly shallow and is protected both in front and behind by bunkers. A shot with loft and spin, therefore, is needed to land between the bunkers and stay there.

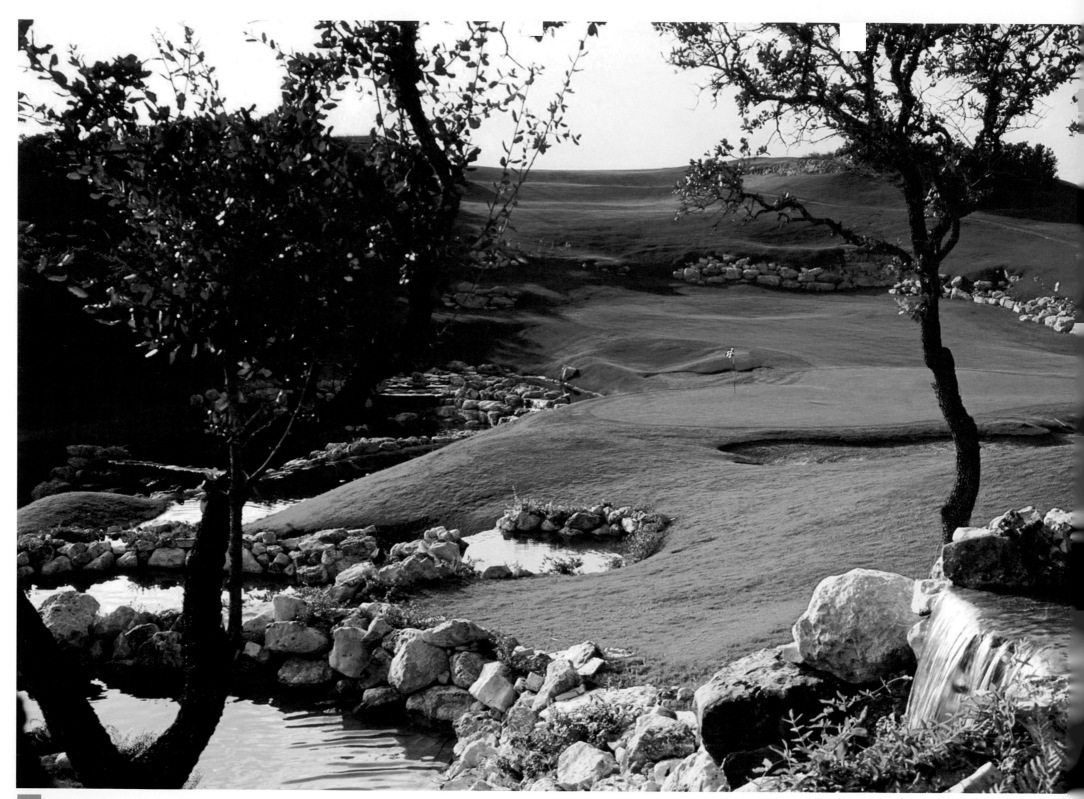

LA CANTERA RESORT

the resort course • 18TH HOLE

426 yards • par 4

San Antonio, TX 800•446•5387 www.westinlacantera.com

Of the three lowest 72-hole scores in the history of the PGA TOUR, two have been produced in San Antonio.

Mike Souchak won the 1955 Texas Open at San Antonio's Brackenridge Park with a score of 257. It stood as the PGA TOUR record for 46 years, until Mark Calcavecchia fired a 256 at the Phoenix Open.

Just two years later, the record returned to San Antonio.

The La Cantera Resort Course is a fun layout from the Tom Weiskopf-Jay Morrish partnership and it provides the typical hill country challenges for the average player. It has also served as a canvas on which the PGA TOUR players have been able to demonstrate just now good they can be.

The Texas Open moved to La Cantera in 1995, much to the delight of Duffy Waldorf and Justin Leonard. Both have recorded two wins on the course. Hal Sutton has been a winner at La Cantera and so has Loren Roberts, who edged Fred Couples by a single shot in 2002.

And then Tommy Armour III had his big week. He won the 2003 tournament with a PGA TOUR record score of 254, a whopping seven shots in front of his nearest challenger.

Armour birdied the final three holes of the third round to take a six-shot lead and the last of those birdies came on a 426-yard hole that requires accuracy off the tee and proper club selection for the second shot.

It is a straightaway hole with Keeter Creek guarding the right side of the fairway.

Bunkers on either side squeeze the landing area and Armour put his tee shot into the left-hand trap in the final round the year he won.

The second shot is uphill and plays at least one club longer than the yardage indicates. There is also a complex of bunkers to the right of the multi-tiered green.

The 18th at La Cantera is certainly not an easy hole and, in fact, Armour bogeyed it on the closing day of the 2003 Texas Open. That bogey, however, did not keep him from winning the tournament or entering the PGA TOUR record book.

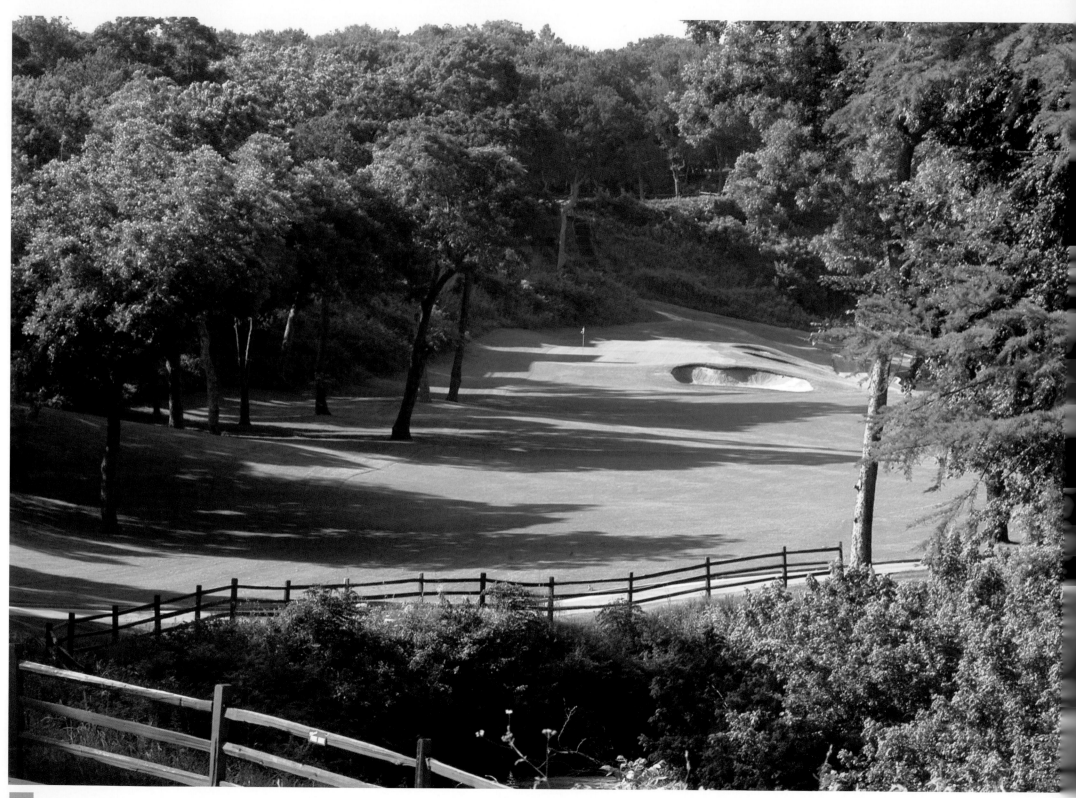

ONION CREEK

ONION CREEK CLUB
12TH HOLE

342 yards • par 4

Austin, TX 512•282•2162 www.onioncreekclub.com

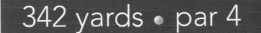

*J*ust a few miles south of the bustle of downtown Austin can be found one of the more historic spots in American golf. Designed by Jimmy Demaret, Onion Creek Club is known nationally as the founding site of the Senior Tour.

In 1978, players the golfing public had not seen for years showed up for a spring time golf event. In only the second year of the tournament, golf fans were treated to a seven-hole playoff with Julius Boros and Roberto de Vicenzo outlasting Art Wall and Tommy Bolt. The high quality golf played by the over 50 set captured the imagination of a national television audience and PGA Tour officials took notice. Soon there were more senior tournaments, and, eventually, a full-fledged tour that still thrives today.

One of the holes on which the playoff took place was the 12th. Accuracy does take a premium over length on this fine par-4. Anything hit to the right has a tendency to bound into the creek which covers the entire length of the hole. Shots to the left typically get hung up on the hillside amongst the pecans, vines, and greenery. The green sits tucked close to the hill with the short grass on the putting surface all but blending in with the thick, forest-like growth on hillside. Bunkers do protect the right side, both front and back, and a pushed second shot had best find one of those bunkers or it will roll down a slope toward Onion Creek itself.

It seems as if the hole is a golf course all by itself, carved out of a wilderness with no other fairways or greens nearby. But far from being isolated, it was very much the center of attention when the world of senior golf debuted back in 1978.

RIVERHILL COUNTRY CLUB
7TH HOLE

442 yards • par 4

Kerrville, TX 830•896•1400 www.riverhillcc.com

Byron Nelson, who competed against Walter Hagen and Bobby Jones, eventually became golf's elder statesman and lent his name to a tournament that raises more money for charity than any other, enjoyed a personal milestone at the Riverhill Country Club.

First of all, he consulted with Joe Finger in creating the course, which travels through gnarly oak trees and has a more manicured look than most Hill Country layouts.

And then, when he was 71, Nelson went out and turned in a score lower than his age. It is a feat accomplished by a comparative few.

"Riverhill is the first course that I shot under my age, which was 71 at the time," Nelson said. "I think it is still today one of the finest courses in Texas."

One of the course's most severe challenges comes at the par-4 seventh, which makes a slight right hand turn through the trees.

The trees, in fact, are the main hazard on the hole. There is no big water feature and no forced carry. But the gently rolling fairway skirts a number of trees that are positioned quite near the ideal ball flight.

The tee shot actually must travel through something of a funnel.

Another of those strategically placed trees can be found a little short and right of the green. It can come into play, as can a bunker that has two large sections and is located short and left of the putting surface.

There is a lot of undulation on the greens at Riverhill and the one at the seventh has a ridge running through it. Behind the ridge, the back half of the green falls away.

Throughout the course, long putts face more than one break. That was something Nelson figured out, however, when he first shot his age.

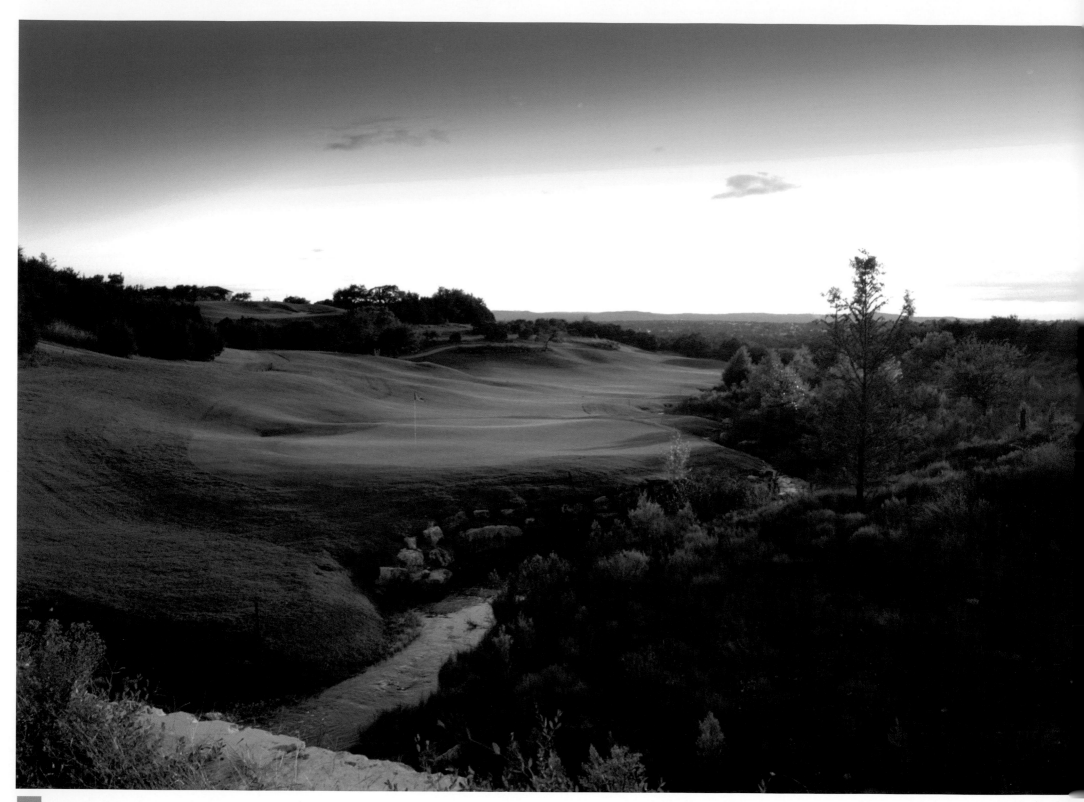

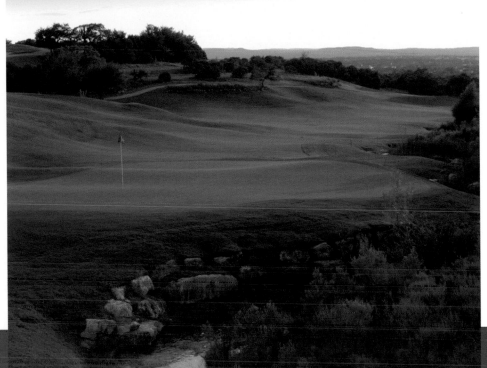

UT GOLF CLUB
THE UNIVERSITY OF TEXAS
GOLF CLUB
7TH HOLE

431 yards • par 4

Austin, TX 512•266•6464 www.utgolfclub.com

The University of Texas Golf Club celebrates all things Longhorns while providing a stern challenge set in the type of breathtaking scenery typically found in the area around Austin.

Each hole memorializes some portion of the school's rich golf history. The careers of Tom Kite, Ben Crenshaw, Justin Leonard, Betsy Rawls and legendary teaching professional Harvey Penick, among others, are summarized on plaques at various holes.

It also should come as little surprise that the back tee markers are painted in the color that bedecks all those who compete in the name of the university — a bright burnt orange.

The dogleg left seventh hole provides classic design concepts. The closer one skirts the trouble off the tee, the easier the rest of the hole becomes.

Not that any part of the hole is truly easy.

The tee shot is a forced carry over a small pond, which then gives way to a creek that runs down the entire left side of the fairway.

At the outside corner of the dogleg sits a bunker that serves as a reference point for the tee shot. The ideal line off the tee is just to the right of that bunker, where there is a generous landing area.

That keeps the player away from the stream and its accompanying hazard, which easily captures a hooked tee ball.

The obvious problem is that the further one plays away from the water, the longer the second shot becomes.

The water trickles right up to the left edge of the green. Any second shot missed to the left will finish wet. A slope to the right of the green does create the chance that a ball hit to that side might bounce onto the surface.

Finding the right section of the two-tiered green is also a key. A putt from the back tier down to the front requires just the correct amount of weight.

It is a hole to challenge even the greatest of the Longhorns' golfing alumni.

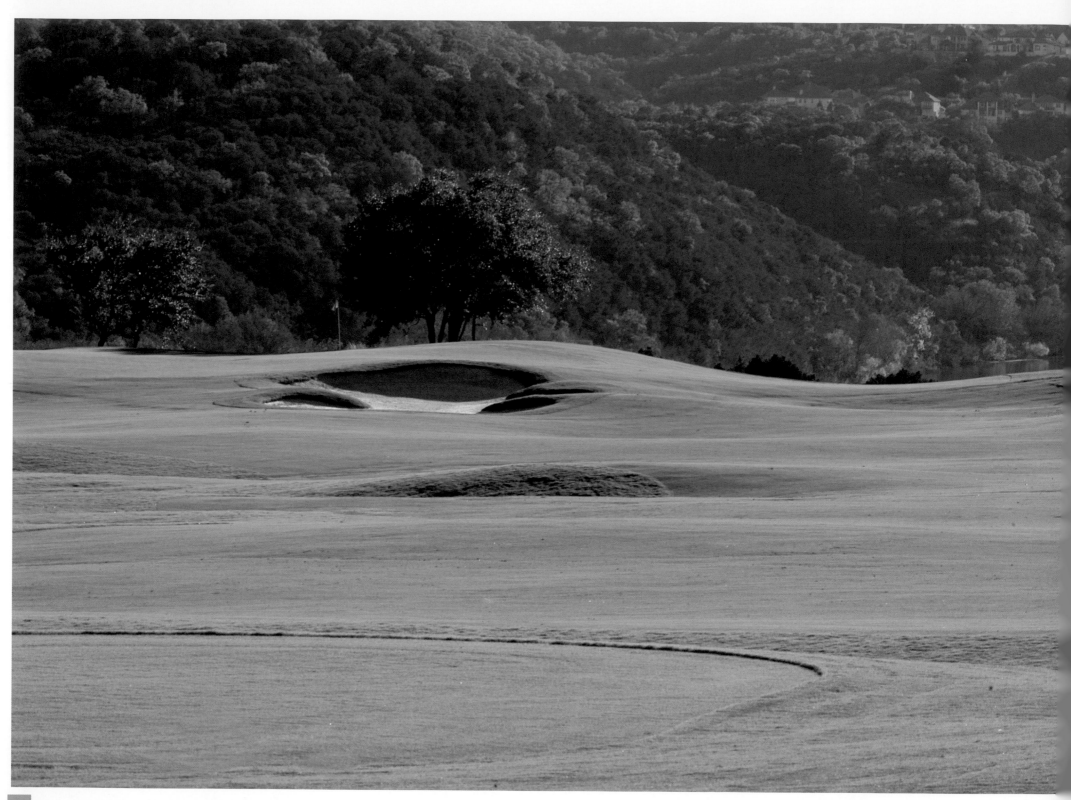

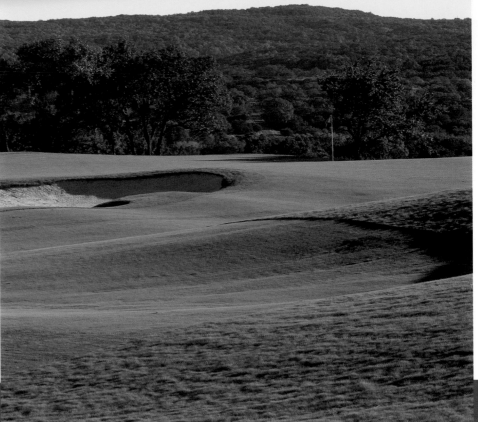

THE UNIVERSITY OF TEXAS
GOLF CLUB
15TH HOLE

437 yards • par 4

Austin, TX 512•266•6464 www.utgolfclub.com

The 15th at the University of Texas Golf Club provides an excellent example of why people want to play golf.

It is a game that takes the player to places where, at any moment, he or she is apt to stumble onto a memorable view.

From the tee at the 15th, such a view is available. Never mind the wild-looking hazard down the left side of the hole. Never mind the bunker off in the distance that is going to have to eventually be negotiated.

What captures the eye is Lake Austin and the Balcones Canyon Land Preserve, both of which spread out beyond the green. Wildlife of many types call the preserve home, including a flock of turkeys.

The four-legged creatures seldom stroll onto the field of play, however, which is fortunate since there are plenty of other problems to work around.

The hole flows gently downhill with the chief thought on the tee being that one must avoid the hazard on the left. There is a drop-off filled with bushes, trees and natural grasses. It is a wasteland from which there is no redemption and the fairway slopes in that direction as well.

A tee shot that favors the right side, therefore, is ideal. But even there, the player must be aware of a large live oak just off the fairway that can easily come into play.

There is only one bunker on the hole, but it is a dandy. The large trap eats into the very front of the green.

Avoiding the bunker to the left might result in another trip to the same forbidding hazard that had to be avoided off the tee.

"Our members spend a lot of time in that bunker," said Jean-Paul Hebert, an assistant professional at the UT Golf Club and the son of 1960 PGA Championship winner Jay Hebert. "The 15th is not the longest hole, but it requires two accurate shots."

And for those whose shots are not all that accurate, the scenery more than makes up for it.

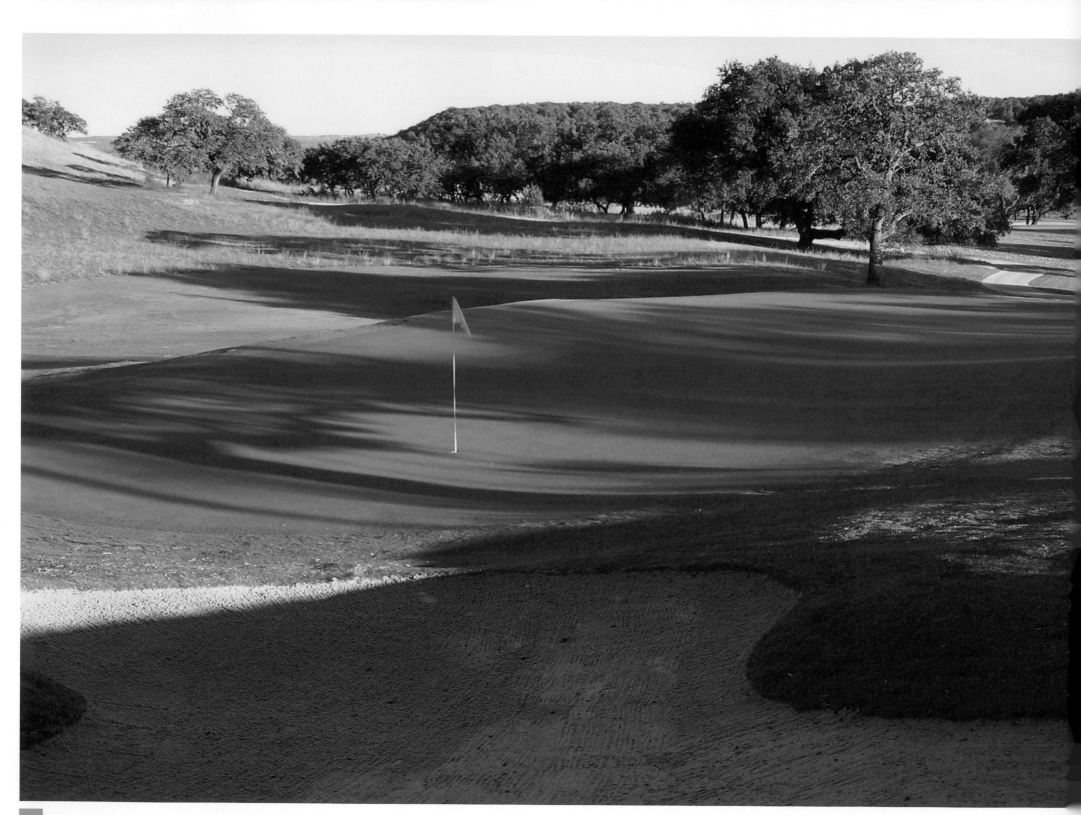

BOOT RANCH

BOOT RANCH GOLF CLUB
2ND HOLE

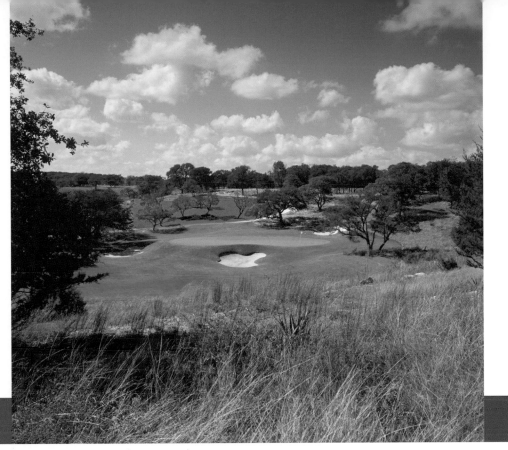

175 yards • par 3

Fredericksburg, TX 830•997•6200 www.bootranch.com

*H*al Sutton, despite being a lifelong resident of Louisiana, has always been a cowboy boot kind of person.

So is it totally appropriate that the major championship winner and Ryder Cup captain brought his expertise to bear in creating a course about as deep in the Hill Country as one can get. And it is also appropriate that it be called Boot Ranch.

Many of the tees are placed on elevated sections of the landscape in an attempt to leave no view unseen. And those views are typical of the region — each one just as memorable as the next.

It does not take long to come upon one of those scenes.

The tee shot at the par-3 second is struck from a lofty spot to a target well below. There is a huge dropoff in front of the tee and then the land slopes upward to the green, which is still a lot lower than the tee.

The cart ride from the tee to the green, therefore, resembles something of a trip on a roller coaster and caution should be taken to avoid a road mishap. After all, it is still very early in the round and it would be a shame to miss the rest of it.

The green is very wide but also shallow, shaped something like a boomerang. There is a small bunker over the green and a good-sized one to the left.

But in the slope heading up to the green there is a bunker that gets a lot of action. Landing in that bunker could be a blessing, however, because shots coming up short that do not find the sand could roll back down into an unpleasant area.

The second at Boot Ranch is fairly short and the downhill nature of the shot makes it play even shorter. No matter the distance, it provides an excellent example of things to come.

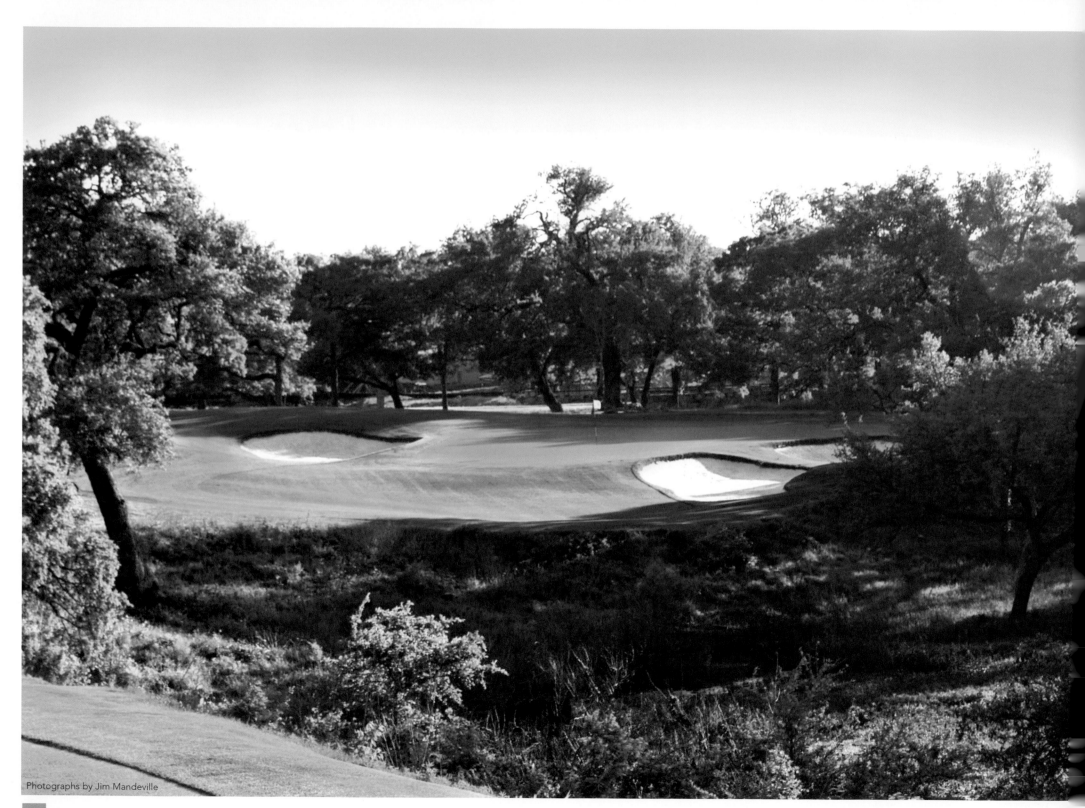

CIMARRON

CIMARRON HILLS
GOLF & COUNTRY CLUB
12TH HOLE

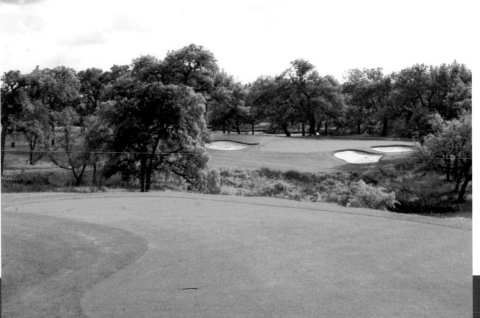

168 yards • par 3

Georgetown, TX 512•763•1800 www.cimarronhills.com

*G*ive Jack Nicklaus a first-class piece of property and the certain result will be a first-class golf course.

And since first-class property is to be found all around the Hill Country, there are a lot of places where Nicklaus might have created one of his many masterpieces.

The wooded, rocky stretch of ground along the San Gabriel River west of Georgetown fit the bill and his Cimarron Hills Golf and Country Club course fits right into his portfolio.

From the Bear tees (as opposed to the Outlaw, Cimarron, Legend or Rose tees), it measures 7,302 yards. That should make the par-3 12th, at 168 yards, something of a pushover. Naturally, it is not.

The hole plays over a grass and tree-infested ravine that makes a sharp turn directly in front of the tee box. At the bottom of the ravine is to be found the Middle Fork of the San Gabriel.

Trees encircle the kidney-shaped green, which is oversized. An extension of the putting surface runs around and behind two bunkers on the right side. Another trap is found on the left. When the pin is placed on the back-right portion of the green, behind the two bunkers, the quality needed on the tee shot suddenly escalates.

For those of a certain age, the 12th at Cimarron brings to mind a hole that no longer exists.

A flood control project in Fort Worth during the 1960s forced changes to some holes at the renowned Colonial Country Club. The par-3 13th was one of the holes that had to be altered and it now bears no resemblance to the wild looking test of golf it was before.

For those who might want to appreciate what Colonial's old 13th looked like, the 12th at Cimarron comes very close.

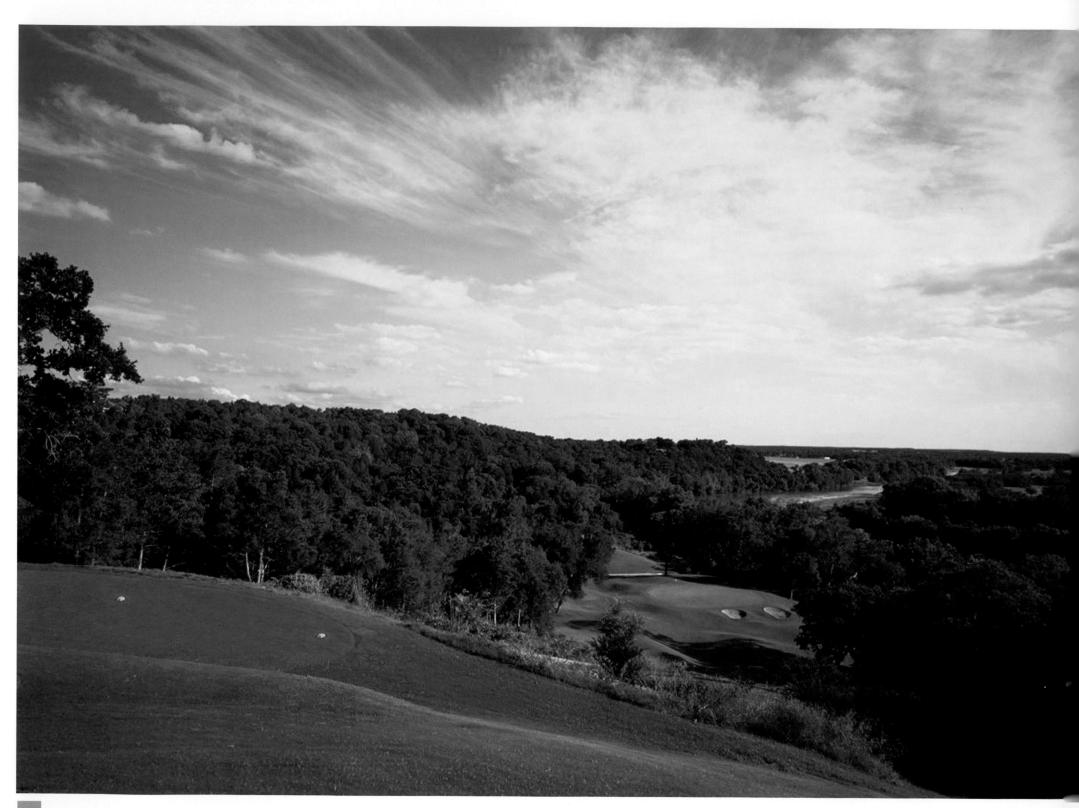

COLOVISTA

COLOVISTA COUNTRY CLUB & RESORT
15ᵗʰ HOLE

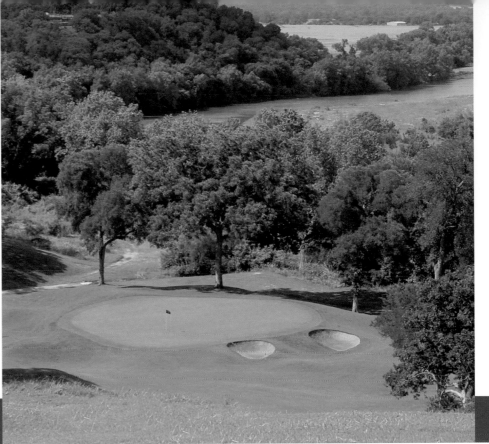

191 yards • par 3

Bastrop, TX 512•303•4045 www.colovista.com

*E*very true golfer has said it at one time or another, "you could put a great golf hole here."

One of those truly rare pieces of land can be found just outside of Bastrop, Texas. ColoVista's signature par-3 looks as if it has been imported from the Colorado Rockies, with views as far as the eye can see and the Colorado River flowing through the beautiful valley below.

Les Appelt, owner and developer, looking at a topographical map saw it as the highest point in the area. He originally thought of putting a practice hole here for personal use and the idea blossomed into the extraordinary golf course ColoVista has become today. ColoVista offers a Texas Style Links layout on the front nine and a Classic Hill Country design on the back nine.

After the brief ascent up the beautiful dog-leg left 14th hole awaits the glorious views of the Signature 15th hole. The two bunkers front right of the green give the hole balance as well as deal punishment to the many golfers that unintentionally find themselves hitting their second shot from them.

A final reminder for playing this outstanding golf hole: play about two clubs less than the score card yardage. Experienced golfers will heed this advice for such extreme downhill shots, but at the same time, remember to play the wind that continuously comes into play on such a dramatic golf shot.

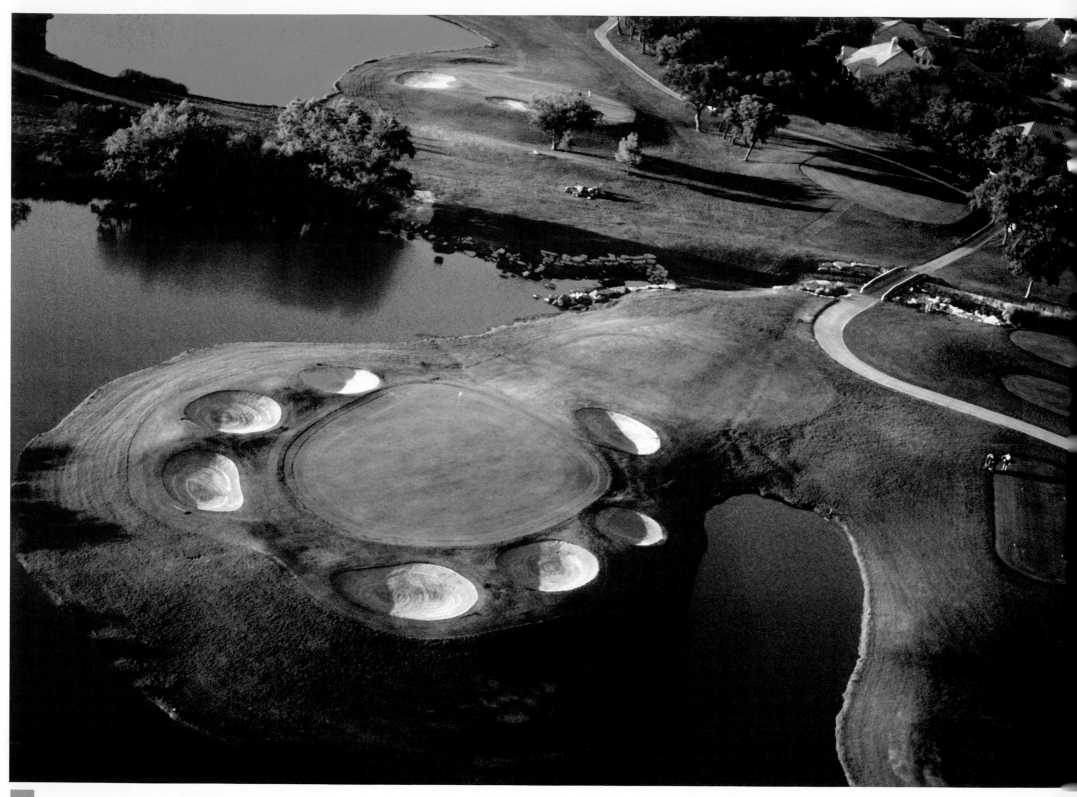

THE DOMINION COUNTRY CLUB
5TH HOLE

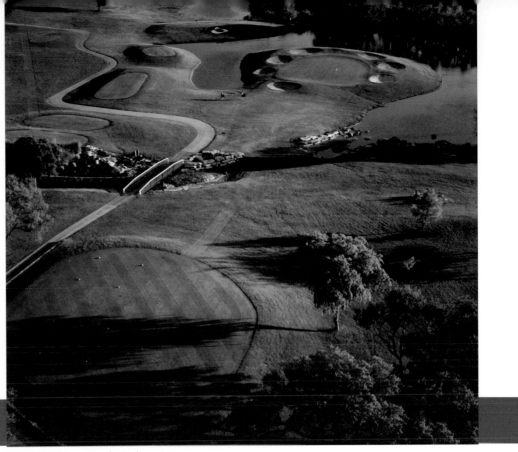

214 yards • par 3

San Antonio, TX 210•698•3364 www.the-dominion.com

For the better part of two decades, the best senior players in the world appeared at The Dominion and they invariably found a good challenge.

Throw in a little adverse weather and par suddenly became a very good score on this course.

At a tournament which was originally known as The Dominion Seniors, J.C. Snead was the winner with a total of just 2-under-par in 1993. Don January captured the first event contested on the course in 1985 and Lee Trevino won two in a row, the first coming in 1991.

One of their more difficult assignments was the par-3 fifth. There is no out of bounds to be found on the hole. Leon Creek is not far away, but there is no water at the fifth. There is, however, lots and lots of sand.

The hole is set amidst a grove of trees and has the look of an ideal picnic spot. It does not strike fear. There will not be a lot of double bogeys run up. It simply calls for a quality shot.

A tree sits just to the left and in front of the tee, acting as a reminder that a dramatically pulled shot is not a good idea. And four bunkers form a semicircle well short of the green — traps that will catch only the poorest of shots.

The green, however, is surrounded by four more bunkers and they are very much in play. They sort of rise up out of the ground with the green nestled down amongst the sandy sentinels.

Local players suggest that whatever tee is used, one more club than usual should be pulled from the bag. That was a lesson the seniors learned during their visits to a course that provided a thorough examination of their game.

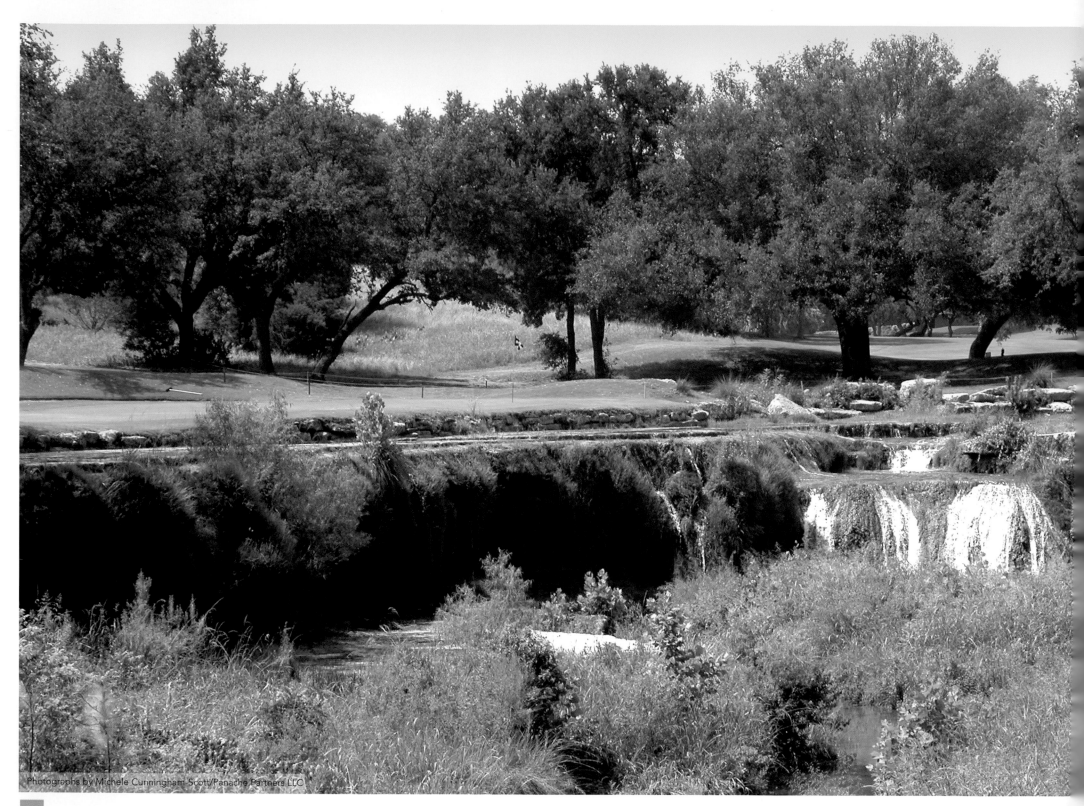

THE HILLS COUNTRY CLUB
the hills • 7TH HOLE

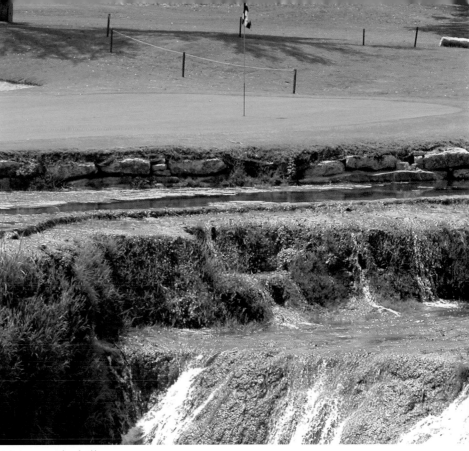

204 yards • par 3

Austin, TX 512•261•7200 www.thehillscc.com

The first golf course Jack Nicklaus built in the region was, as it turned out, a landmark achievement.

Since the day The Hills was opened, it has been the benchmark for Hill Country designs. It was also a magnet for those who wanted to play golf in an out-of-the-way setting.

Dallas Cowboys coach Tom Landry even built a house on the property as his home away from home.

The city of Austin has grown out to meet The Hills and spectacular courses now dot the landscape all around the area. But Nicklaus' original Hill Country test remains a major attraction and eventually became host to a PGA Champions Tour event.

The seventh hole at The Hills demonstrated to other architects what could be done with the combination of the area's dynamic landscape, a fertile imagination and a big bankroll.

In a way, it opened the door to the visually remarkable holes that have been created on similar land in the Austin and San Antonio areas.

The tee shot carries over Hurst Creek to a green that has been placed atop one of the most photographed golfing scenes in the state.

Just in front of the green is a limestone ledge that crosses the entire face of the target. A profusion of moss hangs down from the ledge and water also falls from the rock into a pool down in the creek bed.

The magnificence of the scene can easily distract, which is a danger because club selection is all important. The more to the right the hole is cut, the greater the distance it is from the tee.

One bunker is placed behind the green as both framing devices and honest-to-goodness hazards. A ball that must be struck from one of those traps carries the potential of tumbling off the front of the green and into what has become the granddaddy of picturesque Hill Country hazards. This hole played as the 16th hole (with 9s reversed) during the Fedex Kinko's Champions Tour Event has proven to be pivotal in determining each year's champion.

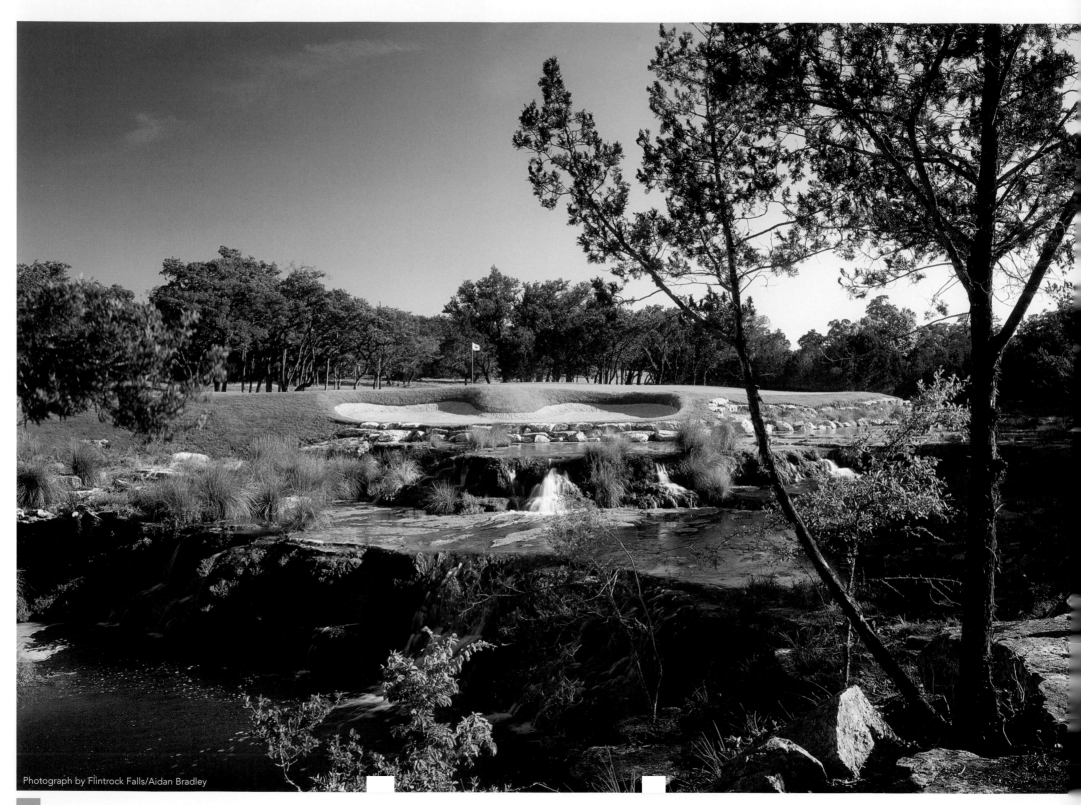

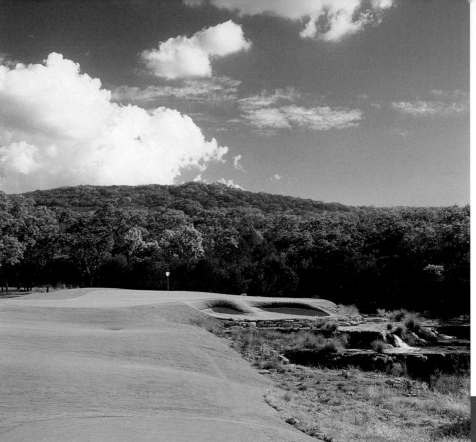

THE HILLS COUNTRY CLUB
flintrock falls • 2ND HOLE

173 yards • par 3

Austin, TX 512•261•7200 www.thehillscc.com

The multitude of magnificent hazards on par-3 holes around Texas usually have something in common.

In order for the player to reach the green, the tee shot must carry over the hazard — be it a stream, pond, rock-filled creekbed or some other maddening menace.

At the second hole on The Hills Country Club's Flintrock Falls Course, that is not the case.

There is, indeed, a very classy looking hazard at the second — one that fits right in with the Jack Nicklaus school of architecture. And a bad tee shot will find it.

But it is entirely possible to stay left of the rocks, water and sand that dominate the view from the tee and still reach the green.

The Flintrock Falls Course has been added to the original Nicklaus-designed Hills Country Club layout and the golfing superstar was joined in the design work by his eldest son — Jack Nicklaus II.

At the second, they have created a hole that if not unique is certainly unusual.

Just in front of the tee is a sort of miniature ravine that should not be a concern and encroaching from the left side are some live oak trees.

The striking things about the hole, however, are the ribbon of fairway stretching all the way to the green and the forbidding area to the right of the fairway that contains the eye-catching trouble.

It is possible, therefore, to hit a low, screaming shot and, if it travels in a straight line, see it run up on the putting surface — or at least the left half of it.

Any shot to the right, though, will likely wind up in tall grass or in the midst of the hazard that contains rock ledges, a waterfall and a bunch of wild grass. It is actually possible to clear all of that and still find the quite large bunker that sits between the hazard and the right-front corner of the green.

The attractive design feature at the second automatically draws comparisons with the fabulous seventh hole on the original course at The Hills.

But that combination of rocks and water must be carried from the tee. The one at Flintrock Falls can, as long as the tee shot is straight and true, be simply admired as the player passes by.

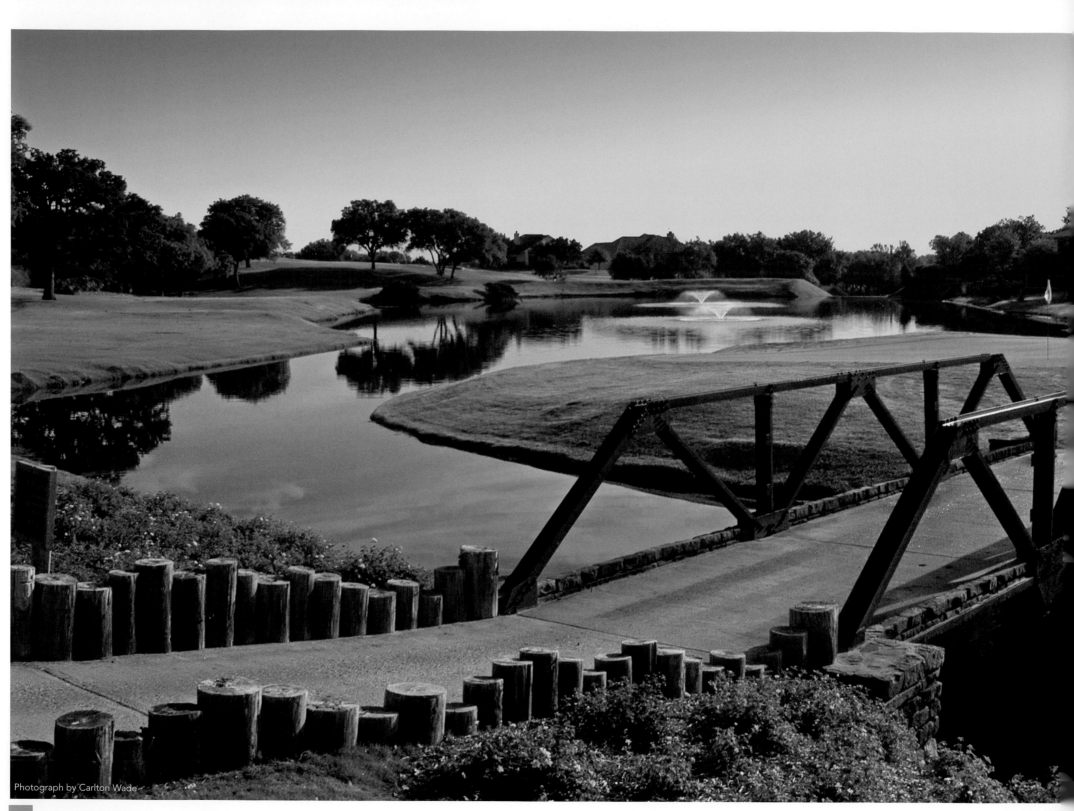

Photograph by Carlton Wade

HORSESHOE BAY RESORT

ram rock course • 4TH HOLE

191 yards • par 3

Horseshoe Bay, TX 830•598•2511 www.hsbresort.com

Ram Rock, the most challenging of the courses at Horseshoe Bay Resort, takes the player over and around either streams, lakes or dry creek beds on almost every hole.

The bunkers, of which there are 62, are deep. And the fairways are narrow. Although it is on the grounds of a resort, it is a significant test even for the professionals.

A testimony to that can be found at the par-3 fourth, where we find one of those ever-popular island greens.

"The 17th at Sawgrass has nothing on this one," said Horseshoe Bay Director of Golf James Rolls, referring to the hole that is featured every year while The Players Championship is being contested in Florida.

"They flip a little 9-iron into that green. On our hole, you have to hit as much as a 3-iron."

After an ideal tee shot, it is a treat to walk around the water, behind the green and then walk to the putting surface across a replica of a rustic railroad bridge. The walk is not so pleasant after hitting one or two balls into the lake, but the scenery can take some of the sting out of the poor shots.

The prevailing wind is across and slightly into the player and the shot is slightly downhill.

Just over the water is a bunker in front of the green and there is another directly behind. About 15 feet of thickish grass separates the green from the water to provide a little room for the less-than-perfect shot to find a landing spot.

A ridge divides the green into two areas and if the tee shot winds up in the wrong section, a bogey could be in the offing. As they stand on the tee, however, a great many would happily settle for a bogey.

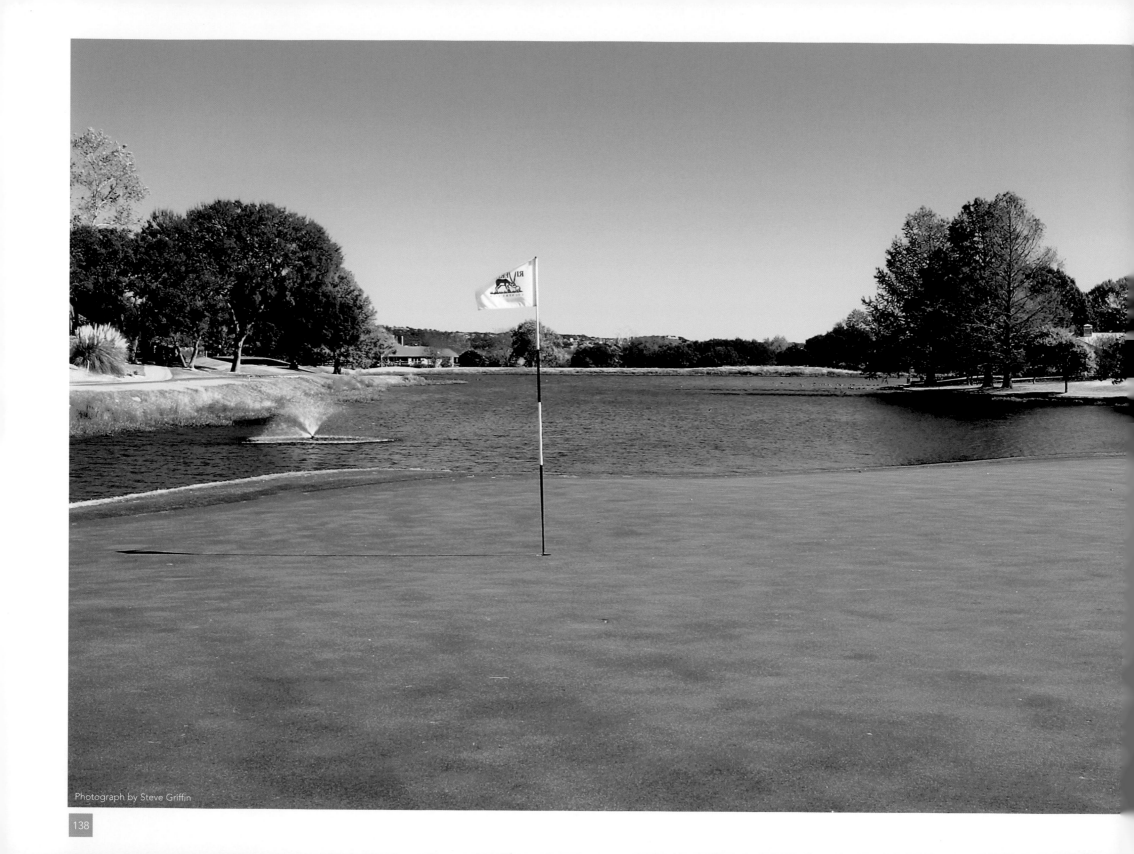

RIVERHILL COUNTRY CLUB
11TH HOLE

177 yards • par 3

Kerville, TX 830•896•1400 www.riverhillcc.com

Two pieces of architecture draw more attention than any others at the Riverhill Country Club and one of them does not even involve golf.

The property on which the course is located was owned in 1899 by Gustav Schreiner and he wanted to build a nice place to live. The result was a grand, three-story structure graced by columns and balconies.

It remains as part of Riverhill's clubhouse and it is the sort of mansion worthy of being on a picture postcard.

And so is Riverhill's 11th hole, a par-3 where the water hazard is created in the best of taste.

Three of the course's four par-3 holes require a carry over water, but the shot to the 11th is by far the most severe.

The hole can be played from as little as 55 yards, a mere pitch over the pond. But from the back tee, with the prevailing wind often blowing hard from left to right, nothing but the best of efforts will do.

Other than the water, the chief feature of the hole is the attractive rock wall separating the green from the water — a wall that is higher in some spots than others. The sickening sound of a ball slamming into the wall and bouncing back into the water is one that is all too familiar.

The green is wide and shallow, as is the case on so many par-3s over water. And directly behind the green, as is again often the case on such a hole, one will find a wide bunker.

The left side of the green is substantially lower than the right, creating the possibility of either dramatically uphill or downhill putt.

If a ball carries past the green and avoids the bunker, it could come to rest near the trunk of one of the trees that nestles nearby.

It is, all in all, an elegant looking hole. But not any more-so than is the century-old homestead that serves as the club's headquarters.

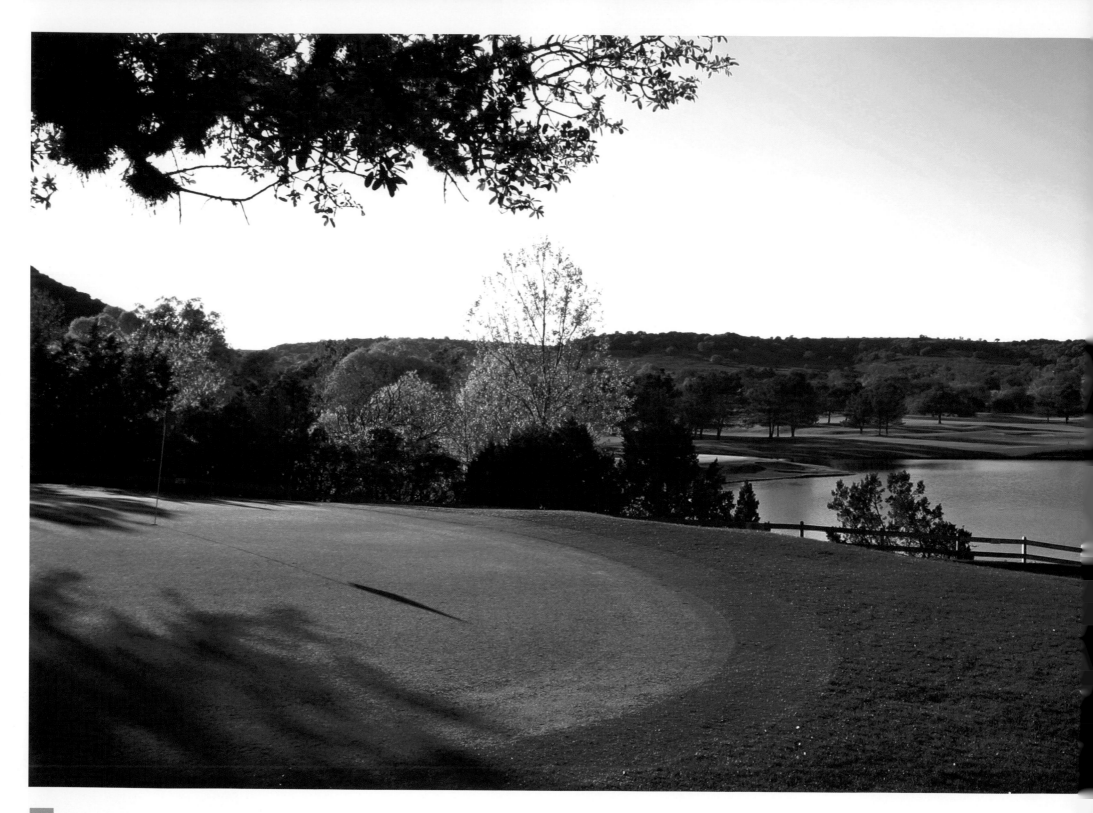

TAPATIO SPRINGS
RESORT & CONFERENCE CENTER
valley course • 2ND HOLE

158 yards • par 3

Boerne, TX 800•999•3299 www.tapatio.com

*T*exas is filled with getaway spots, where it might be possible to do lots of different things or, if the mood strikes, nothing at all.

Tapatio Springs ranks among the best of such places, although the golfers in the crowd would never think of doing nothing at all.

This location literally takes one to the end of the road — a destination that attracts both honeymooners and business people who want a quiet place to make heavyweight decisions.

And all those who head to Tapatio Springs are given one word of caution before embarking on their trip. Watch out for the deer. They can pop up without warning.

The resort's chief feature is its golf course, the original 18 holes of which were built in the shadow of a 160-foot limestone cliff. There are now three nine-hole courses — the Valley, Lakes and Ridge.

Throughout much of the trip around Tapatio Springs, the player has reasonably generous areas in which to drive the ball. But there is a very small landing spot at what was at first the 11th hole and is now the second on the Valley Course.

It is a medium-length par-3 and if the tee shot does not wind up on the green, chances for a par are remote.

From the back tee, the ball must carry over the edge of a pond that has trees growing all along its edge. So the proper elevation as well as the proper length is required.

The water and trees are in play to the right of the green and a round bunker is situated just short of the putting surface. Only slightly left of the direct path to the green are two trees, one a little short of the green and one alongside it. They will easily bat down anything hit in their direction.

And over the green is a hill, from which a difficult chip awaits.

Plenty of adventures await on this and other holes at Tapatio Springs, but no matter how challenging those adventures might be, those addicted to the game would far prefer taking them on instead of settling for peace and quiet.

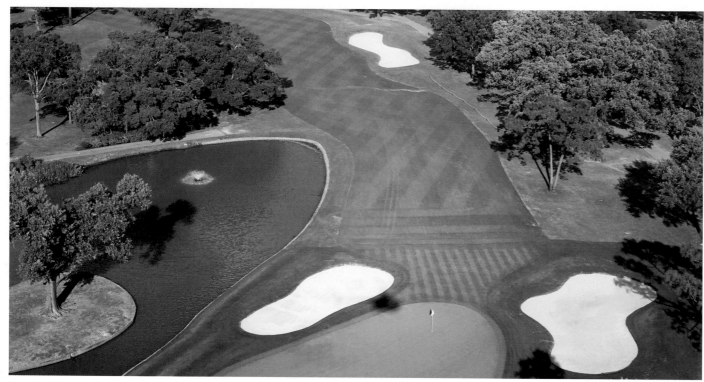

River Oaks Country Club 9th Hole (Photograph by Golf Shots Unlimited)

Golf Shots Unlimited, Inc. has provided the golf industry with world class aerial photography since 1990. They have shot over 9,000 courses worldwide and their images have appeared in numerous magazines including *Golf*, *Golf Digest*, *Avid Golfer*, numerous state golf guides, and *Travel & Leisure*.

You can learn more about their services at www.golfshotsunlimited.com or by calling 303.814.6826.

SOUTH TEXAS

Presented by Golf Shots Unlimited, Inc.

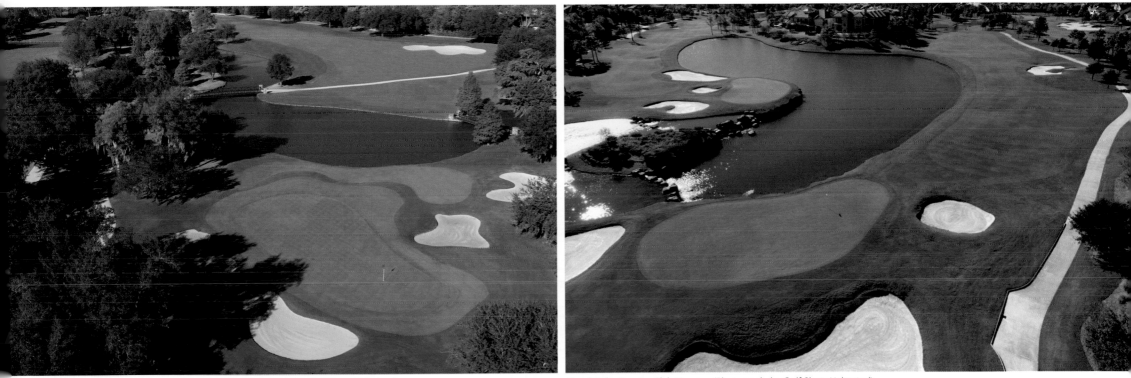

Braeburn Country Club 5th Hole (Photograph by Golf Shots Unlimited)

Royal Oaks Country Club Houston (Photograph by Golf Shots Unlimited)

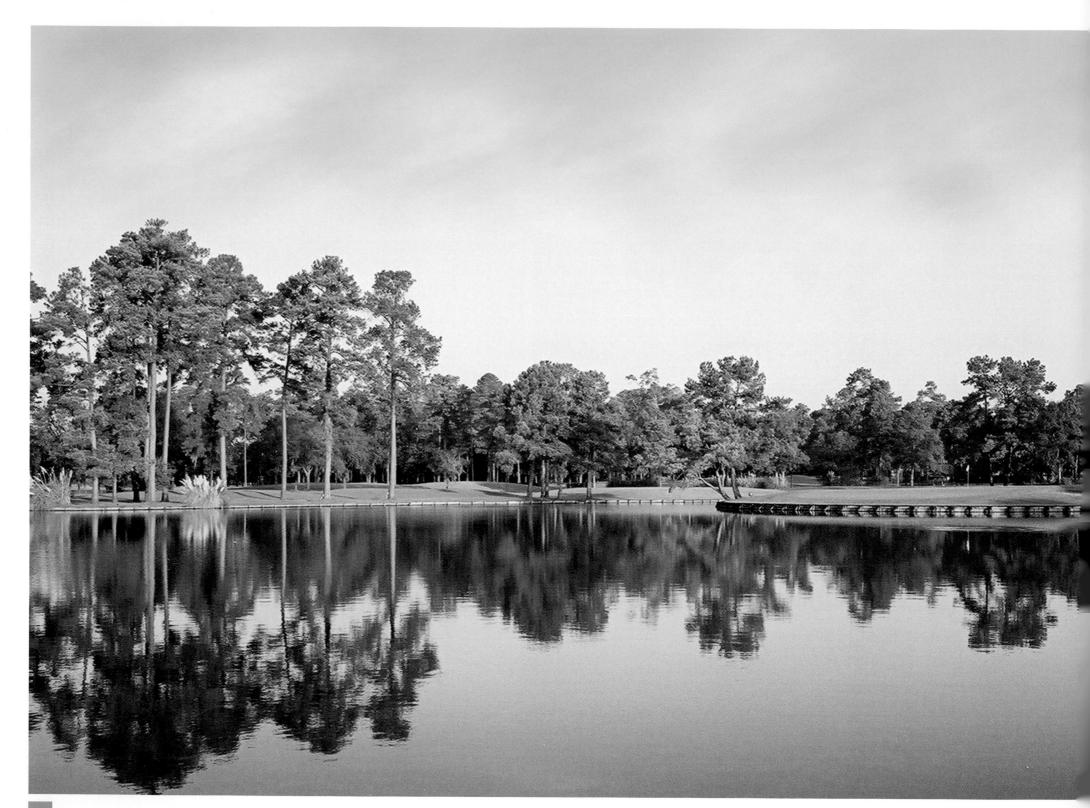

KINGWOOD

THE CLUBS OF KINGWOOD
island course • 18TH HOLE

578 yards • par 5

Kingwood, TX 281•358•2171 www.theclubsofkingwood.com

It is not always possible to save the best for last when laying out 18 holes, but designer Joe Finger did so at the Clubs of Kingwood's Island Course.

"This finishing hole will test the bravest," Finger said when the course was unveiled. He wasn't kidding. The hole consistently appears in polls as being among the most difficult closing holes in Texas.

The 18th needs to be played a number of times before it will be possible to figure out the best way to play it. The ultimate conclusion will probably be that there isn't a best way.

The most significant thing is to avoid the water, which is extremely difficult to do since there is quite a bit of it.

To the right of the lake, in the middle of the fairway, is a pond, which creates a big twist.

From the tee, one has to decide whether to simply stay short of the pond or to try to fit the ball into one of the ribbons of fairway that run to the left and right of the unusual hazard.

The player who hopes to reach the green in two shots must go to the left of the pond, creating a second shot of between 200 and 250 yards. To reach that spot in the fairway, however, a large amount of the lake must be carried.

The safer play, by far, is to go to the right of the pond and then either stay to the right with the second shot or carry the pond into a small landing area that leaves an approach to the green in the 100-yard range.

That approach, of course, must carry over the lake to a green protected in front and behind by bunkers.

There can be a lot of mental anguish built up during the playing of this hole. The chief chore with the tee shot is trying to figure out where to hit it. Then the problem becomes trying to figure out where to hit the next shot.

In the end, it becomes a case of "whatever works."

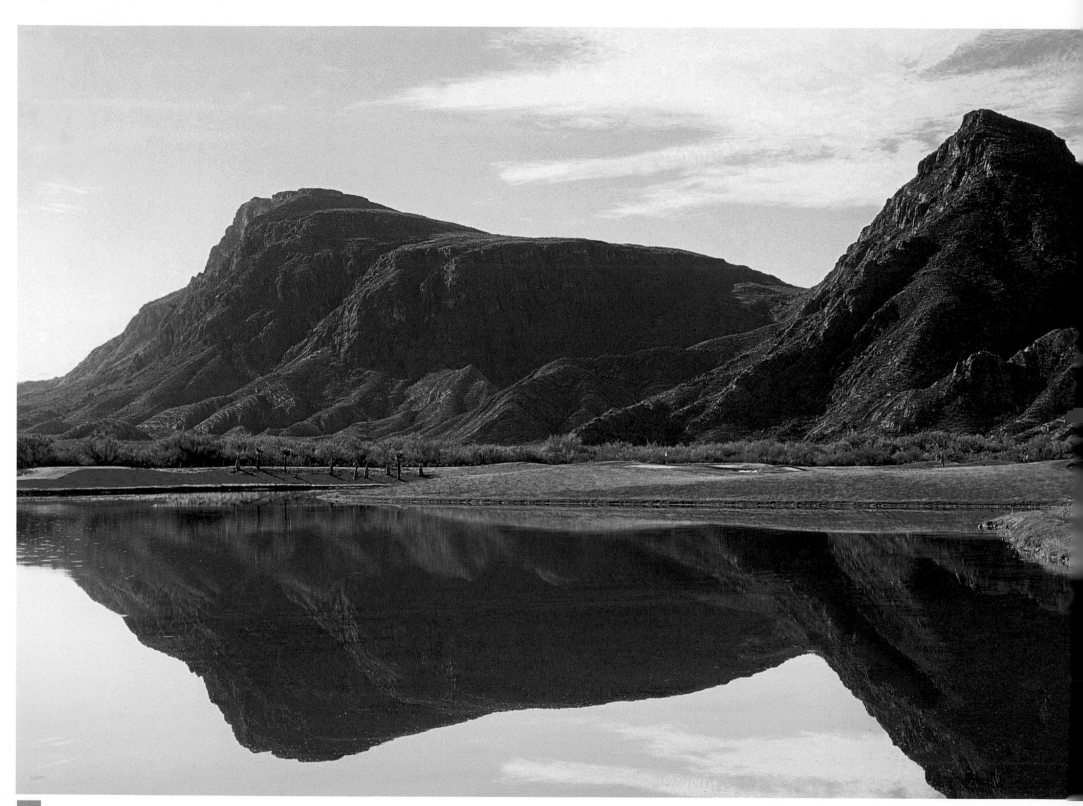

LAJITAS THE ULTIMATE HIDEOUT

ambush course • 15TH HOLE

522 yards • par 5

Lajitas, TX 432•424•5001 www.lajitas.com

*A*lthough there has been no official poll taken, it stands to reason that if a golfer is going to go to the trouble to get to the Ambush at Lajitas, that golfer is going to be the kind that does not often lay up.

The 15th hole at this remote course gives those who smash the ball a reasonably long way a chance to go for it. Getting to the green in two big shots, however, is just part of the chore.

Number 15 is guarded along the left side by a water hazard and there are bunkers sprinkled along the fairway beginning 150 yards from the tee and continuing for about 100 yards.

The ever-present desert is all along the right.

Despite the problems found on both sides of the fairway, it is the green and its surroundings that provide the biggest concern.

The green is small, which is not uncommon for a par-5. And it has three bunkers guarding it, which is certainly not unusual.

The course boundary, one it shares with the Big Bend National Park, is just over the green. The biggest problems, however, are on the green itself.

There are ups and downs all over the surface. The undulations are so numerous and so intense that three putts, or more, are commonplace. So the fact a player has the length to reach this green in two certainly does not ensure a birdie.

In the harsh locale where the Rio Grande makes its enormous bend, all manner of history has been made.

Dinosaurs once roamed the now barren hills. Comanches made the area home. Pancho Villa conducted occasional forays in the region and Gen. John "Blackjack" Pershing set up shop in hopes of protecting would-be settlers.

Now, in the midst of all the desolation, there is a first-class course, one that demonstrates a quality golf shot can be rewarded here just as much as it can anywhere else.

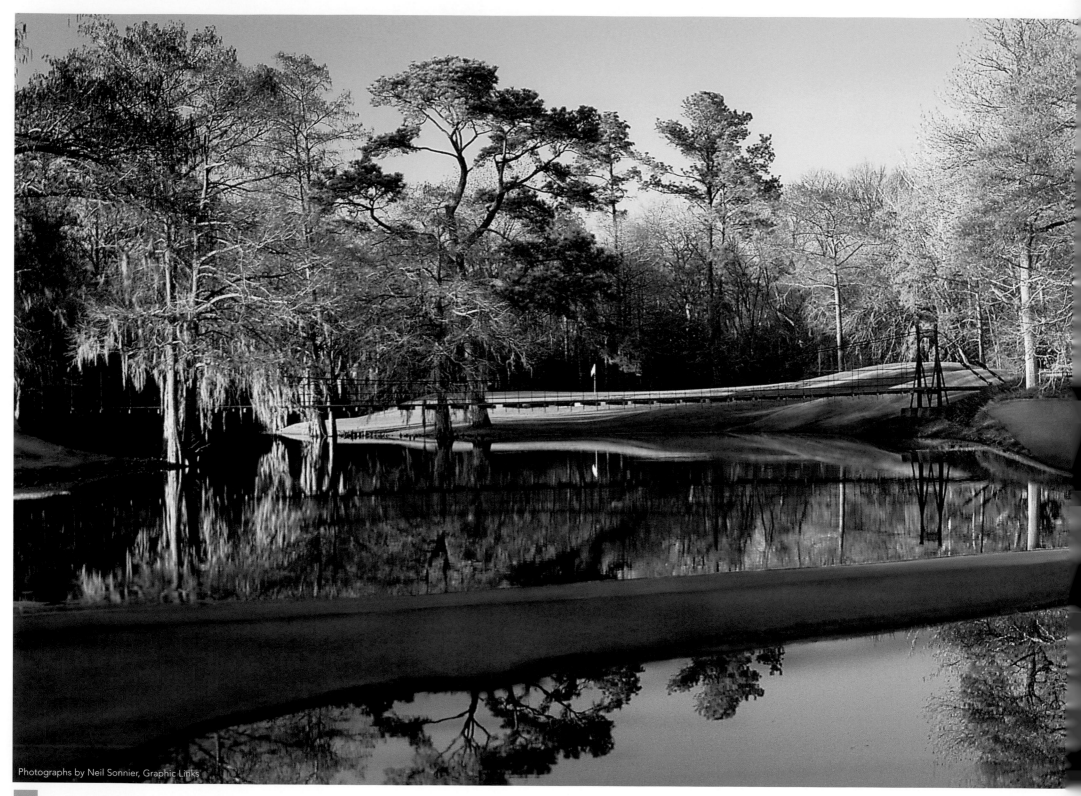

Photographs by Neil Sonnier, Graphic Links

LAKESIDE

LAKESIDE COUNTRY CLUB
18ᵀᴴ HOLE

503 yards • par 5

Houston, TX 281•497•2222 www.lakesidecc.com

To step out onto the veranda of the clubhouse at the Lakeside Country Club is almost like stepping onto the back lot of a movie studio where they are filming a movie about life on the bayou.

Only this is real.

Just a few feet from the back door of the clubhouse, down a grassy slope, there is what amounts to a wide stream that makes almost a complete circle — leaving areas in the middle for play on various holes. There are lily pads. There are trees growing out of the water, creating the image of swampland.

Enormous pines stand on the banks, casting shadows that move on the liquid below.

It is this atmosphere that awaits the players as they complete their round at Lakeside, a course that reeks of days gone by.

At 7,000 yards, this is not a short course. And the first three par-5 holes measure in at 592, 564 and 578 yards. But the closing hole, at 503 yards, gives everyone a chance to end their round with something positive to remember.

The fairway is just about as straight as a string, but the tee and green are offset from the fairway just a little — making a right-to-left shot very handy to have.

Long hitters who find the fairway will have no trouble reaching the green in two, even though the second shot has to carry over the same water that winds around behind the clubhouse.

But trees come into play down both sides and if a ball ventures into them it will likely be difficult to escape far enough down the fairway so that a third shot can be directed at the green.

The water not only fronts the green but wraps around the left side of it. And a sizeable bunker protects the right.

The real world lurks just beyond the confines of the Lakeside Country Club. But standing on the 18th green, in the midst of a setting worthy of a large-budget Hollywood film, one would never know it.

149

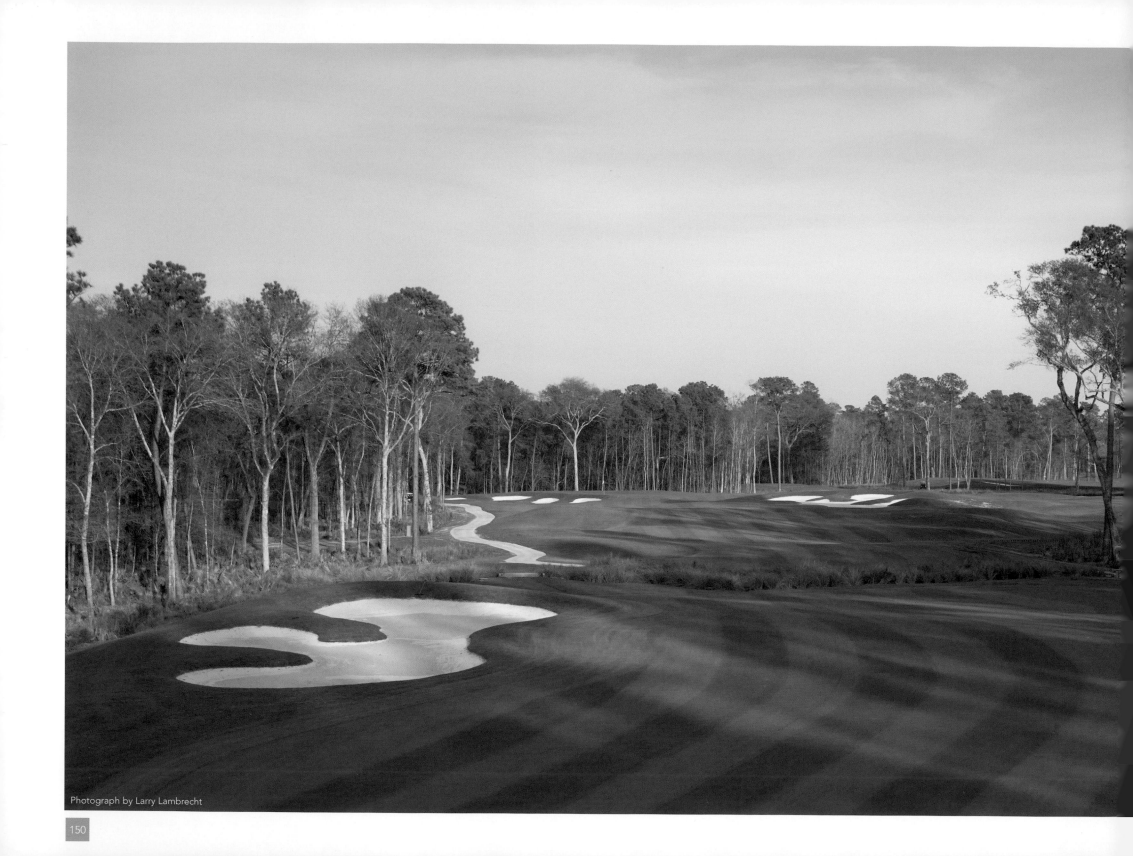

Photograph by Larry Lambrecht

REDSTONE GOLF CLUB
tournament course • 15TH HOLE

609 yards • par 5

Humble, TX 281•459•7800 www.redstonegolfclub.com

There was a time when a 600-yard hole was something of a rarity. Such a thing has now become almost commonplace, especially on courses that host the game's elite.

Designer Rees Jones and PGA TOUR consultant David Toms turned the closing par-5 on the Redstone Tournament Course into just such a hole, one that forces even the longest of hitters to play it as a three-shotter.

Well, maybe not everybody.

John Daly, whose mammoth drives inaugurated the explosion of power that eventually overtook the game, got home in two at Redstone's 15th with a driver and 3-wood when the Shell Houston Open was played on the course for the first time.

But for the most part, the sport's top players recognize the hole as something other than an automatic birdie.

After a not-so-long forced carry off the tee, the first major obstacle to negotiate is a hazard that crosses the fairway about 320 yards from the driving ground. If the hole plays downwind, the blasters who consider a 300-yard launch routine might have to gear back a little to make sure they do not run out of fairway.

An expansive bunker sprawls alongside the right side of the fairway in the area where a good second shot will typically land and that shot needs to flirt with the trap in order to set up the best angle to the green.

The putting surface rises to a plateau in the back and is protected by sand on the left side.

Traveling the length of this hole will take some time and, for the player of routine talent, it might take a number of shots as well. But these days such challenges are popping up far more often than they used to.

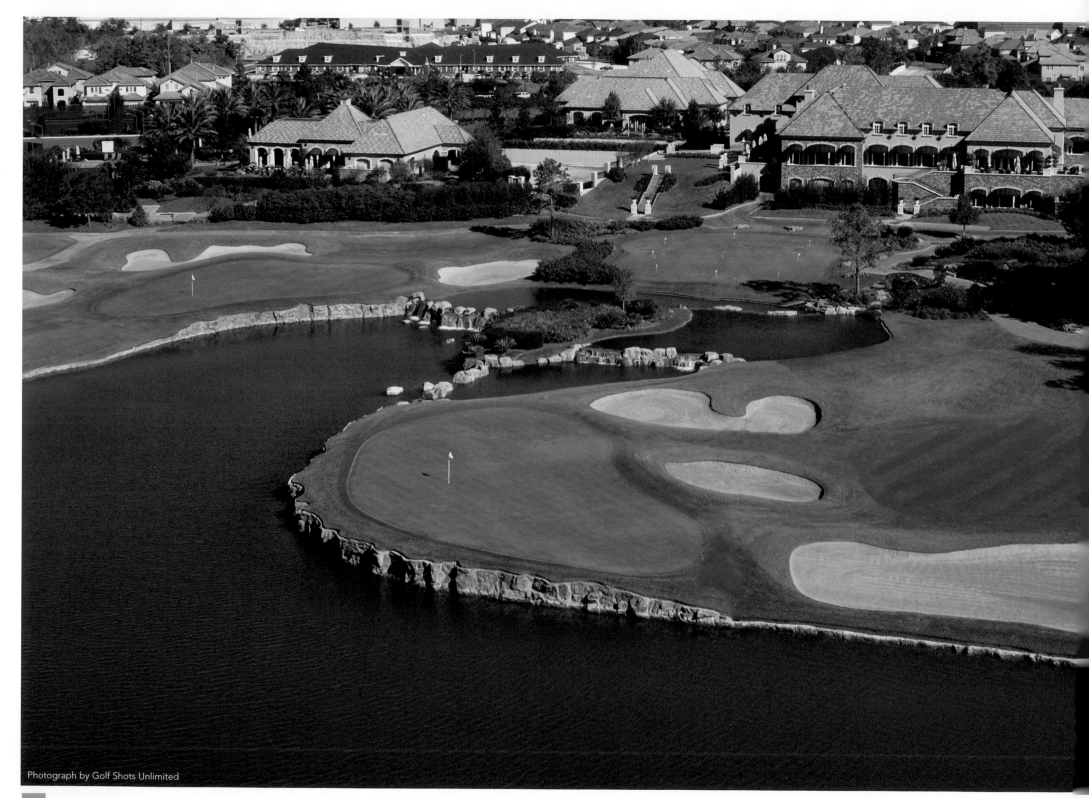

ROYAL OAKS COUNTRY CLUB
9TH HOLE

500 yards • par 5

Houston, TX 281•493•6041 www.royaloakscc.com

Masters champion and fan favorite Fred Couples, like so many of the high-profile players of his generation, has entered the world of golf course design.

His future in that regard appears quite promising since his Royal Oaks Country Club is a flashy layout that reeks of quality.

Couples said the design, "will make every hole a pleasure for any level of golfer."

Such as the ninth. It is a short enough par-5 so that the average player can easily get home in regulation. But because so much trouble surrounds the hole, only solid (if not particularly long) shots will do.

At 500 yards, the big hitters will have no problem reaching the green in two. But like any good short par-5, the risks are substantial.

The hole makes a turn to the left about halfway along the way and there are fairway bunkers at the inside corner and outside bend of the dogleg. For those hoping to get to the green in two, the tee shot must be tucked in between those bunkers or blasted all the way past them.

Then comes the water, in the form of a lake that is in play on both the ninth and 18th holes. It runs down the left side of the ninth fairway, all the way to and around the back of the green.

A second shot that is struck with the intention of traveling all the way to the putting surface must carry this water because the green juts out into the lake.

Three bunkers are located across the front of the green. The one on the far left sits very close to the water.

Two visual features top off the hole. The imposing clubhouse and its gabled roofline is in the background and an array of rocks with a waterfall is located just over the green.

"We crafted this water feature to offer beauty to some and disaster to others," Couples said in describing the ninth.

If a player does encounter disaster, it will be short lived. It is the beauty of the hole and the rest of the course that will endure.

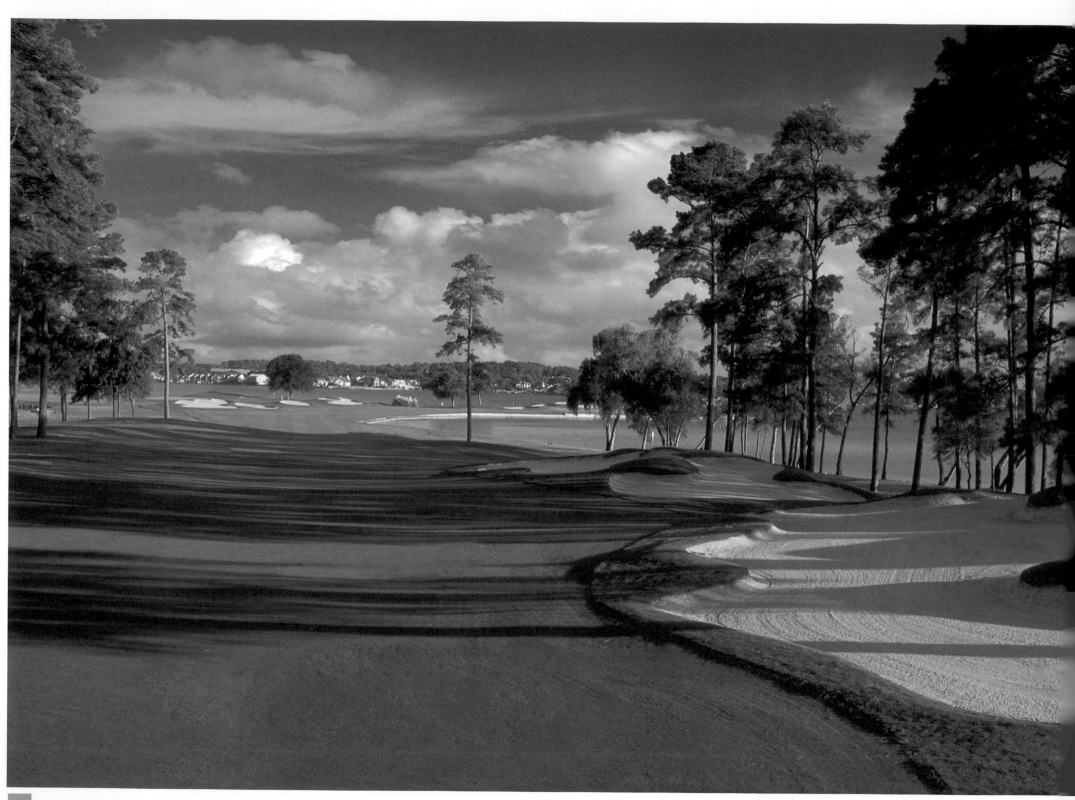

WALDEN ON LAKE CONROE
GOLF CLUB
11TH HOLE

582 yards • par 5

Montgomery, TX 936•448•6440 www.waldengolf.com

A phrase often associated with a high-quality golf course is that, "you have to use every club in your bag."

It is not out of the question that a player might have to use every club in the bag while trying to navigate a single hole at the Walden on Lake Conroe Golf Club.

The 11th, stretching almost 600 yards over and around trees, sand and water — not to mention the possibility of a gusty wind — is about as challenging a par-5 as can be found in Texas. *The Dallas Morning News* has named this hole both one of the prettiest holes and the toughest par-5 in the State of Texas. *Golf Magazine* has named it as one of the top 500 holes in the world.

Although no official statistics are kept, Walden head professional Danny Jones says the 11th green has been reached in two shots from the back tee less than 10 times.

Reaching the green in the regulation three shots is plenty hard enough.

The tee shot must thread through the trees with out-of-bounds to the left adding to the hole's complexity.

An extra big effort from the tee box has a chance of running through the fairway into one of four bunkers that protect the outside of the first of two doglegs on the hole.

The fairway turns left and another near-perfect shot is needed just to get into position to have a chance at going for the green in three. Although it was not visible from the tee, Lake Conroe soon comes into play down the right side on the second shot.

Another set of bunkers, again on the outside corner of the second dogleg, must be avoided. The second shot needs to be placed between the lake and the sand.

Even after reaching an area between 100 to 150 yards from the green in two, the work is nowhere near done. The approach is carried into a long, narrow green that sits at an angle to the fairway and is protected in the front left by a bunker and all across the back by a series of traps.

When the day's play is being discussed, the happenings from the 11th hole are almost certain to be featured.

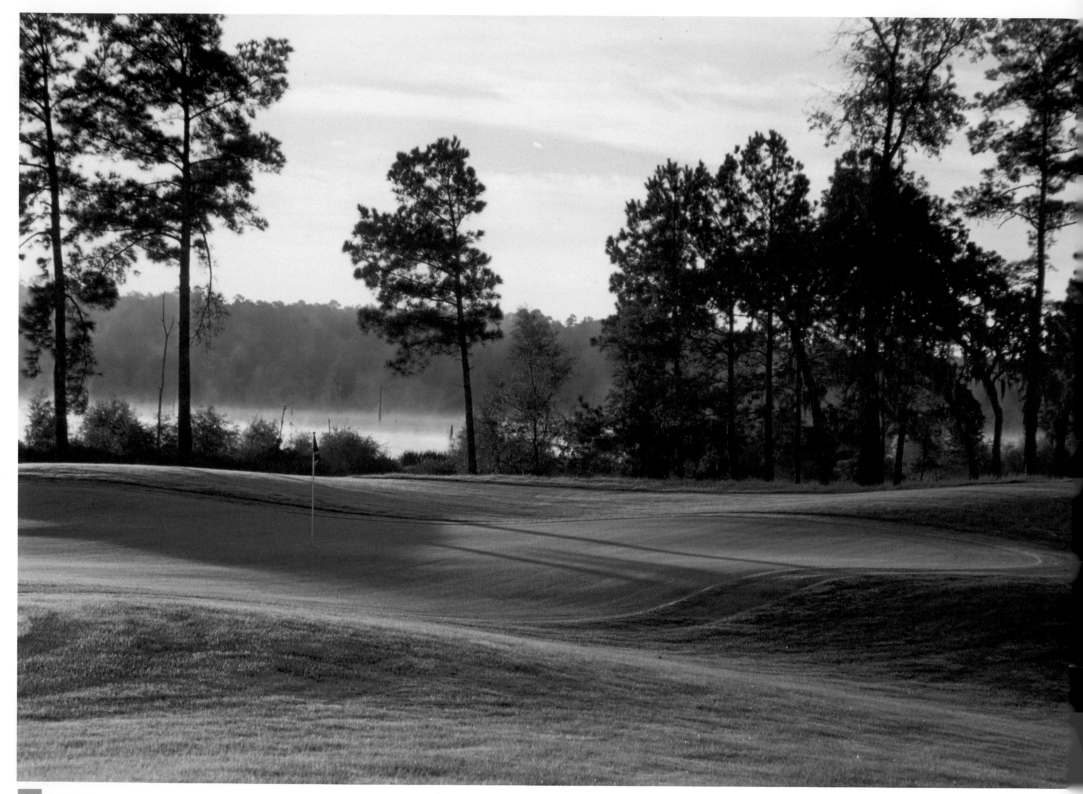

WHISPERING

WHISPERING PINES GOLF CLUB
17TH HOLE

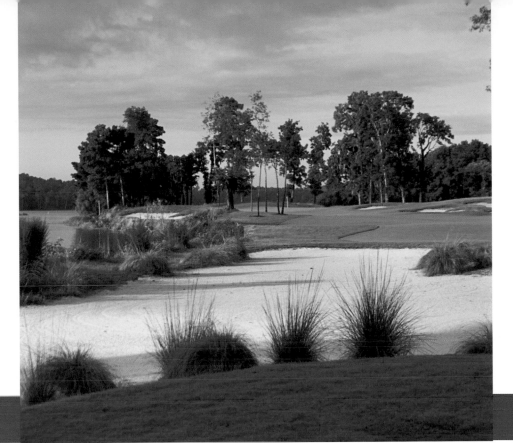

559 yards • par 5

Trinity, TX 936•594•4980 www.whisperingpinesgolfclub.com

There is an abundance of sand, water and very tall trees at the Whispering Pines Golf Club and quite a lot of all three can be found at the par-5 17th.

The water is to the left, the trees are to the right and the sand is all over the place.

Caney Creek runs down the entire length of the hole on the left side and actually must be carried from the championship tee to reach the fairway. The drive must also fly over a series of bunkers with the carry totaling about 220 yards to a narrow landing area.

A waste bunker is just left of the fairway as well, very much in play if a tee shot is sent in that direction. And soaring up out of that bunker are some pine trees that can block the preferred route of the second shot.

Yet another waste bunker begins about 240 yards from the green on the left and can catch a truly big smote off the tee that has managed to avoid all the original trouble.

The second shot for the long hitters or the third shot for the vast majority will be played into a green that is guarded in the front right by a group of four bunkers and in the front left by a huge trap that sits between the putting surface and the creek that has maintained its presence all the way along the fairway.

The green itself is dramatic, with severe undulation and a false front much like the 14th at the Augusta National. The greens at Whispering Pines have been known to run at 14 on the stimp meter, which is runaway fast.

Any par-5 of championship quality carries with it problems from start to finish and there are two or three holes worth of problems at the 17th.

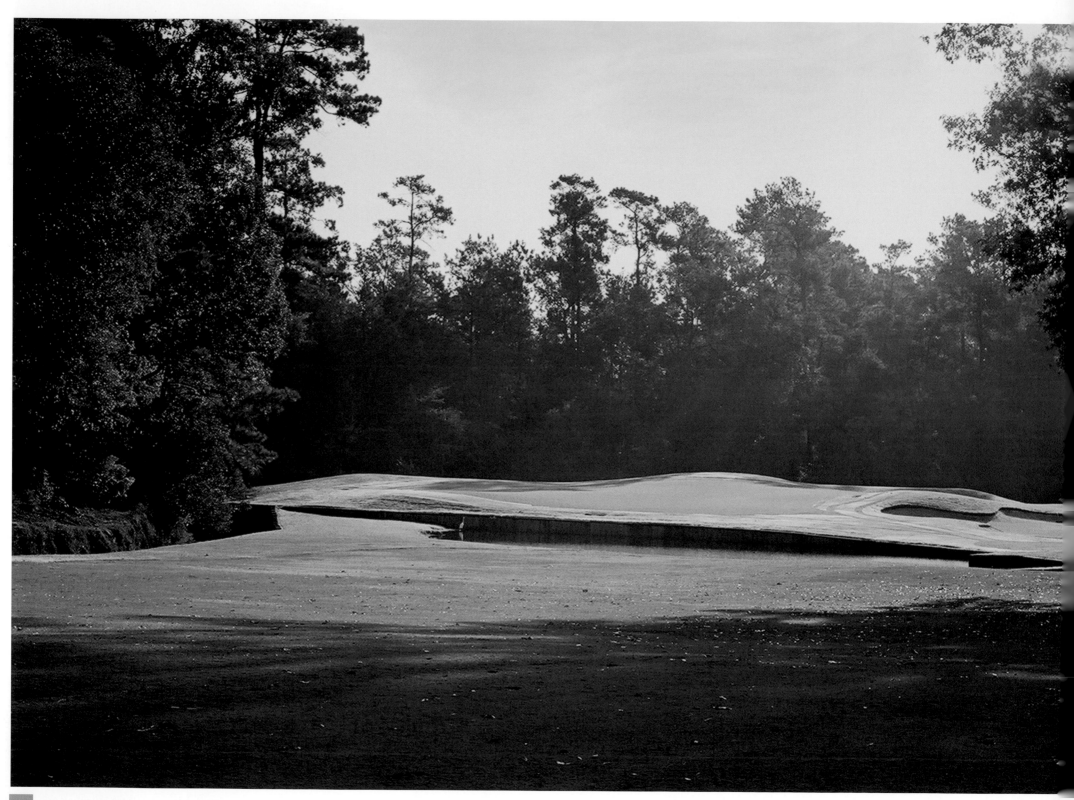

411 yards • par 4

Kingwood, TX 281•358•2171 www.theclubsofkingwood.com

The Clubs of Kingwood is a Texas-sized golf facility.

At last count there were 117 holes along with 34 tennis courts, five swimming pools and 10 dining rooms. It is billed as one of the largest private country clubs in the world, and it would be hard to argue with that assessment.

For all of the golf available, The Deerwood Club attracts a majority of the attention host of the second stage of the PGA TOUR Qualifying school. It is a Joe Finger design with the assistance of Byron Nelson that opened in 1982 and received an upgrade to its greens in 2004.

In some cases, the course pummels the player about the head and shoulders. In other cases, the assault can be subtle.

The fourth hole is a stout test being the number one handicap hole on the course and one that features a design technique as old as golf itself. The bigger the risk one takes off the tee, the easier the second shot will be but demanding the player to hit two quality shots.

There is a generous fairway on what, with the advancement of technology, is still a long hole maximizing out at 453 yards.

From the tee a player is required to hit a quality tee shot. Most players would think that a tee shot on the left side of the fairway would be ideal given the slight dogleg to the left.

But the ideal line is not out to the left. The right edge of the fairway is the best place to be leaving a player with 175-200 yards to a well-protected green.

The green is offset to the left and is guarded by three bunkers and water that runs across the approach. If the tee shot has finished on the extreme left side of the fairway, the second shot must come from a difficult angle, avoid trees and carry numerous hazards around the green.

Many golf enthusist will remember the 4th hole at Deerwood that served as the finishing hole in the movie "Tin Cup." We all remember what happens if your approach shot is not dead solid perfect!

Of the 117 holes available at Kingwood, the 4th may be the pinnacle of classic holes in Texas. Any golf designer or player will look at this hole and recognize it for what it is – a work right out of the book of classic architecture.

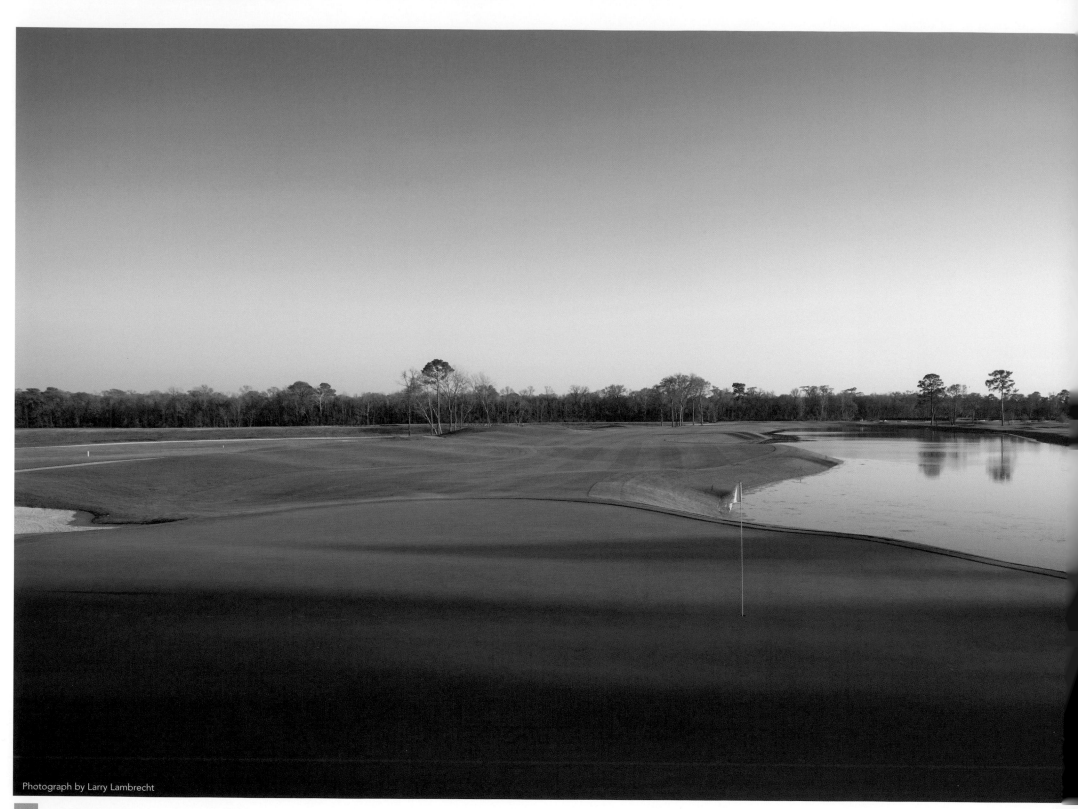

REDSTONE GOLF CLUB
tournament course • 18TH HOLE

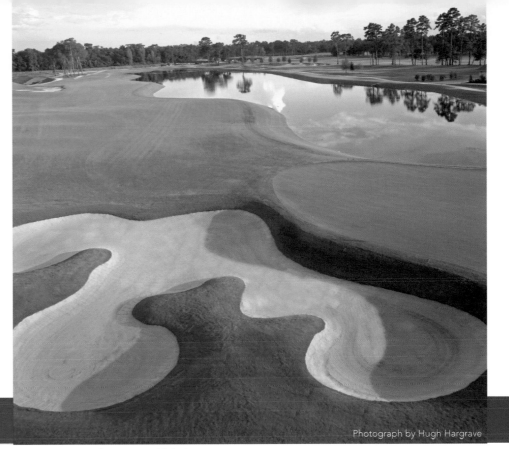

484 yards • par 4

Humble, TX 281•459•7800 www.redstonegolfclub.com

Photograph by Hugh Hargrave

When the PGA TOUR's Houston-area stop moved to Redstone Golf Club in 2003, the plan was to play the event there three years and then move it to the club's Tournament Course, which at the time was on the drawing board.

That plan came to fruition and the best players in the world are now given a chance to compete on a 7,422-yard course designed by Rees Jones with tour veteran David Toms acting as a consultant.

If the Shell Houston Open comes down to the wire, as so many professional events do, the challenge will be a fierce one.

The closing hole is one of those modern-day par-4s that stretch to almost 500 yards.

There is some good news in that the prevailing south wind will be helping on this hole. But if a springtime front blows through and turns the breeze around, par will be a very appreciated score.

Water runs down the entire left side of the fairway and, from the back tee, a portion of that water must be carried.

Keeping the golf ball dry is of paramount concern off the tee, but there is also a 60-yard long bunker on the right and a drive in excess of 315 yards will be needed to get past the sand.

Hitting a second shot from the bunker is not the prescribed way to make birdie.

The green is a deep one and to the right is a bunker almost as big as the green itself. To the left is the water. A slope to the left of the elevated green will cause just about any ball that misses to that side to bound down into the hazard.

A plateau rises up in the back left portion of the green, a spot where one would expect to find the flagstick on championship Sunday. Any player standing on the 72nd tee at Redstone with a one-shot lead has some serious golf to play before being able to grab the trophy.

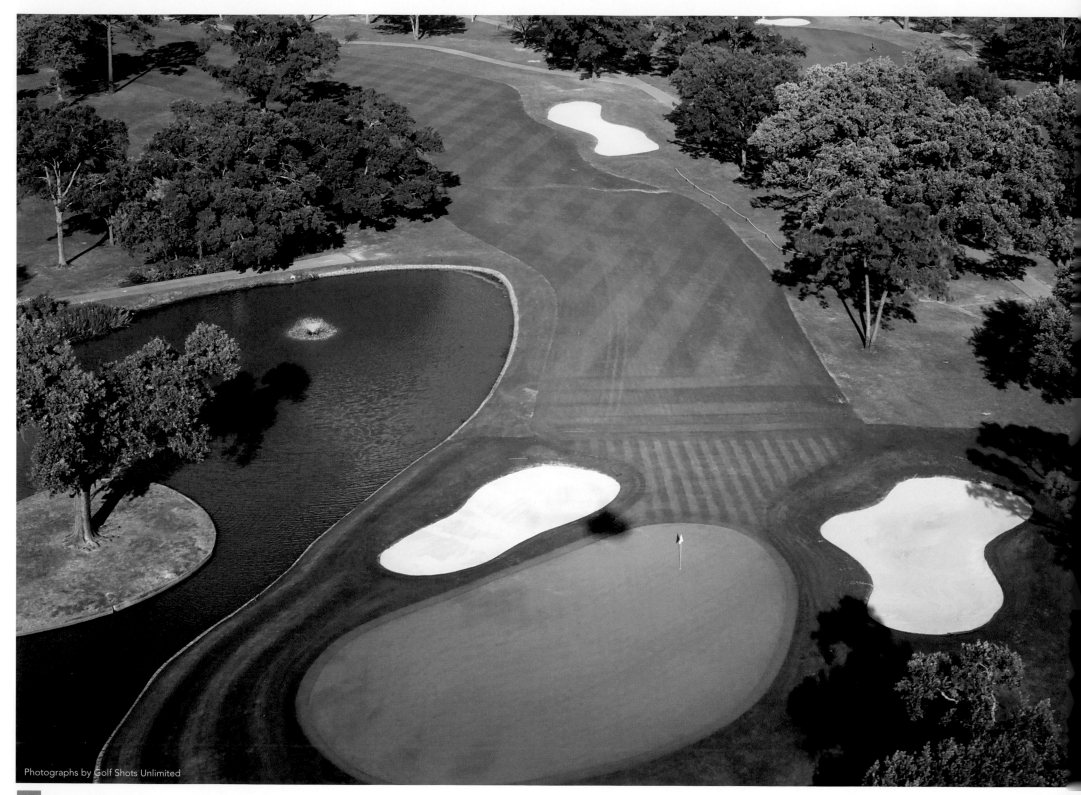

RIVER OAKS COUNTRY CLUB
9TH HOLE

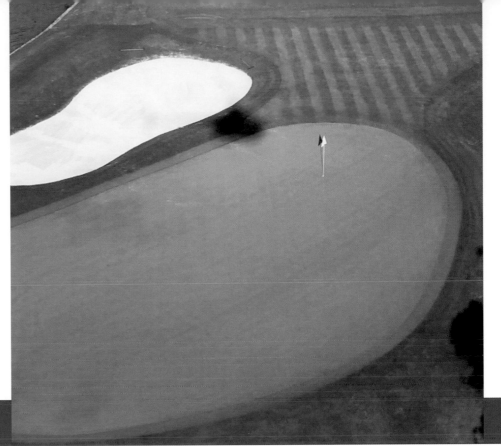

376 yards • par 4

Houston, TX 713•529•4321 www.riveroakscc.net

For the golf historian, the narrow fairways and small greens at River Oaks make up nothing less than a national landmark.

Time has perhaps obscured the role the golf course has played in the history of the game, but River Oaks played host to an event that needs to be recalled from time to time — just to make sure it is not lost to future generations.

The course, separated from Houston's Memorial Park by Buffalo Bayou, is a Donald Ross design. That makes it special to begin with.

But the happenings that took place in 1946 among the magnolias, dogwoods and azaleas cemented River Oaks' place in golf lore.

That was the year Houston first hosted a PGA TOUR event and it was played at River Oaks, where Texas' two greatest golfing legends staged yet another duel.

The previous year, Byron Nelson had won 18 tournaments. Before 1946 was out, Hogan would win 13 and finish second five times. They were by far the game's dominant players when they arrived in Houston in May of 1946.

Already that year Nelson had edged Hogan to win in Los Angeles, San Francisco and New Orleans. Hogan and had done the same thing to Nelson in San Antonio.

In Houston, Nelson recorded a 72-hole total 274 and won the first-place check of $2,000. Hogan was two shots back in second place.

Never again would those two giants of the game finish 1-2 in a PGA TOUR individual stroke-play event. Nelson, his career in full bloom, retired as a full-time player the next year.

A fine example of the charm of River Oaks is the final hole on the front nine, a dogleg-right, par-4 that — as so many holes on the course do — has a driving area that is tighter than tight.

To the right of the green, and encroaching in front of it, is a lake. The green slopes to the water and there is a large bunker to the right that will keep some shots from reaching the hazard.

In the current era, length is never an issue at River Oaks. As the ninth demonstrates, however, precise shotmaking is and always has been critical.

But the main concern with this course is preservation because golfing treasures should always receive the care that their historical significance demands.

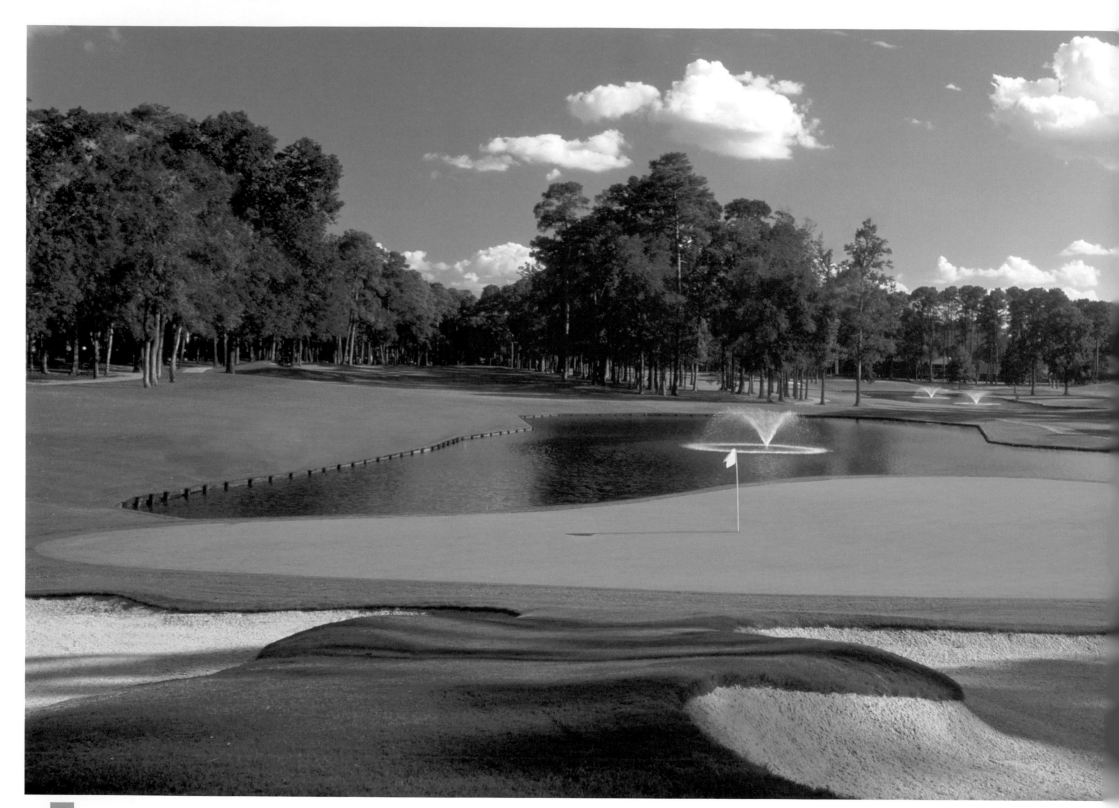

WALDEN

WALDEN ON LAKE CONROE
GOLF CLUB
18TH HOLE

430 yards • par 4

Montgomery, TX 936•448•6440 www.waldengolf.com

For the type of championship course that Walden on Lake Conroe Golf Club was designed to be, it would be expected that the closing hole provides something to remember.

The 18th does not disappoint.

After facing one taxing tee shot after another, the player finds that at the closing hole, only something in the neighborhood of perfect will do.

One last time, trees inch in from both sides, but accuracy is not the only requirement on the final tee ball of the round.

A bunker bordering the right side of the fairway is placed about 150 yards from the green and is very much in play. Those who can start the ball at the bunker with an ever-so-slight draw will have an advantage.

Distance is extra handy at this hole because the second shot is all carry over a pond that reaches almost to the front edge of the green.

A nest of bunkers is placed behind the entire width of the green, making the second shot a prime example of target golf. Without both

the right distance and the right trajectory, the player is faced with either a penalty stroke or the task of coming out of the sand to a green that runs back toward the water.

As a final chore, the ultimate tournament pin placement is found in the front left of the kidney-shaped green — just over the water. To get close to that hole location, a shot must land in an area about the size of a card table.

If a par at Walden's 18th is achieved to claim a tournament title or simply for bragging rights over fellow competitors, it will have been truly earned.

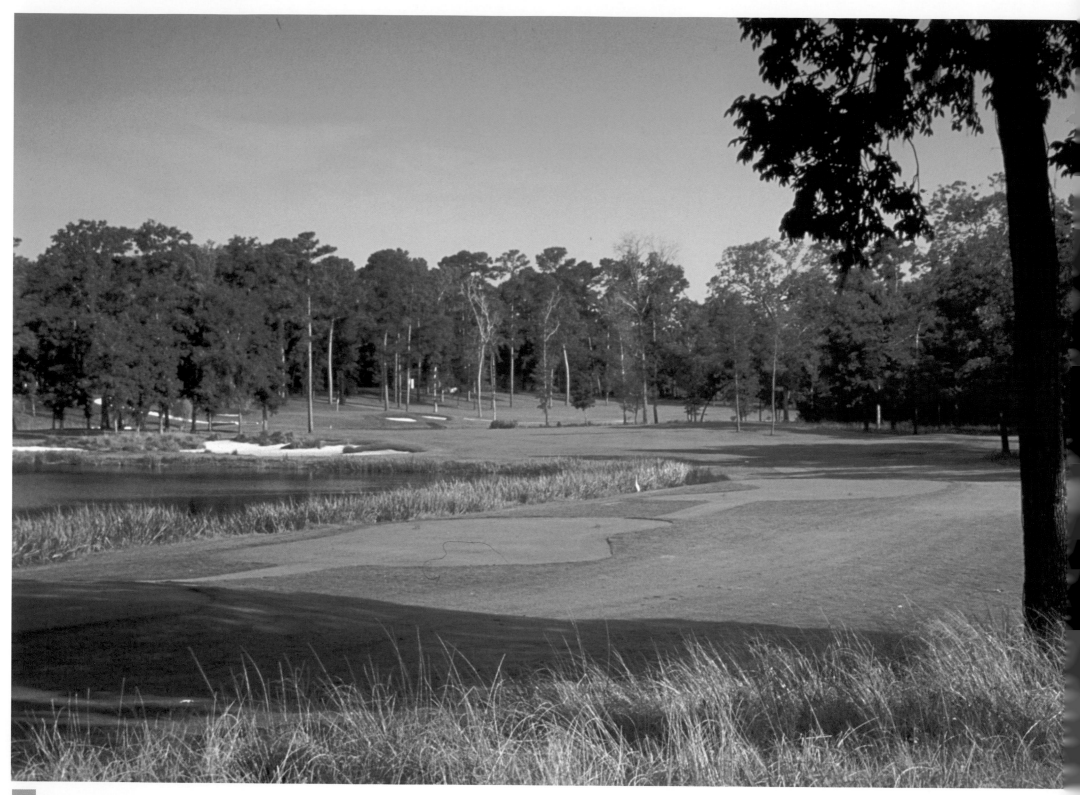

WHISPERING
WHISPERING PINES GOLF CLUB
18TH HOLE

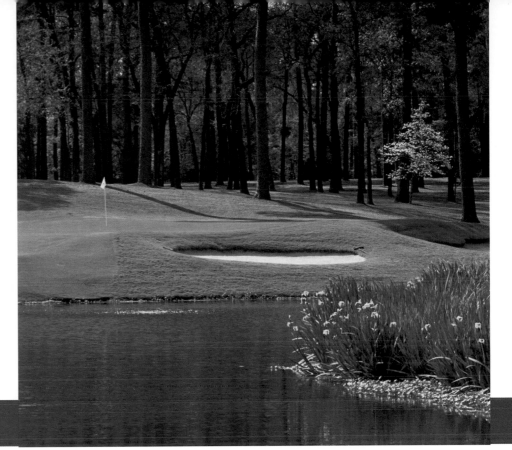

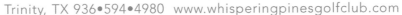

485 yards • par 4

Trinity, TX 936•594•4980 www.whisperingpinesgolfclub.com

Chris Rowe, head professional at the Whispering Pines Golf Club, has been around the block a time or two so his opinion carries some weight.

And here is his opinion concerning the finishing hole at his course:

"It is the hardest 18th hole I have ever played. I think only the 18th at Southern Hills (the major championship test in Tulsa) can rival it."

Whispering Pines comes to a close with a massive undertaking, one that begins alongside the northernmost part of Lake Livingston and finishes not too far from the only home on the course.

It is a historic house that was originally located in Huntsville before it was divided into four pieces, moved by barge to its current location and reassembled. The house and the property on which the golf course rests has been handed down in the same family for generations and the current head of household is former University of Texas all-American linebacker Corby Robertson.

The 18th makes a left-hand turn and there is a lot of fairway to the right side that acts as a bailout area. But to have any chance of reaching the green in two, a portion of the lake must be carried off the tee. In addition, the drive must flirt with an enormous bunker that is placed just over the lake and at the inside corner of the dogleg.

Pine trees are located along the edge of the bunker and they can block the view of the second shot.

The action, however, is just beginning.

A perfect tee shot still leaves a second of between 180 and 200 yards and that effort must carry over some more water, in the form of a pond that guards the front of the green. The pond turns into a small stream that runs to the left and over that stream has been built a replica of the Swilken Bridge, the landmark found on the 18th at St. Andrews.

Players do not walk across the bridge at Whispering Pines. It has been built simply as a final touch of scenery.

Even after clearing all the water, there is a three-tiered green with which to contend.

"It is," said Rowe, "the hardest golf hole day in and day out you would want to play."

Photograph by Jay Stevens

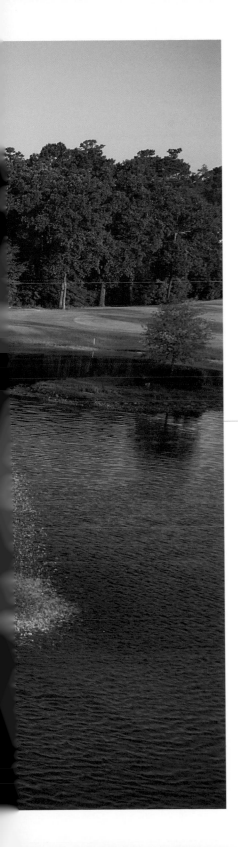

THE WOODLANDS RESORT & CONFERENCE CENTER

panther trail course™ • 18TH HOLE

429 yards • par 4

The Woodlands, TX 281•863•1400 www.thewoodlandscc.com

The Houston Open was played in The Woodlands for 28 consecutive years on two different courses and some of the game's more familiar figures emerged from the pine trees with a PGA TOUR title to their credit.

The last 18 of those tournaments took place at the TPC The Woodlands layout, but during the decade before that, the event was held at The Woodlands Resort, Conference Center & Country Club on a layout that was made up partly of the Panther Trail™ course and partly of The Oaks course.

Number 18 at Panther Trail™ was also the 18th for the tournament and such notables as Corey Pavin, Curtis Strange, Gary Player and Bruce Crampton walked off that green as a winner.

And so did Gene Littler. In 1977, at the age of 47, Littler shot a 65 in the second round and a 67 in the third to take a five shot lead. He held on to defeat Lanny Wadkins by three strokes. It was the 29th win for Littler on the PGA TOUR. It was also his last.

Just over four months later, Wadkins defeated Littler in the first sudden death playoff in the history of major championship golf to capture the PGA at Pebble Beach.

Although the hole as it was played during the Houston Open has been remodeled, the 18th at Panther Trail™ is still worthy of a finishing hole for tournament golf.

The par-4 plays into the prevailing wind and the object off the tee is to avoid the two bunkers that cut into the right side of the fairway.

Getting to the green then requires the player to pick the right club and trust it. The second shot must carry over a pond that reaches almost all the way around the green.

There is an island in the pond, just a little left of the intended flight, and a large tree stretches up out of the island. The hole, therefore, is known as, "Lone Tree."

Bunkers guard the right and left front corners of the green.

It is a hole that crowned a number of worthy champions, including one who was never to win on the tour again.

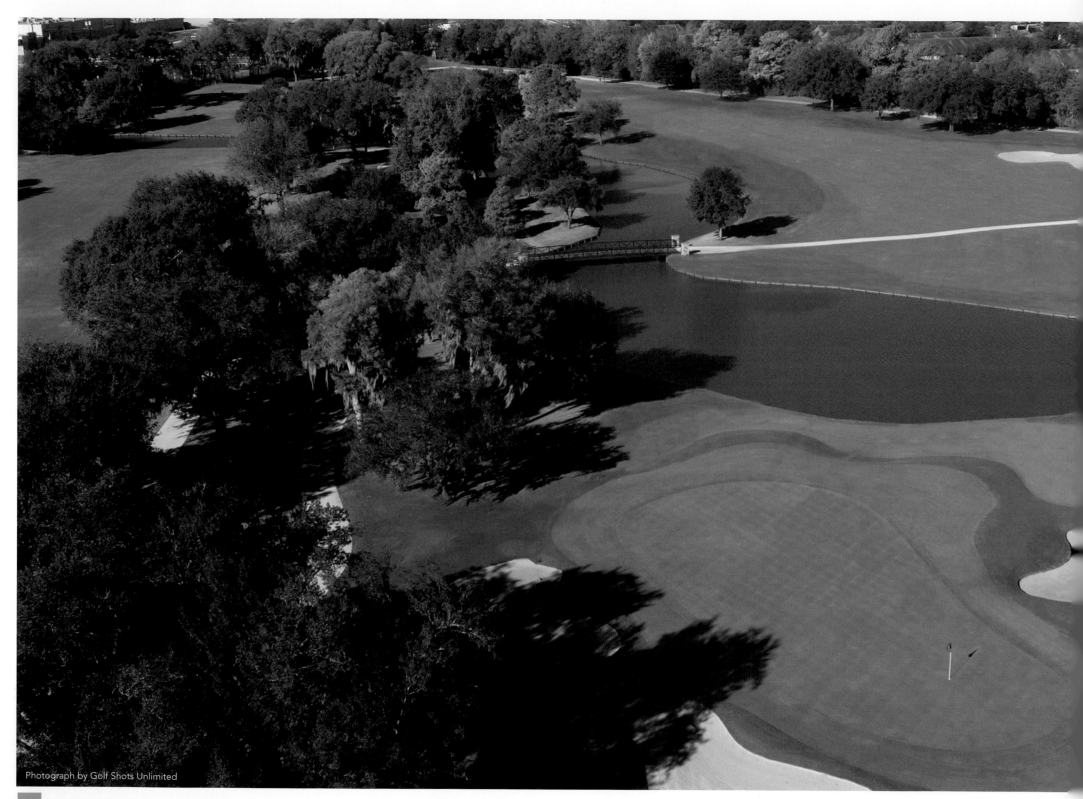

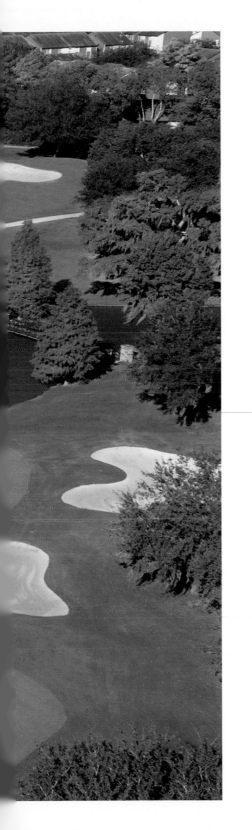

BRAEBURN COUNTRY CLUB
5TH HOLE

405 yards • par 4

Houston, TX 713•774•2586 www.braeburncc.com

*S*ince the game is played by those with varying levels of skill, few golf holes are approached the same by everybody.

That is especially true with what are sometimes referred to as "finesse" holes. The super-skilled, long-hitting player will go about it one way. The player with more limited talent will attack things in another fashion.

BraeBurn Country Club, the traditional-style course in southwest Houston, has a classic example of such a hole.

The par-4 fifth, by 21st Century standards, is not all that long. It is barely over 400 yards from the tees that stretch back near the property line and about 30 yards less from the spot where the members normally play.

The hole makes a pronounced turn to the right with the catch being that water runs down the right side of the fairway and then expands into a pond in front of the green.

A bunker has been placed on the outside corner of the dogleg to gobble up the shots that have been struck with an excessive fear of the water in mind.

It is clear what sort of varying mindsets can be brought to bear on this hole.

The big hitters, even from the back tee, are seeking position. It is a fairly wide open tee shot, but even so something less than a driver could be in order in hopes of setting up the proper angle for the second shot.

After all, the highly skilled player is not going to be worried all that much about the water that must be negotiated with the second shot.

For those with more routine talent, the chief goal off the tee is obvious. The idea is to hit the ball as far as possible so that less of a carry will be required with the second. Being inside the 150-yard mark is far preferable to being outside it.

A deep but narrow split-level green awaits with the higher portion on the back left. Two bunkers are placed on the right side and one on the left, creating a smallish target.

It is a target that is eventually reached by all, but not always with the same game plan.

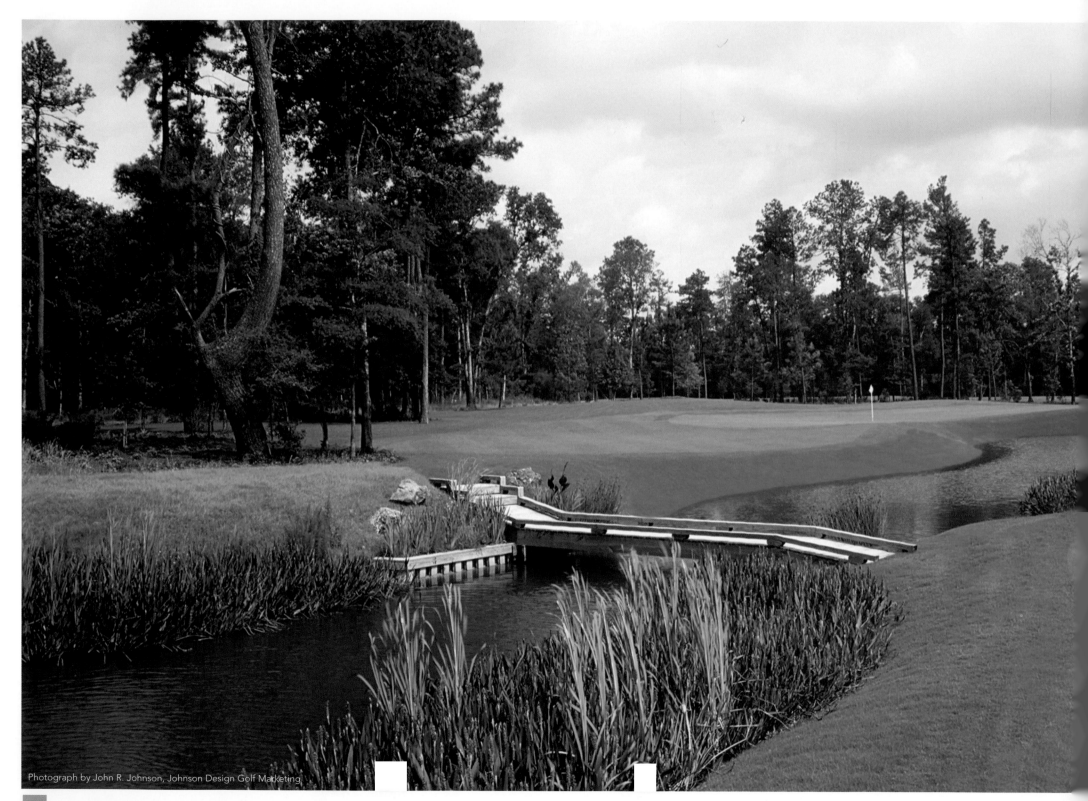

THE CLUB AT CARLTON WOODS
15TH HOLE

461 yards • par 4

The Woodlands, TX 281•681•1945 www.carltonwoods.com

Carlton Woods received rave reviews from various golfing publications when it opened and that came as little surprise since the course was designed by Jack Nicklaus.

The layout is carved out of the pines that populate the region and serve as a continuing attraction for the nation's top designers.

"This course takes full advantage of the beautifully wooded terrain in this area of the country," Nicklaus said after he created the 7,368-yard jewel that includes four par-4 holes of more than 450 yards.

One of those is the 15th, which, like most of Nicklaus' outstanding holes, is unforgiving.

The always present trees are found on both sides of the fairway, but the chief feature of the hole is water. And there is a lot of it.

A pond sits in front of the championship tee and it then narrows down to a nice-sized stream that runs down the entire left side of the hole.

Shortly before reaching the green, the water angles to the right and forms a small pond that sits squarely in front of the putting surface.

Nicklaus usually gives the player a reasonable landing area and there is a decent amount of room in this fairway, which makes a slight left-hand turn for the second shot.

But for those who do not find the fairway, plenty of woe awaits.

Those familiar with major championship courses might find some slight resemblance between the 15th at Carlton Woods and one of Nicklaus' favorites holes.

In Georgia, there is a hole that makes a slight dogleg to the left and has water running down the left side before turning back in front of the green. It is the 13th at the Augusta National, where Nicklaus won six of his major titles.

CYPRESS
CYPRESS LAKES GOLF CLUB
3RD HOLE

422 yards • par 4

Cypress, TX 281•304•8515 www.cypresslakesgc.com

When a golf course has the word "lakes" in its name, it is not hard to figure out what sort of hazards one will find on it.

Sure enough, there is lots and lots of water at Cypress Lakes Golf Club, a course that has earned a reputation for the quality of its greens. It is consistently selected by Houston area media as having the best greens in the region and on top of that it has a remarkably efficient drainage system.

There have been occasions when golf carts have been allowed back on the fairways a day after a five-inch rain.

Water is in play alongside 10 of the 18 holes and it is really in play at the par-4 third.

One lake stretches from a few steps to the right of the tee down almost the entire length of the hole, finally coming to an end just short of the green.

On the left side, another water hazard begins at about 170 yards from the green and is in play most of the way to the putting surface.

The tee shot, therefore, must be carved between the two bodies of water as well as between the bunkers that guard either side of the fairway.

The bunker on the left is in play for only the longest of hitters. A tree planted alongside that bunker as a memorial to a club member is the aiming point. If the tee shot heads directly toward the tree it will be in good shape. One that has a slight left-to-right turn will be even better.

Any shot down the right side, however, could be in trouble because the fairway slopes toward the water on that side. It is not unheard of for a ball to land on the right portion of the fairway and wind up wet.

The green is significantly elevated and also slopes hard from back to front — especially on the left side. The back right portion is a little flatter, but it takes a flawless shot to get there because of the bunker that sprawls across the front right portion of the green.

The third is the number one handicap hole on the course and with all the water in play it is easy to see why. It is, however, exactly what one should expect from a course named Cypress Lakes.

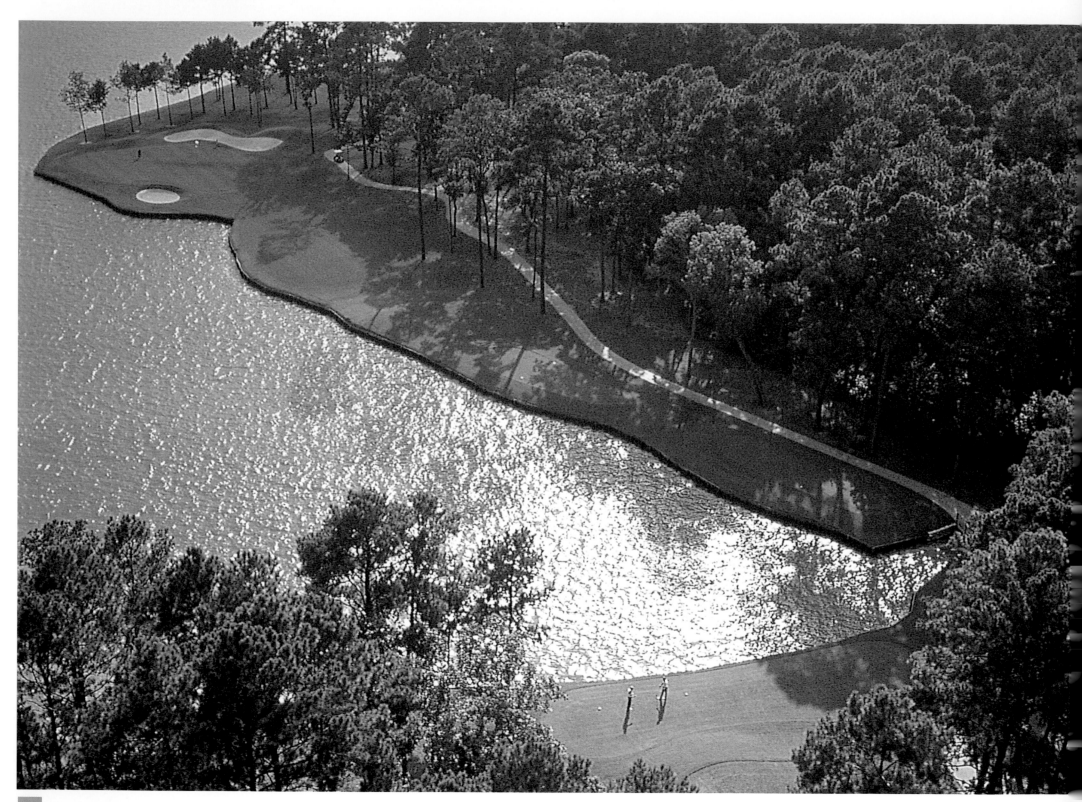

BENTWATER® ON LAKE CONROE

weiskopf and morrish • 14ᵀᴴ HOLE

203 yards • par 3

Montgomery, TX 936•449•5700 www.bentwater.com

The next-to-last victory in the PGA TOUR career of Tom Weiskopf came in Texas and once he became a much-in-demand designer, he, along with designer partner Jay Morrish, returned to create one of the state's more breathtaking courses.

Familiar Weiskopf and Morrish design features can be found throughout with fairways that roll and greens that do the same thing.

The 12th, for instance, has two fairways divided by a stand of trees and the 18th has an enormous landing area.

But the hole that really catches the eye is the 14th, where a player fighting a chronic look is apt to be in big trouble.

Those skilled enough to test the hole from the back tee will likely need a long iron. Most, however, will wind up reaching for some sort of big-headed club in the hope that they can put a solid hit on it. Nothing else will do.

All along the right side are the pines, a few of them near the green encroaching quite close to what should be the intended line of flight. If a slight draw is planned but not executed properly, the ball can easily slam into one of the giant trees.

And to the left is Lake Conroe, with the grass separated from the water by wood pilings all the way from tee to green. About 20 steps short of the green, the water edges into the fairway so that a mis-hit shot, even if it is relatively straight, might still find the wet stuff.

A small bunker guards the front left portion of the green and a much larger one is to be found back right.

An occasional pleasure boat motoring along the lake only adds to the distraction.

Weiskopf and Morrish have created holes all around this course that are likely to be remembered. No one, however, is going to forget Number 14.

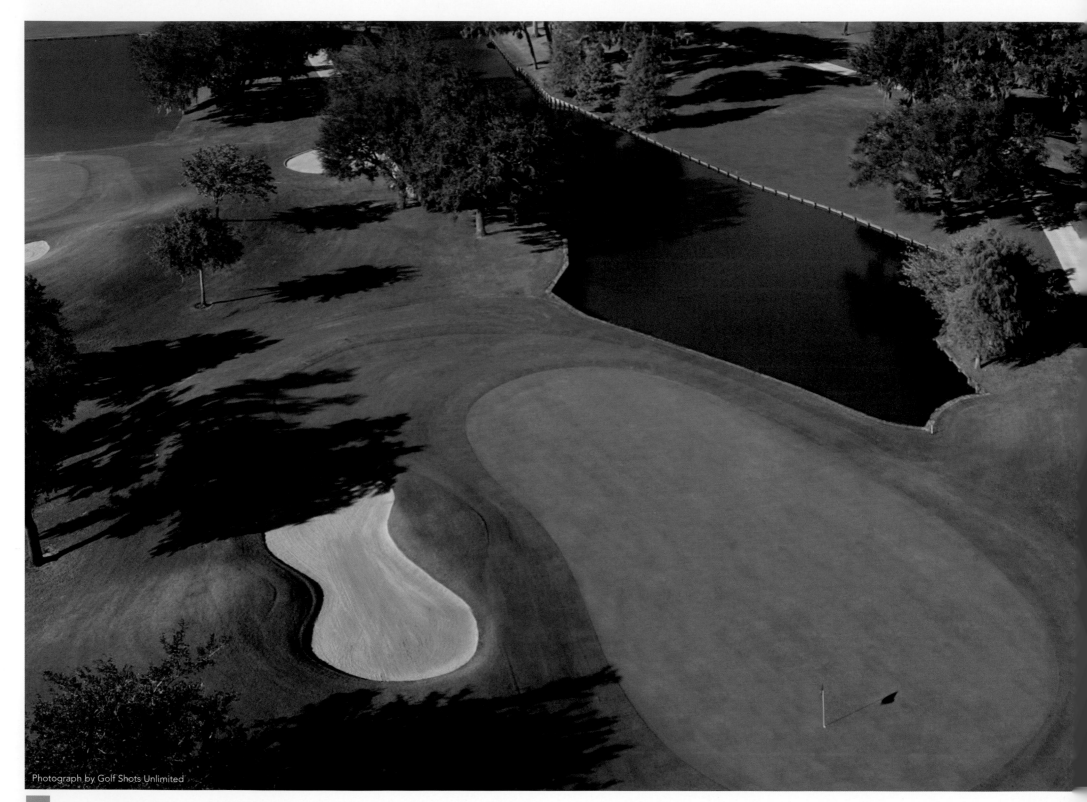

206 yards • par 3

Houston, TX 713•774•2586 www.braeburncc.com

It is always disconcerting to begin the round with a well-played hole and then immediately come upon one of those challenges that can very quickly ruin the day.

Opening with a par and following it promptly with a triple bogey usually leads to a case of the unshakable grumbles.

The second at the BraeBurn Country Club presents its members with just such a potential spoiler.

After all, a par-3 of more than 200 yards over water is just the thing to initiate a little uneasiness and there is no room for such a thing when confronted with this tee shot.

Brays Bayou drifts through the property and it has been expanded upon in spots to create ponds. They, in turn, serve as hazards and one of them is found in front of the green at the second.

The water also runs along the right side of the green. There is a small collection area to the left of the green and a wide bunker behind it — creating places where a penalty stroke can be avoided. But, as is the case with most long par-3 holes over water, the most likely place a poor shot will land is in the liquid.

The green is a two-tiered affair — front and back. Just being on the green, however, is enough to elicit the age-old comment that, "a dry ball is a happy ball."

BraeBurn's second is not all that unlike the second at Medinah, where Hale Irwin and Tiger Woods, among others, have won major titles.

The idea is to check out the nerves very early in the round with a shot, which if it does not come off, will cause the player's patience to be placed under substantial strain.

Those who play their golf at BraeBurn are used to the experience.

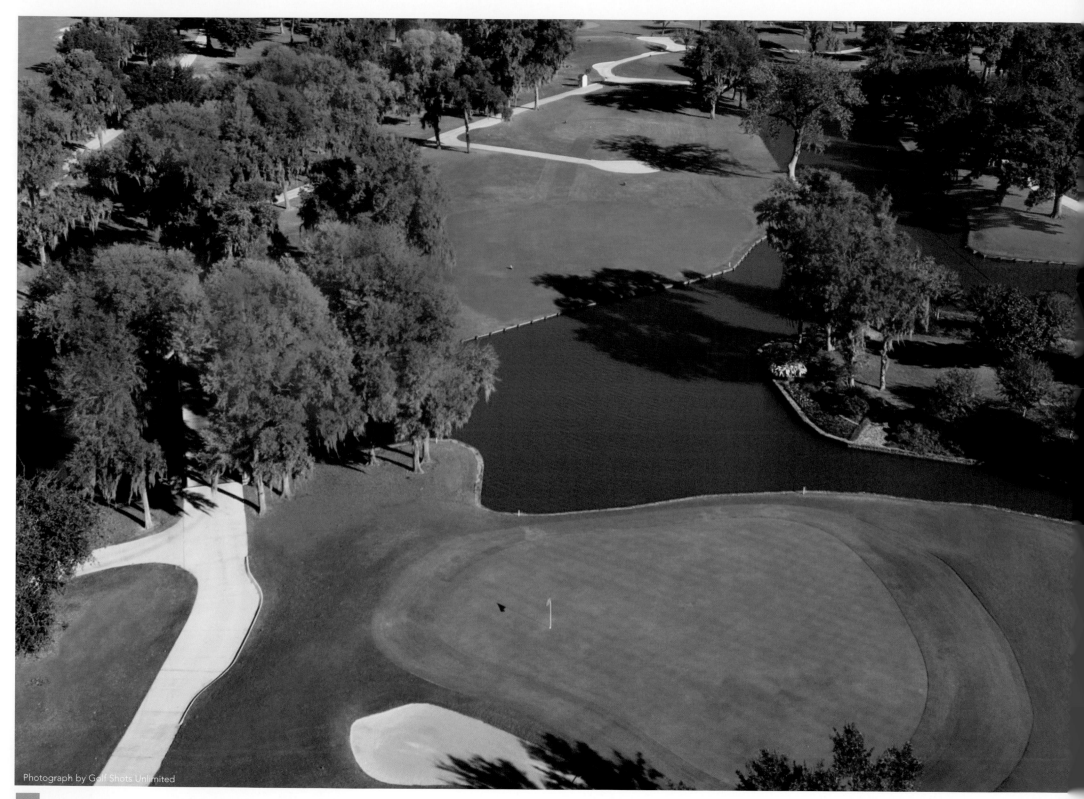

BRAEBURN
BRAEBURN COUNTRY CLUB
7TH HOLE

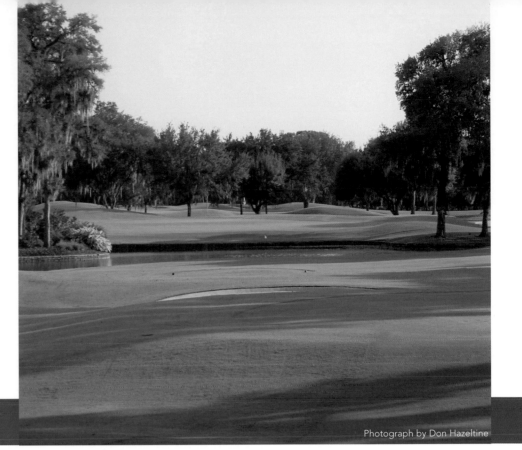

199 yards • par 3

Houston, TX 713•774•2586 www.braeburncc.com

Photograph by Don Hazeltine

*G*olf perhaps did not take root in Texas as early as it did in some other parts of the United States, but when it did, BraeBurn Country Club was at the forefront.

The course was created in 1926 and its history is now not only lengthy but quite distinguished.

John Bredemus, who was originally hired to design Colonial Country Club in Fort Worth, brought BraeBurn to life.

The course was revamped in 1991, but retains its traditional appearance with stately trees and offshoots of Brays Bayou coming into play throughout.

In 1950, just four years after the PGA TOUR came to Houston for the first time, BraeBurn hosted the city's still new experiment with big-time golf. None other than Cary Middlecoff, who had won the U.S. Open two years earlier and would win it again six years later, emerged as champion at BraeBurn.

It was the only year the tournament was played at the course, but it later hosted qualifying for the U.S. Open and U.S. Amateur — once serving as a qualifying site for both events in the same year.

One of the course's glamour spots is the par-3 seventh, a hole that at first glance might be thought of as being a little before its time. But that would be an incorrect assumption.

If the seventh had looked in the 1920s as it does today, it certainly would have been an unusual hole. After all, long shots over water were not as common back then as they are these days.

BraeBurn's seventh, however, was where one of the major alterations took place when the course was redesigned.

Prior to the change, the par-3 was a little more than 100 yards in length and the green sat in front of the bayou. When the dust had settled, the green had been moved to the opposite side of the bayou.

Nowadays it takes a solid long iron from the championship tee to reach the pear-shaped green, which has a large bunker hard up against the back right edge.

BraeBurn looks just like what a golfing traditionalist would hope to see in an older course. The seventh hole, though, provides a taste of what modern golf is all about.

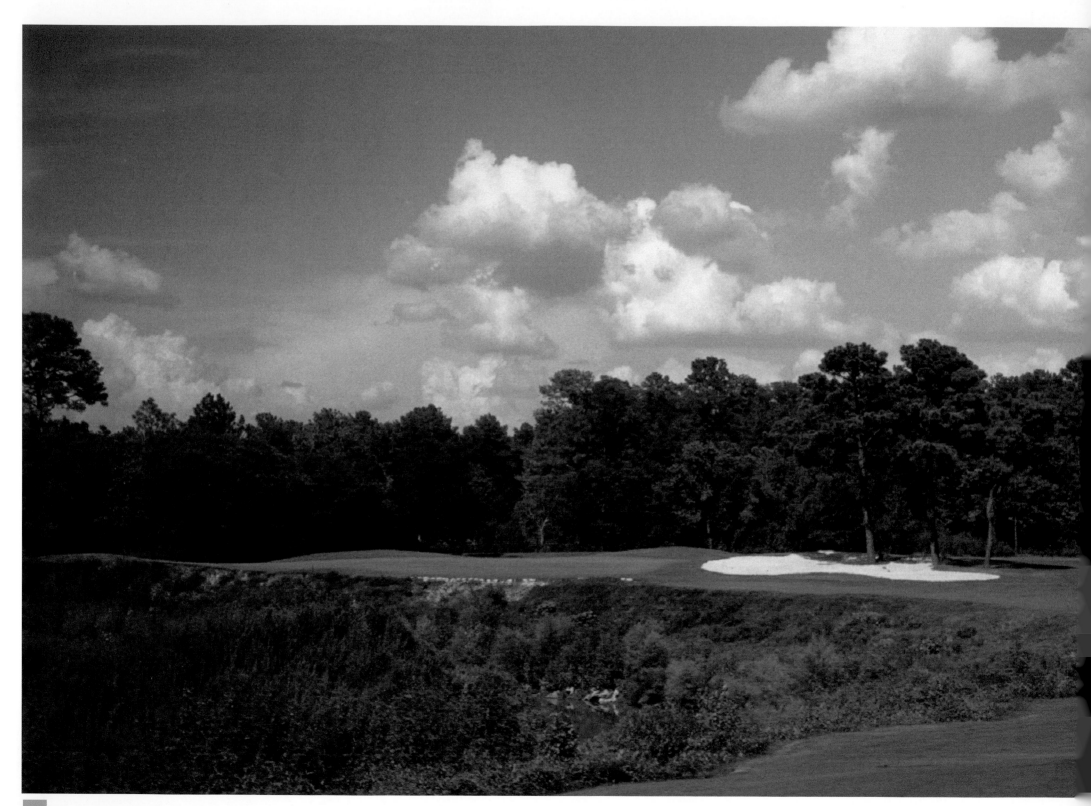

CHAMPIONS GOLF CLUB
4TH HOLE

228 yards • par 3

Houston, TX 281•444•6449 www.championsgolfclub.com

Jimmy Demaret and Jack Burke, Jr., Masters champions who will forever be etched in the history of their sport, saw to it that the Champions Golf Club was built during the middle of the 20th Century.

Before that century had run its course, their creation had become one of golf's elite locales.

Champions has been host to a U.S. Open, one of only three Texas courses to have done so. The Ryder Cup matches have been played in Texas just once and that was at Champions.

Arnold Palmer won a PGA TOUR event on the course and Tiger Woods captured one of the Tour Championships conducted there.

It was also at Champions that Ben Hogan played the last competitive golf of his career.

In 1970, at the age of 57, Hogan finished tied for ninth in what was then known as the Champions International.

He returned the following year in hopes of matching that outstanding performance. But in the opening round he hit three shots into the hazard at the par-3 fourth hole, took a nine, withdrew after playing 12 holes and never entered a PGA TOUR event again.

The fourth hole, therefore, has its own special niche in the game's lore. And Hogan has not been the only player it has humbled.

Between the tee and the green at the fourth hole, Cypress Creek makes a sharp turn. So the tee shot must carry the water and also needs to miss the big bunker to the right of the green.

In Hogan's day, the creekbed was filled with small shrubs and wild grasses. It had an altogether wild looking appearance.

The hazard has been cleaned up since then. The banks of the creek have been cleared out and a wall has been built to prevent erosion. Depending on where it finishes, a ball that finds the hazard might actually be playable.

But even if the fourth at Champions looks a little different than it once did, the hole's historical significance will be forever unchanged.

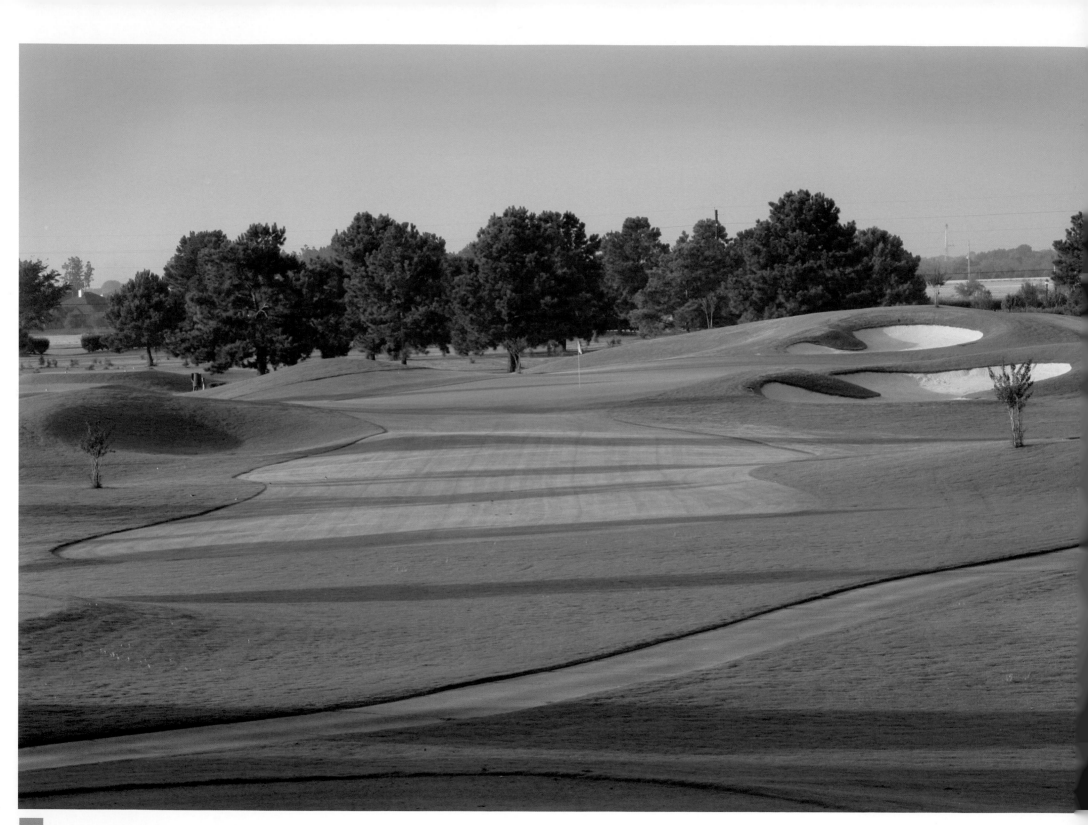

CYPRESS

CYPRESS LAKES GOLF CLUB
4TH HOLE

204 yards • par 3

Cypress, TX 281•304•8515 www.cypresslakesgc.com

*S*ince the Cypress Lakes Golf Club opened shortly before the most recent turn of the century, it has been steadily changing its look.

Hundreds of trees have been transplanted onto the course from a neighboring property and plans call for the project to continue until the layout takes on as much of a wooded look as it does a watery look.

There is no water in play, however, at the par-3 fourth, where the chief hazard comes in the form of length and a series of large bumps in the ground.

Although there is no forced carry on the tee shot, it requires a lot of club, especially when the prevailing winds are howling.

The green is long (42 yards) and narrow and has two bunkers hard up against the right side. The most difficult pin placements are to the right, especially in the back of the green, which makes a little curve behind the second of the two bunkers.

When trying to make an aggressive swing on a long par-3, the tendency is to pull the ball. And if a right-handed player does that, the mounds placed left of the green can become a major factor.

There is a grass bunker in the left front and the mounds can turn an off-line tee shot into a very difficult second shot. The ball can wind up dramatically below or above the player's feet. There could be a sharply downhill lie or an uphill one.

The chances are very good that a shot from the mounds will be of a sort that is rarely practiced.

Once on the green, a quick putt can be expected — just as is the case everywhere at Cypress Lakes. When it was first reviewed, the course was described as, "the best kept secret," in the Houston area. Because of the consistently pristine playing conditions, that is no longer the case.

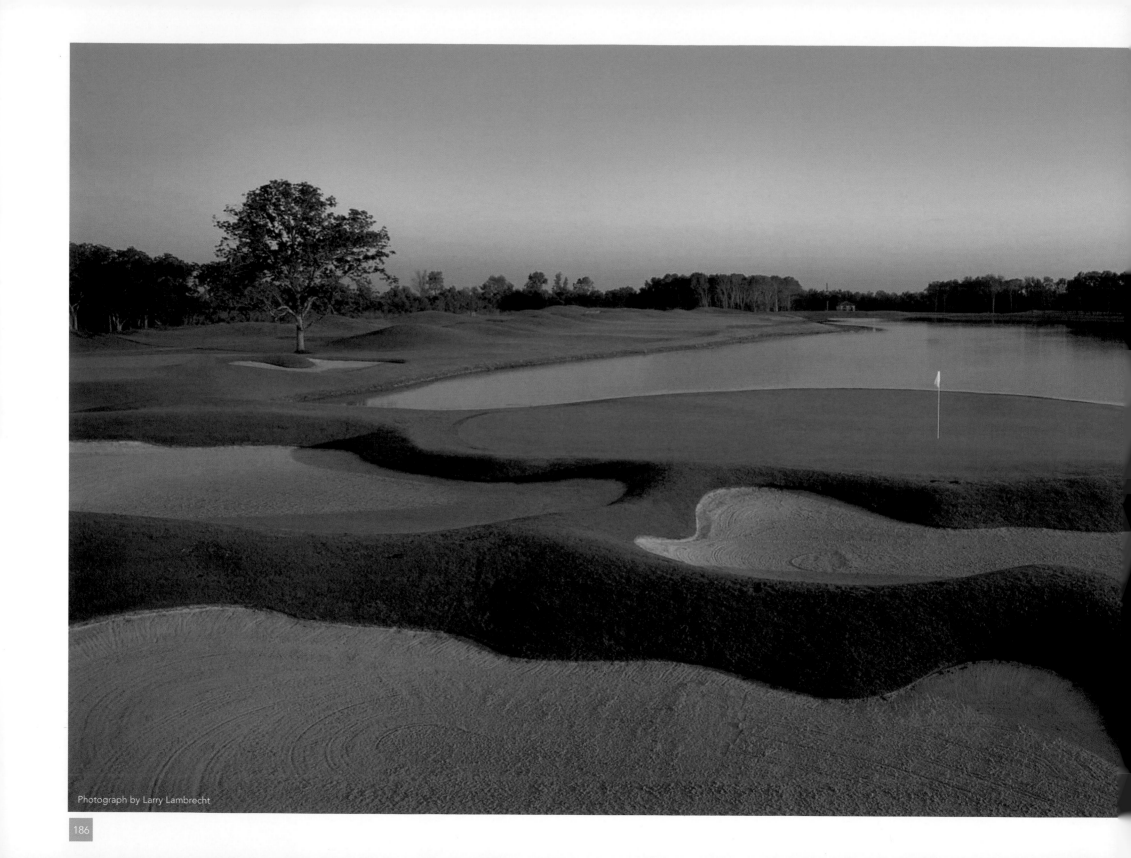

THE HOUSTONIAN GOLF & COUNTRY CLUB
15TH HOLE

167 yards • par 3

Richmond, TX 281•494•4244 www.houstoniangolf.com

The sight of large bodies of water often brings out the worst in a golfer.

If there is a need to carry the ball any distance at all to avoid going in the drink, the swing seems to pick up an extra hiccup.

For those who suffer such a malady, there is both a curse and a blessing to be discovered at The Houstonian.

Yes, there is water. Lots of it. The large bodies of water that take up much of the property come into play on an even dozen holes. But the good news is that, for the most part, it is possible to play around the hazards.

It is true that a hook here or a slice there will bring about a reduction in the player's golf ball supply. But a shot aimed straight down the fairway that goes where it is intended has a chance to stay dry all day, even if it does not stay airborne for the desired amount of time.

The most substantial carry of the round comes at the par-3 15th and even there it is possible to aim the ball a little to the left and find a haven of grass short of the green.

The idea, however, is to get to the green in one and on this Rees Jones designed hole there is a slight twist.

Often in modern-day designs, a hole over water is played to a wide, shallow green with a bunker in the back. The trouble, therefore, is to be found both short and long.

At Houstonian's 15th, the green is quite deep. The bulk of the trouble is to the sides.

A lake that occupies the middle of the course skirts the right side all the way from tee to green. It even goes partway around the back.

And to the left are three quite large bunkers, two of them up against the green and a third one even farther left. A shot from that third bunker must sail over one of the other two bunkers to get to the green and, alas, there is the water waiting on the other side.

The Houstonian does allow the golfer to tiptoe around the water. But it is never far away.

THE HOUSTONIAN GOLF & COUNTRY CLUB
17TH HOLE

207 yards • par 3

Richmond, TX 281•494•4244 www.houstoniangolf.com

The word that springs to mind when gazing at The Houstonian Golf & Country Club's 17th hole is, "panoramic."

It is fashionable for today's more eye-popping par-3 holes to have a focal point — usually in the form of a dramatic hazard. The hole might have all sorts of nooks tucked away that can be appreciated in time, but there is a chief feature that demands instant attention.

The Houstonian's next-to-last hole, however, is made for the wide screen because there is so much to take in all at once.

The tee shot at the 17th is the only significant forced carry on the golf course. Although the property is laden with water that awaits the poor shot, the vast majority of the liquid can be skirted.

At this hole, however, it is impossible to tiptoe around it. The nice thing for those who will never be mistaken for a major championship winner is that the Houstonian has five sets of tees on every hole.

So if it is a bit daunting to tackle this challenge from the back tee (which sits 207 yards from the middle of the green), there are options all the way down to 123 yards.

The pond, however, constitutes just part of a hole that is broad in scale.

Across the water is a very wide green that has been pushed up out of the earth to form a miniature mesa. It resembles a sort of stage with the water in the place where the orchestra pit would be.

To the left of the green is a complex of bunkers about half as wide as the green itself. On another hole, this imposing sort of hazard might be the first thing the player noticed when stepping to the tee. But on this hole it is just part of the overall view. A smaller bunker is placed to the right of the green, a putting surface with more depth on its left side than on the right.

The tee shot is into the prevailing wind and a blustery breeze can cause a player to reach for a big-headed club.

The design features on the hole are certainly not unique. But as in the case of a tasty meal, the ingredients have been very nicely blended so that they share your attention.

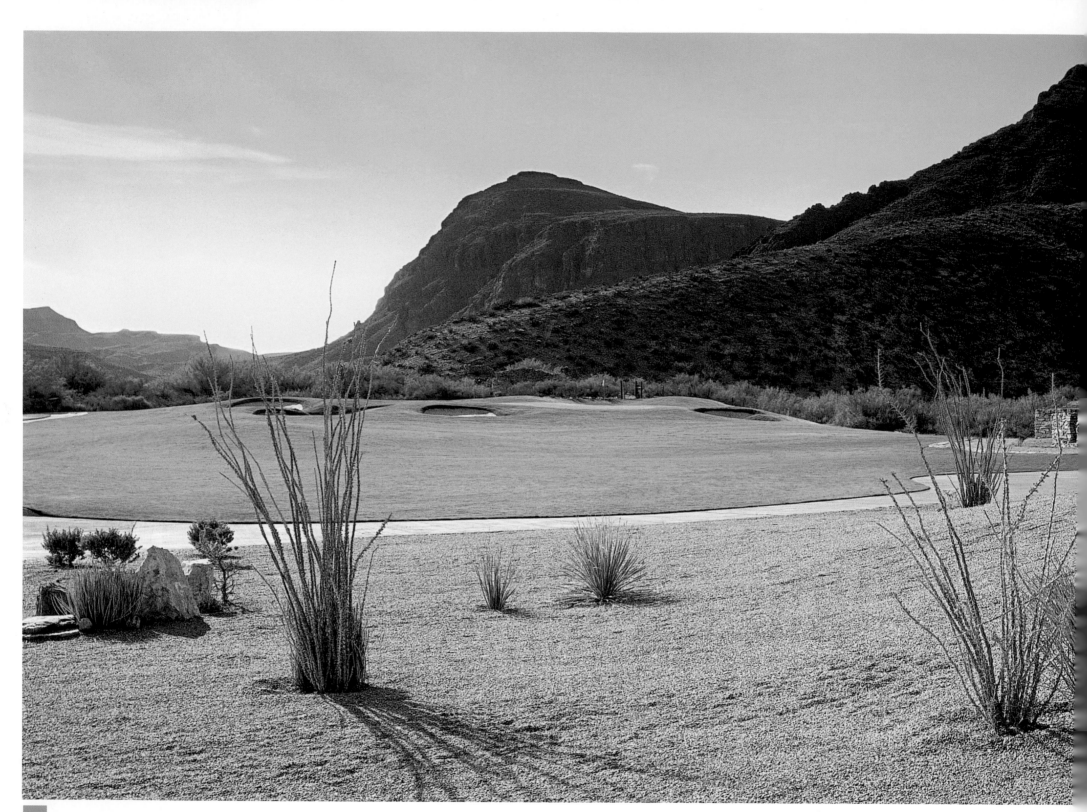

LAJITAS THE ULTIMATE HIDEOUT
ambush course • 13TH HOLE

166 yards • par 3

Lajitas, TX 877•525•4827 www.lajitas.com

The Big Bend region of Texas is certainly long on old-fashioned rugged scenery. In fact, that's about all there is in the hundreds of square miles that make up this somewhat ominous appearing land.

So it is to be expected that the Ambush at Lajitas is going to have some views to write home about.

Sure enough, at the par-3 13th, there is such a view.

The back tee is located 85 feet above the green, which may not be the world record for elevation change on a par-3 but is surely pretty close.

It is possible to see the entire course from the tee box at Number 13. Over there you can see the first tee. And over there is the village of Lajitas, with its shops and its lodge that is designed to resemble a cavalry post.

It is a view of vastness, but at some point the task at hand must be addressed and that involves figuring out which club is best suited to sending the ball out into the atmosphere in hopes that it will come to rest on the green—way down there.

The green is slightly raised from the otherwise flat ground around it and has bunkers short left and short right.

Behind the green is the boundary of the Big Bend National Park and beyond that are a couple of hills that rise up dramatically. Out of bounds is located to the right of the green as well.

The putting surface has a lot of undulation and, like the rest of the bent greens at Lajitas, runs very fast.

In the atmosphere one finds in the amazing panorama that is the Big Bend, an ordinary golf course could simply not be tolerated. The 13th hole at Lajitas demonstrates for certain that there is nothing ordinary about this golf course.

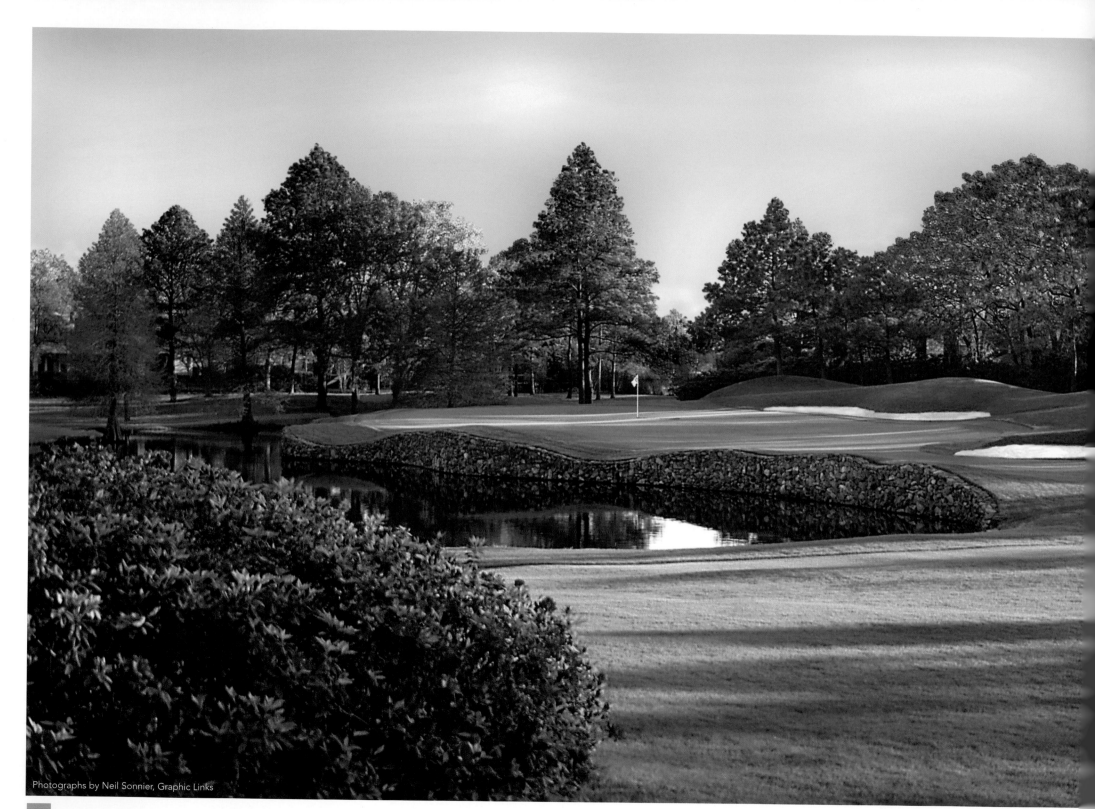

Photographs by Neil Sonnier, Graphic Links

LAKESIDE

LAKESIDE COUNTRY CLUB
4TH HOLE

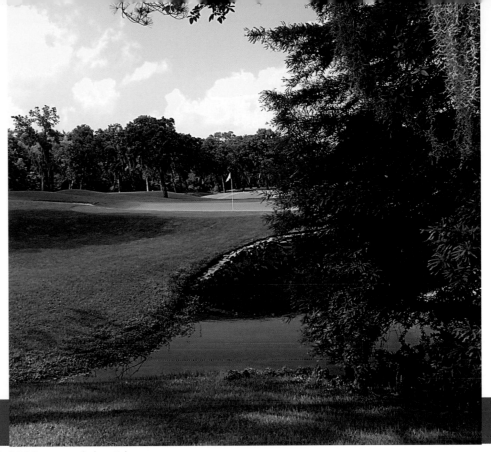

169 yards • par 3

Houston, TX 281•497•2222 www.lakesidecc.com

The Lakeside Country Club, a venerable member of the Houston golf scene, has both an outstanding course and a colorful history.

The land on which Lakeside sits was purchased for less than a dollar an acre just 15 years after Texas became a state. Several owners later, a house was built on the property that is as much of a conversation piece as the course itself.

Because the Buffalo Bayou sits nearby and because of the threat of flooding, the property owner constructed a house that was virtually waterproof. It had 18-inch thick, concrete walls reinforced with steel. The basement even had two big pumps.

The whole thing cost just over $150,000 in 1934, which was a pretty good amount of cash during The Depression. That structure became part of what is now the clubhouse at Lakeside, which opened for business in the early 1950s.

Although water comes into play often, it does not have to be carried at Lakeside until the par-3 fourth. It is not a long hole by any means, but it is one that is pleasing to the eye and can be pleasing to the scorecard with the proper club selection and a well-struck shot.

A pond runs across the entire front of the green and circles around the left side. The water is shored up by a rock wall. There is a tiny bunker to the right of the green, more for show than anything, and a big one stretches across the back.

The left side of the green requires more of a carry to reach than does the right side, thus affecting the club selection decision.

With trees and mature, flowering shrubs all around, the hole gives the look of having been around for a very long time, which, in fact, it has.

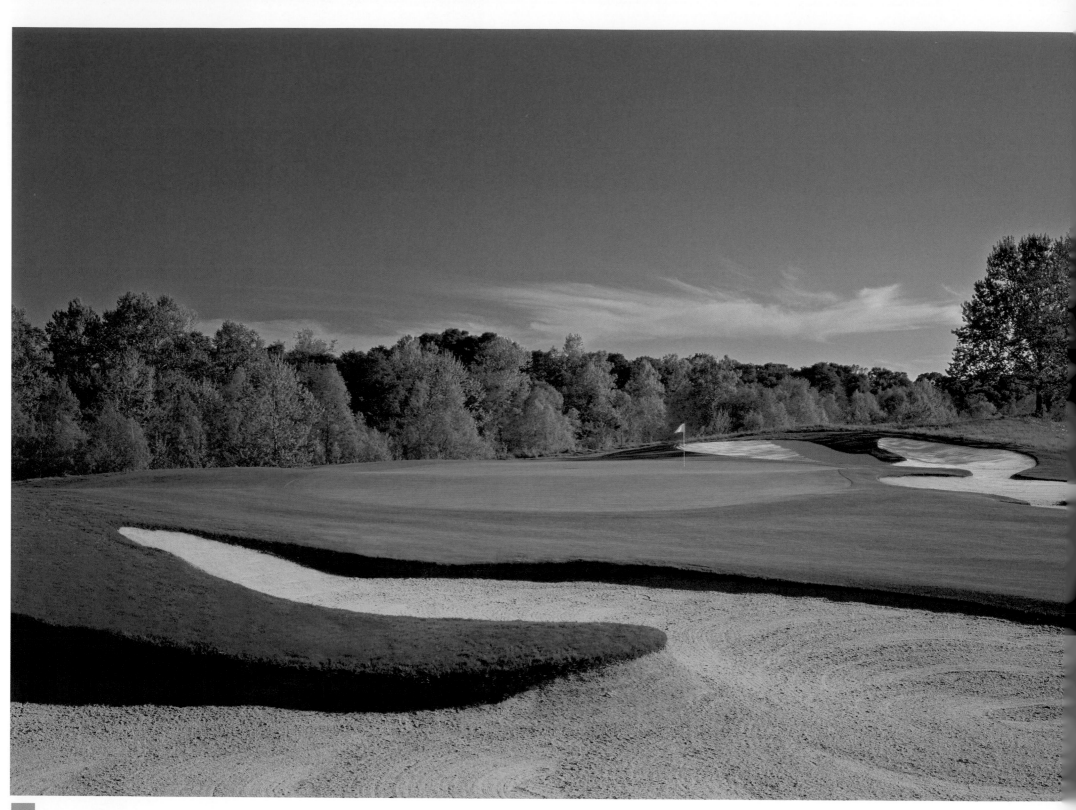

MEADOWBROOK

MEADOWBROOK FARMS
GOLF CLUB
6TH HOLE

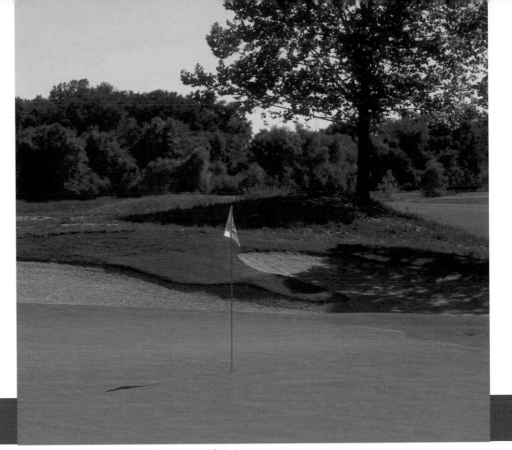

160 yards • par 3

Katy, TX 281•693•4653 www.meadowbrookfarmsgolfclub.com

*I*n an area thick with natural grasses and brimming with a large assortment of wildflowers, Greg Norman designed his first Texas golf course.

"Meadowbrook Farms," Norman said, "is one of my most favorite courses. From day one, being selected as its designer was always a privilege."

There are streams. There are woods. There is marshland. There is Norman's own type of hybrid Bermuda on the tees and fairways — a grass that carries the designation of GN-1.

Sitting above it all, with a panoramic view of the course, is a ranch style clubhouse. Minus the cattle.

Norman has thrown in some bunkers with sod walls, reminiscent of Scotland. But at its heart, the course is pure Texas — big, beautiful and first class.

The sixth hole is a lovely example, a fairly short par-3, on which the tee shot must be played over a small bit of marsh with a lake edging in short and right of the green.

The tee shot does not have to be carried all the way to the green. There is an immense bunker short and right of the green that separates the putting surface from the lake and marsh. It takes a pretty poor shot to find the water, although such a happening is not out of the question.

Another large trap is situated on the back right corner, one that is built into the side of a mound that oozes up out of the ground.

After taking in all the chief hazards, the player needs to focus in on the pin position because a ridge runs at a diagonal from front left to back right. The two sections of the green are fairly level, but a ball that comes to rest in the section opposite of where the hole is located must be putted up and over the ridge.

Behind the green is more marshland and beyond that is a thick grove of mature trees that are as dense as they are attractive.

The trees create a perfect backdrop for a hole that looks so much like an oil painting from the tee that it is a shame to upset the natural beauty; but it is worth it.

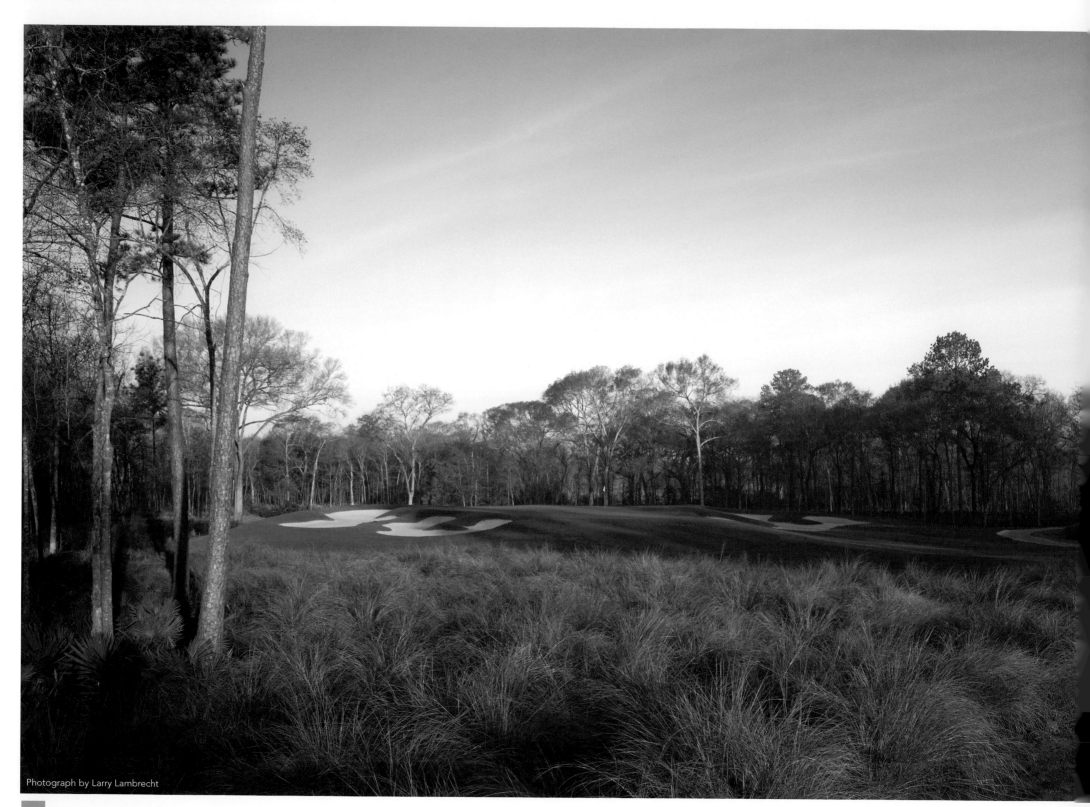

Photograph by Larry Lambrecht

REDSTONE GOLF CLUB
tournament course • 14TH HOLE

215 yards • par 3

Humble, TX 281•459•7800 www.redstonegolfclub.com

*N*o matter how scenic a course might be, its worth will eventually be determined by its greens.

Redstone Golf Club's Tournament Course has a special set of greens, as became obvious when the PGA TOUR made its first visit there in 2006.

Longtime Tour Tournament Director Mark Russell found the greens very much to his liking because, as he said, they were actually three or four greens in one. That made it easy for him to tuck pins in positions that were difficult to find.

And Tour winner Ted Purdy went so far as to say that when the Houston tournament is played the week prior to the Masters, it will provide an excellent warmup for the first major championship of the season.

"It's a very similar green design to Augusta," Purdy said. "They have big undulations, just like at the Masters."

Those undulations are certainly present at the par-3 14th, a hole in which the green is the chief attraction.

The putting surface has three distinct levels and a tee shot that finds the correct level will set up a birdie chance. It is not that easy, however, to hit the right level from 215 yards away.

There are very deep bunkers both left and right and if the tee shot winds up in a trap that is adjacent to the hole location, making par will be very unlikely.

There is a hazard in front of the green in the form of a waste area that includes pampas grass. But it is far enough removed from the target that a reasonable shot will easily avoid it. Even those playing the forward tees should expect to clear the hazard.

Instead, the biggest hazard at the last par-3 on the course is the green itself.

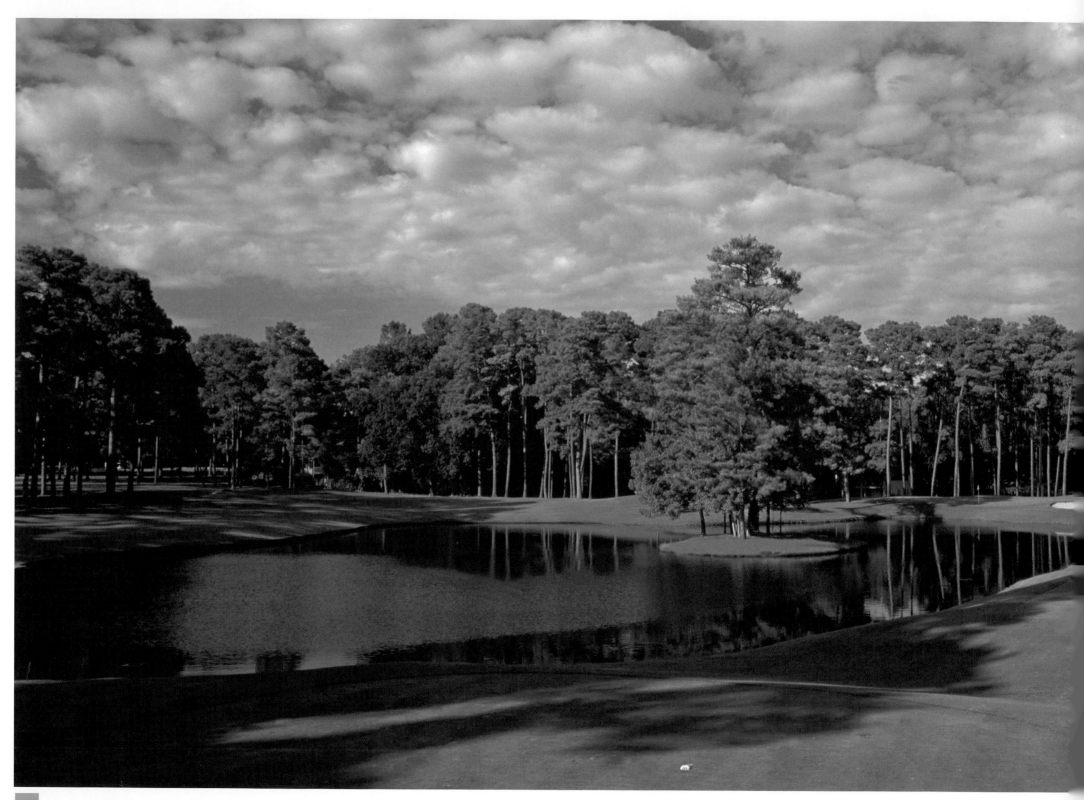

WALDEN ON LAKE CONROE
GOLF CLUB
6TH HOLE

189 yards • par 3

Montgomery, TX 936•448•6440 www.waldengolf.com

Year in and year out, the course that winds its way around Lake Conroe has been placed in various rankings as one of the top 10 layouts in the state.

It combines views of the lake with shot-confining stands of pines and oaks.

Small wonder, therefore, that it has been the site of various United States Golf Association qualifying events along with Southern Texas PGA competitions.

The design work of Robert Von Hagge and Bruce Devlin, Walden on Lake Conroe Golf Club provides a mixture of holes that leaves the player anything but bored.

A good example is the par-3 sixth, where the concept of visual intimidation is carried out to the fullest.

It is certainly not the most difficult hole at Walden. The low-handicap player using the back tee requires a middle or long iron and those using the forward tees face a shot that does not require an enormous carry.

If all that stood in the way of such a shot was a flat piece of ground with green grass on it, there would be few concerns.

But there are trees down the right side plus a small lake that extends all the way down the left and guards the front, left corner of the green. The right side of the putting surface is protected in front by a bunker.

That should mean something long is a lot better than something short. That theory, however, runs into trouble because of the sharp downward slope behind the green which will carry a ball to the course boundary.

Any par-3 in the world can be conquered with a decent tee shot. On this hole, that shot needs to be more than decent.

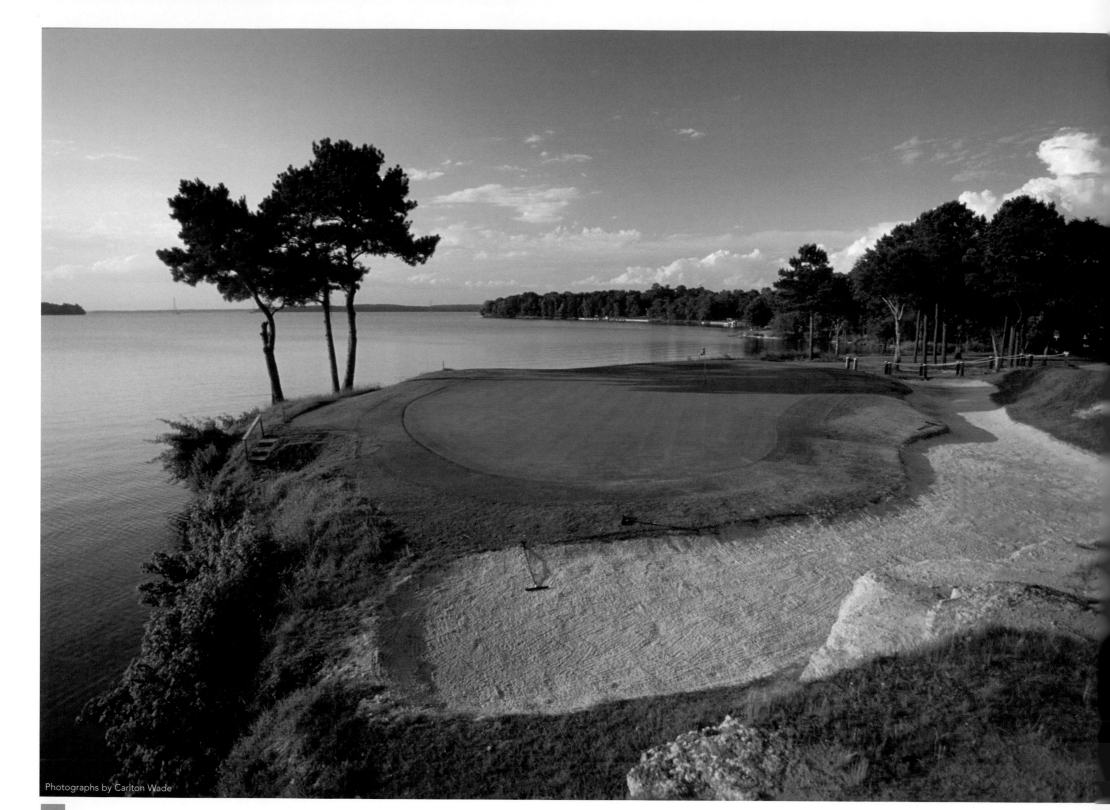

WATERWOOD

WATERWOOD NATIONAL
14TH HOLE

225 yards • par 3

Huntsville, TX 877•441•5211 www.waterwoodnational.com

A golf building boom in Texas that began late in the 20th Century and continued briskly into the 21st created an astonishing number of "must see" courses populated by "must see" holes.

Before that boom began, however, there was Waterwood National, which burst upon the scene as an attraction that golfing aficionados soon found they could not miss.

Pete Dye created the course along the edge of the Sam Houston National Forest and near the banks of Lake Livingston. Pete Dye courses are never dull and they are routinely formidable.

Waterwood National made such an impression when it opened that on three occasions it hosted the final round of qualifying for the PGA TOUR. Major championship winners Hal Sutton, Paul Azinger, and Larry Mize, among others, became official tour members by surviving the rigors of this course.

It is a layout that fell into disrepair over the years, but has now been resorted to its original glory.

The challenge is relentless, although the most frightening assignment comes at the par-3 14th. It is commonly listed among the most difficult holes in Texas and there need be no guesswork as to why.

The hole is 100 percent carry and it is 100 percent long. At least it is long from the back tees. But no matter which tee is used, no mediocre shot is forgiven.

In front of the tee is a segment of Lake Livingston, forcing a carry that seems to the eye to be quite a bit farther than the yardage mentioned on the scorecard.

Across the water and slightly to the right of the intended ball flight is a rock plateau, rising well above the green with trees and brush covering much of it. To the left there is a large tree, somewhat removed from the range of a good shot but standing ready to swat down a bad one.

And then there is the green itself, sitting in the middle of all that nature atop a miniature cliff with a thick grove of trees serving as a background.

It is a daunting shot, but daunting shots become the norm when attempting to deal with Waterwood National.

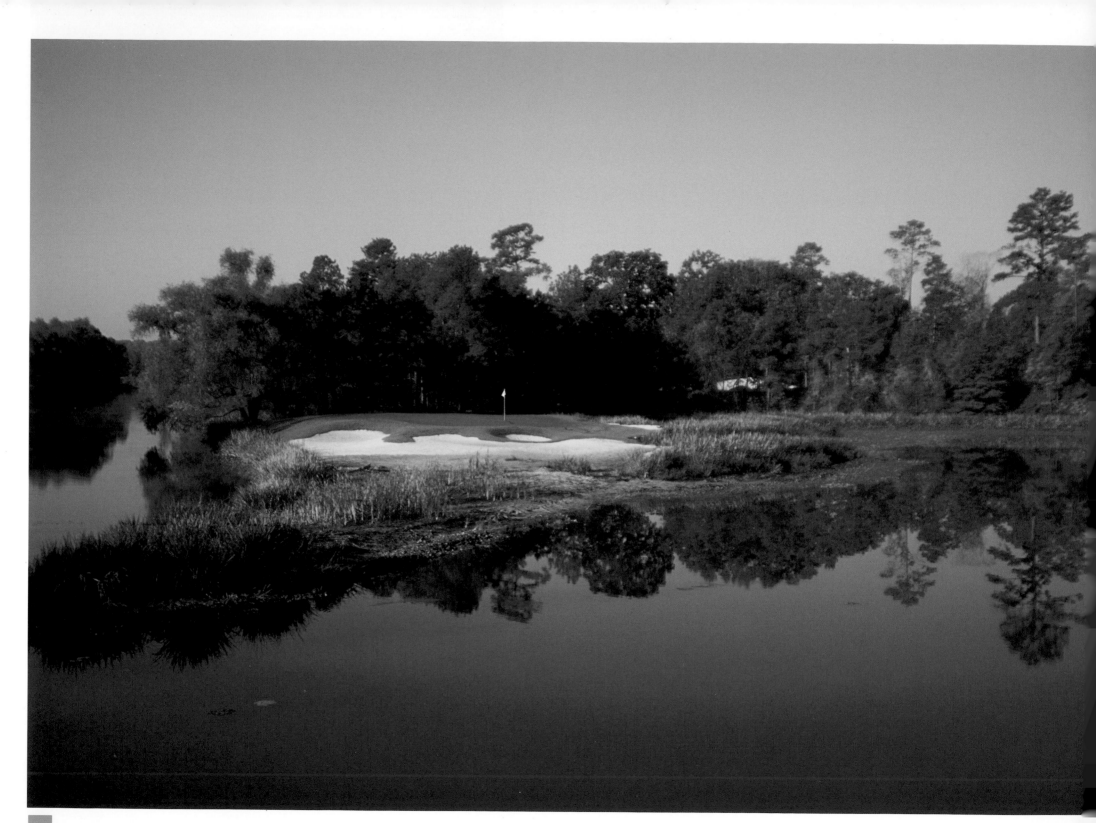

WHISPERING PINES GOLF CLUB
15TH HOLE

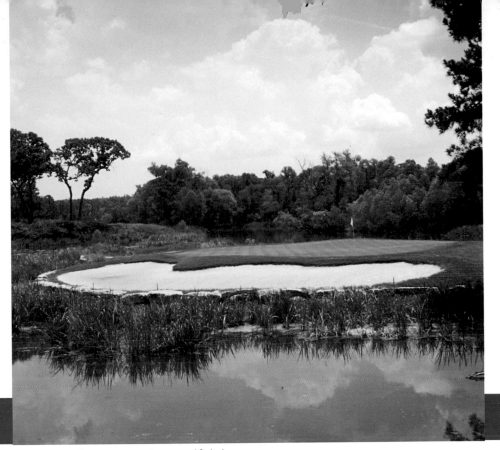

178 yards • par 3

Trinity, TX 936•594•4980 www.whisperingpinesgolfclub.com

There is much that is unique to Whispering Pines, recognized in a variety of polls as among the very best courses in Texas.

For one thing, it is closed in the midst of both winter and summer. It is open to its 145 members only when the very best conditions can be maintained.

It is also the host every other year to a sort of Olympics of amateur golf. The event, known as the Spirit International, is a mixed team tournament in which 24 countries are represented.

The stars of tomorrow are tested by a variety of challenges along the banks of Lake Livingston. Those challenges only intensify as the course nears its conclusion and the par-3 15th comes with an out-of-the-ordinary hazard.

From above, the 15th looks like a triangle placed in the middle of a lake deep in the woods. From ground level, it does not look like a work of geometry at all. It simply looks impossible.

The tee shot must travel over the water, then over a bunch of marsh grass and then over a bunker about the size of Rhode Island. Only then will it find the green, which has a drop-off to the water on the left and a long bunker on the right that runs the entire length of the putting surface.

And then there are the alligators.

The hole was created where a group of the unpleasant looking rascals used to reside. And some of them are still on the property. In a recent count by the Texas Parks and Wildlife Department, 36 alligators were identified in Walker County and 25 of them were at Whispering Pines.

The living, breathing obstacles usually keep to their place, something the golfers certainly appreciate. After all, the 15th at Whispering Pines is difficult enough on its own.

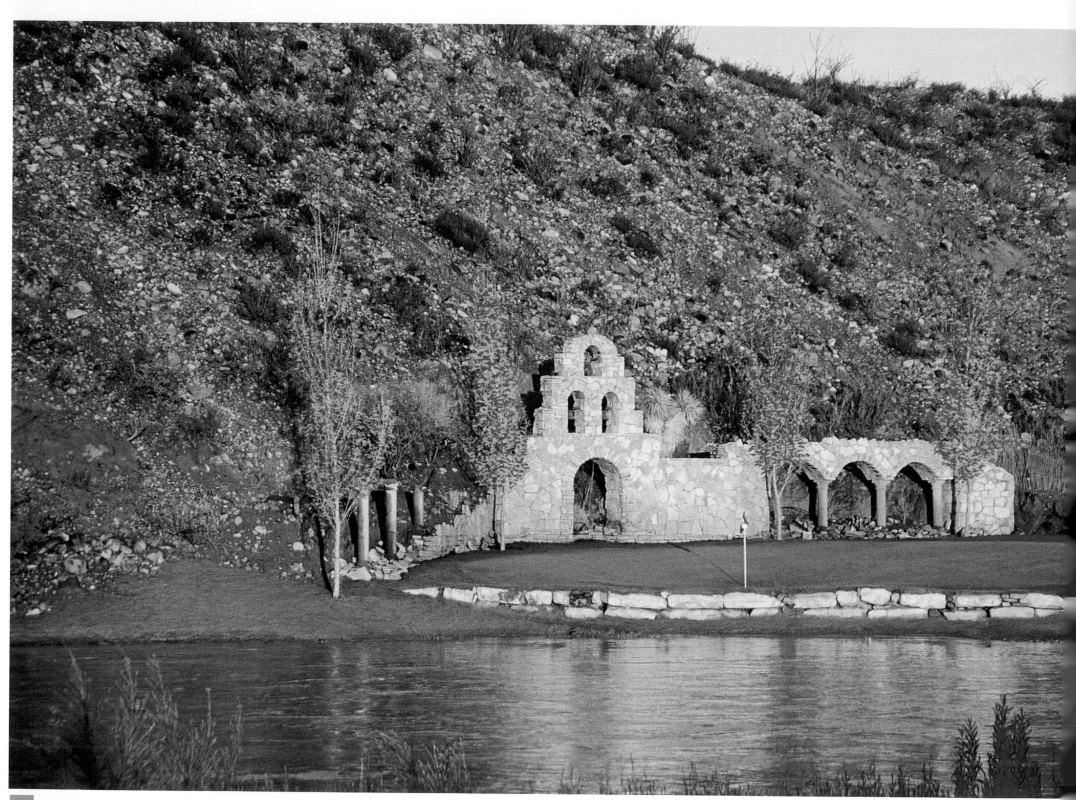

LAJITAS THE ULTIMATE HIDEOUT

ambush course • 11TH HOLE-A

99 yards • par 1

Lajitas, TX 877•525•4827 www.lajitas.com

Located in the midst of what is certainly one of the most out-of-the-ordinary destinations the sport has to offer, those who have made the journey can find what might be described as both the longest and shortest hole in all of resort golf.

It is to be found partway through a trip around the Ambush at Lajitas.

Lajitas does not come by its reputation without cause. It is, as much as any course in the country can be, in the middle of nowhere.

Its slogan — "The Ultimate Hideout" — is not overstated. Hard by the Rio Grande and sitting on the edge of the Big Bend National Park, Lajitas is not the sort of place one just happens to stumble onto.

But once there, it is probably a good idea to stay a while because there will be no golfing experience like it.

The course, designed by the acclaimed team of Roy Bechtol and Randy Russell, is player friendly. And it features a novelty hole of the first order.

After completing play at the 10th hole of this one-of-a-kind facility, the opportunity arises to play what is listed as hole Number 11-A.

It is a long hole because it begins in the United States and ends in Mexico. It is a short hole because it is only 99 yards across the Rio Grande to the green.

The green is shaped a little like a bowl so that the ball has a chance to wind up close to the hole. And there is added atmosphere in that a façade of a Spanish-style mission has been created just behind the green.

No matter how good or bad the tee shot might be, it is the only time the ball can be struck on the hole. Since there is no access to the green, there is no putting out.

For the record, par on the hole is one. Therefore, on this most international of holes, it is impossible to make a birdie.

THE PUBLISHING TEAM

Panache Partners LLC is in the business of creating spectacular publications for discerning readers. The company's hard cover division specializes in the development and production of upscale coffee-table books showcasing world-class travel, interior design, custom home building and architecture, as well as a variety of other topics of interest. Supported by a strong senior management team, professional associate publishers, and a top-notch creative team of photographers, writers, and graphic designers, the company produces only the very best quality of these keepsake publications. Look for our complete portfolio of books at www.panache.com.

We are proud to introduce to you the Panache Partners team below that made this publication possible.

Brian G. Carabet

Brian is co-founder and owner of Panache Partners. With more than 20 years of experience in the publishing industry, he has designed and produced more than 100 magazines and books. He is passionate about high quality design and applies his skill in leading the creative assets of the company.

John A. Shand

John is co-founder and owner of Panache Partners and applies his 25 years of sales and marketing experience in guiding the business development activities for the company. His passion toward the publishing business stems from the satisfaction derived from bringing ideas to reality.

Steven M. Darocy

Steve is the Executive Publisher of the Northeast Region for Panache Partners. He has over a decade of experience in sales and publishing. A native of western Pennsylvania, he lived in Pittsburgh for 25 years before relocating to his current residence in Dallas, Texas.

Karla Setser

A true Texan at heart, Karla was born in Houston and followed the man of her dreams to Tarrant County in 2002. With a background in marketing and public relations, Karla is well suited to promote something she is extremely proud of—Texas and her love of great golf courses. Some of Karla's favorite course discoveries include Lajitas The Ultimate Hideout, Boot Ranch, Whispering Pines, Royal Oaks Country Club Dallas and Horseshoe Bay Resort.

Mike Rabun

Mike Rabun, the book's writer, recently retired from United Press International after more than 40 years of covering and editing news and sports events. He has covered 10 Olympics, 15 Super Bowls, six Final Fours, about 40 major golf championships, scores of PGA TOUR events and hundreds of regular-season professional and collegiate football, baseball and basketball games. A true golf enthusiast.

ADDITIONAL ACKNOWLEDGEMENTS

Sr. Associate Publisher	Martha Morgan
Project Management	Carol Kendall and Beverly Smith
Design Team	Michele Cunningham-Scott, Emily Kattan and Mary Elizabeth Acree
Production Coordinators	Kristy Randall, Jennifer Lenhart, Laura Greenwood
Editorial Staff	Elizabeth Gionta, Rosalie Wilson, Aaron Barker and Sarah Toler.
Special Thanks to	*Richard Ellis, Jay Morrish, Carter Morrish and Alan Stillwell.*

THE PANACHE PORTFOLIO

The catalog of fine books in the areas of interior design and architecture and design continue to grow for Panache Partners, LLC. With more than 30 books published or in production, look for one or more of these keepsake books in a market near you.

Spectacular Homes Series

<u>Published in 2005</u>
Spectacular Homes of Georgia
Spectacular Homes of South Florida
Spectacular Homes of Tennessee
Spectacular Homes of Texas

<u>Published or Publishing in 2006</u>
Spectacular Homes of California
Spectacular Homes of the Carolinas
Spectacular Homes of Chicago
Spectacular Homes of Colorado
Spectacular Homes of Florida
Spectacular Homes of Michigan
Spectacular Homes of the Pacific Northwest
Spectacular Homes of Greater Philadelphia
Spectacular Homes of the Southwest
Spectacular Homes of Washington DC

Other titles available from Panache Partners

Spectacular Hotels
Texans and Their Pets
Spectacular Restaurants of Texas

Dream Homes Series

<u>Published in 2005</u>
Dream Homes of Texas

<u>Published or Publishing in 2006</u>
Dream Homes of Colorado
Dream Homes of South Florida
Dream Homes of New Jersey
Dream Homes of New York
Dream Homes of Greater Philadelphia
Dream Homes of the Western Deserts

Order two or more copies today and we'll pay the shipping.

To order visit www.panache.com
or call 972.661.9884.

Creating Spectacular Publications for Discerning Readers

INDEX OF GOLF COURSES